A COMPLETE GUIDE TO
Chinese Brush Painting

INK • PAPER • INSPIRATION

Caroline Self
Susan Self

TUTTLE Publishing

Tokyo | Rutland, Vermont | Singapore

Dedication

This book is dedicated to people who want to try something new
and keep something old alive.

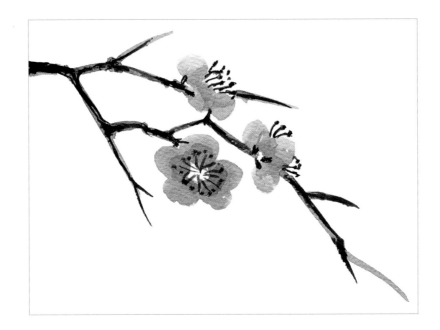

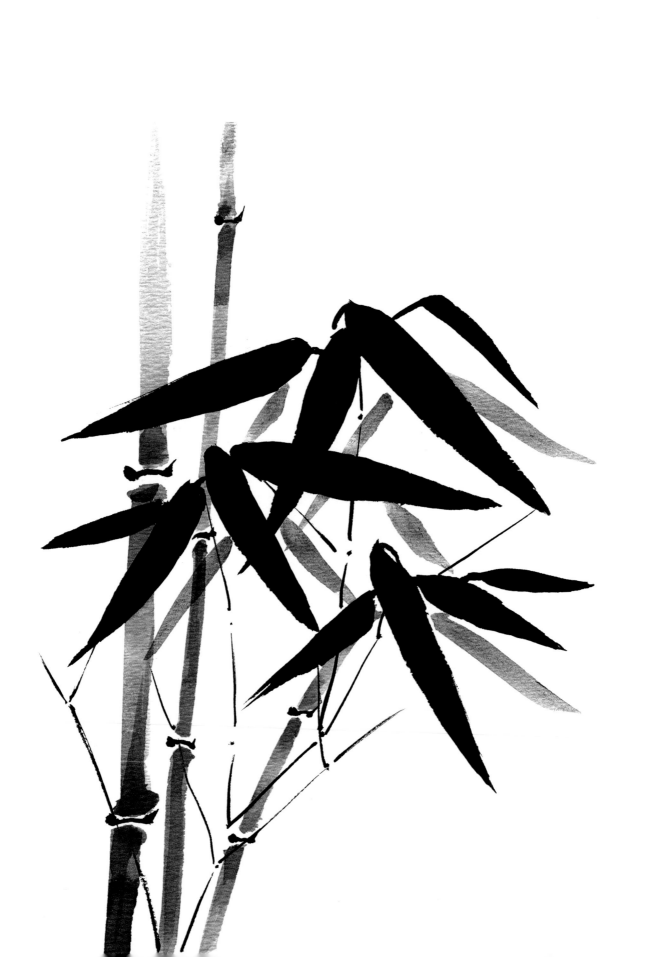

Contents

Why We Wrote This Book

This book introduces you to the art of painting with ink on rice paper using traditional Chinese techniques developed over a thousand years ago. Unlike many other books on Chinese painting available, this book does not teach the use of colored inks, watercolor techniques, or styles of composition influenced by Western traditions. The "colors" here are painted with shades of gray made by diluting the ink, just as black-and-white photography composes with light and darkness.

You will learn to paint the classic subjects that inspired the ancient painters: towering landscapes; the elegant Four Gentlemen: bamboo, orchid, plum blossom, and chrysanthemum; the rugged, steadfast pine; and five fun animals from the Chinese Zodiac: rat, rabbit, rooster, horse, and dragon. Numerous exercises help you to master the brush before you start painting a subject. Since many painters were master calligraphers, you will also learn to paint the basic strokes used in calligraphy to acquire the expressiveness of line that makes a painting energized and eye-catching. The survey of how calligraphy developed over time will teach you to recognize and appreciate the different styles, many of which are still practiced today.

Our first book, *Chinese Brush Painting: A Hands-on Introduction to the Traditional Art*, was geared for beginners from 9 to 90, as a low-cost, entry-level approach suitable for children in schools and adults just trying out the art. This book addresses the more committed adult beginner willing to invest money in high-quality supplies and time in practicing a larger variety of techniques and subject matter. Instead of the method of using tempera paint and watercolor brushes, this book introduces you to grinding your own ink with an ink stick and an ink stone, and the meditative practice that action introduces into the painting process. You will learn to distinguish the qualities of different types of brushes, ink stones, ink sticks, and paper so you know what to buy. In addition to the free-form or boneless style taught in the previous book, this book teaches the outlined or boned style of painting each subject. You will develop a larger range of techniques and strategies in learning the boned style and will come to appreciate the accomplishments of the artists that practiced it. You will get a sense of the strengths and weaknesses of each style and how to mix them for artistic effect.

One of the larger intentions of this book is to provide an understanding of the historical context from which the art arose and the symbolism in the paintings for the artist. Chapter 1 surveys the history of the Chinese dynasties and the influence of the philosophies of Yin and Yang, Confucianism, Daoism, and Chan Buddhism on the painting traditions. The chapter notes historical situations that provide an understanding of elements introduced in later chapters of the book. You will be able to "get inside" the art of painting and appreciate it more from the point of view of the ancient artist. As "the soft martial art," brush painting is a meditative discipline with canons, principles, and time-honored practices geared toward achieving the most satisfying aesthetic results. The accomplished artist has trained the body, arm, and brush to move as a unit to create strokes with power and spontaneity. The ways of looking at the subject matter and becoming one with it enable the artist to paint the living essence of the subject and not just its physical appearance. Painting thus becomes the artist's transcendent experience captured in ink to evoke in the viewer a similar experience.

Chapter 1

A Brief History of Chinese Brush Painting

This book teaches the styles of Chinese brush painting that flowered in the Song dynasty (960–1279 CE) and the Yuan dynasty (1271–1368 CE). The styles are not just techniques but the expression of a world–view rooted in Chinese philosophies that developed over four thousand years of history. Understanding the history and philosophies and the aesthetics related to them can help you to appreciate the significance of painting as practiced by the traditional Chinese artists. It can also help you to develop some of the same reverence and respect for your own practice of painting.

Yin and Yang and the Eight Trigrams

According to legend, the first simple system of notation in China was developed by the legendary Emperor Fu Xi in the 28th century BCE. The Bagua or "eight symbols" system reflects the dualistic philosophy of yin and yang. Yang is the positive, masculine principle of the universe, associated with heaven, light, the father, strength, and hardness. Yin is the negative, feminine principle, associated with earth, darkness, the mother, weakness, and softness. The image of the dragon hidden in the clouds was first used to represent the yang principle and was matched by the tiger crouching on the earth to represent the yin principle.

In the 10th century BCE, the black-and-white yin-yang symbol was developed to represent the duality. The symbol is called *Taijitu* (T'ai-chi), "diagram of the supreme ultimate." The curve in the symbol means that the proportion of yin and yang varies among objects. Each waxes and wanes in proportion to the other over time in a constant process of change, as with day and night, the moon, the tides, and the seasons. The small circles mean that some yin is always in yang and some yang is always in yin.

The eight trigrams were formed by combinations of three layer stacks of the yang and yin signs, – and --. The combinations show different proportions of the yin and yang qualities associated with major elements in the universe. The paired opposites are now typically shown around the yin yang symbol. Lake is separated from water, as mountain is separated from earth, showing the special significance of mountains and lakes or rivers. These are the primary elements of Chinese landscape painting, where the character for landscape, *shanshui*, is composed of the characters for mountain and water.

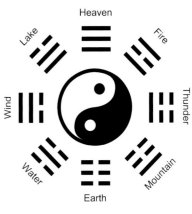

Eight trigrams

The sequences and locations of the trigram pairs were moved in later versions to show a change from a static, primordial configuration to a dynamic configuration. The Bagua was elaborated when King Wen Wang of Zhou (1099–1050 BCE), the founder of the later Zhou dynasty, stacked groups of two trigrams in their various permutations to create 64 hexagrams.

The *Yi Jing* (*I-Ching* or *Book of Changes*) was written perhaps in the 3rd or 4th century BCE. The book is devoted to the cosmic principles and philosophy of the ancient trigrams and hexagrams used as symbols. It has also been used as a manual of divination to interpret natural events for the superstitious through readings based on the symbols.

The Bagua system has been applied to various studies, such as astronomy, astrology, geology, geomancy, anatomy, time, and the seasons. In modern times, interpretations of the Bagua are commonly referenced in relation to Feng Shui and the martial arts.

The principles of yin-yang permeate traditional Chinese art and architecture. In a Chinese garden wall, you may see a round lattice window with a pattern of curvy lines (yin) beside a hexagonal window with angular, geometric lines (yang). The yin and yang, feminine and masculine, style windows alternate and change as you walk by. Similarly, the elaborately-shaped tiles on the ground alternate in black-and-white patterns.

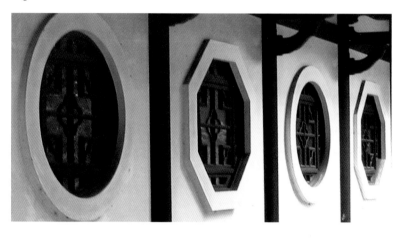

The symbolism of opposites can even be seen in the contrast of black ink on white paper in calligraphy and brush painting. In painting, the artist's tools are either yin or yang. The strokes on the page go right and left, balancing the yin and yang. A strong and dark stroke is yang or male, while a soft and pale stroke is yin or female. All opposites are yin and yang, and a painting becomes a harmonious one on the basis of these qualities.

The principles of yin-yang permeate traditional Chinese art and architecture

The Hundred Schools of Thought

Ancient pottery and bronzes were adorned with ornamental patterns, pictures of animals, or picture-characters that supported government rites meant to keep people in fear of their rulers and society in order. Subtle warnings and admonitions were used in art to improve social morality and foster right living.

Towards the end of the ancient era, in the Eastern Zhou Dynasty, the social order started to fall apart. Feudal lords rose up against the king and each other, and leaders of different states competed to gain power over the Empire. The nobles supported scholars and literary men to enhance their own reputations, however, which allowed the flowering of the Golden Age of Chinese Philosophy known as the Hundred Schools of Thought. The philosophies put forth different solutions to the social unrest.

Confucianism

Confucius (551–479 BCE) was a social philosopher active at the end of the Spring and Autumn Period who tried to stave off the chaos that eventually came in the Warring States Period. His real name was Kong Qui, and he was known as Kong Fuzi, Master Kong, which was later latinized to Confucius in the 16th century by the Italian Jesuit priest Matteo Ricci. Confucius traveled around the country in vain trying to spread his political ideas and influence the kings vying for supremacy in China. After his death, his disciples or their disciples wrote the Confucian Classics that defined a Confucian system. During the Warring States Period, the Confucian follower Mencius (371–289 BCE), or Mengzi, developed Confucianism into a political and ethical doctrine.

Confucius thought that society could be saved by restoring the old habits, social relationships, and traditions of rulership from earlier dynasties. Social harmony would prevail if all people knew their place in the social order and played their parts well. Virtues should be taught and internalized through good habits, such as following rules of etiquette. Relationships should be governed by mutual respect and obligation between sovereign and subject, parent and child, elder and younger sibling, husband and wife, and friend and friend (as equals). Filial piety, or a child's respect for his parents, should be matched by the parents' benevolence and concern for the child. Similarly, the sovereign plays the role of a benevolent autocrat towards his subjects. He must develop himself sufficiently so that his personal virtue spreads a positive influence throughout the kingdom. If he does not behave humanely towards his subjects, he risks losing the Mandate of Heaven that gives him a right to rule, and the people no longer need to obey him.

Confucianism exhorts all people to strive to achieve the ideal of the "gentleman." As a combination of a saint, scholar, and nobleman, a gentleman was expected to be a moral guide to the rest of society. He should embody internalized good habits and virtues, filial piety and loyalty, and humanity and benevolence. This concept of a "gentleman" gives greater symbolic significance to the group of classic painting subjects known as The Four Gentlemen: bamboo, orchid, plum blossom, and chrysanthemum. Each of these subjects embodies in some way the virtues of a gentleman.

Confucius saw that a virtuous farmer who cultivates himself can be a gentleman, while a selfish, disrespectful prince is a lowly person. Confucius allowed students of different classes to be his disciples, disregarding the feudal structures in Chinese society. He also fostered the idea

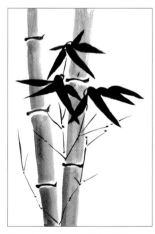

Bamboo—one of the "Four Gentlemen" of classical painting subjects

Ancient
3 Sovereigns and 5 Emperors 2698 – 2070 BCE
Xia Dynasty 2100 – 1600
Shang Dynasty 1600 – 1046
Zhou Dynasty 1046 – 221
Western Zhou Dynasty 1046 – 771
Eastern Zhou Dynasty 772 – 221
Spring and Autumn Period 772 – 476
Warring States Period 475 – 221

Imperial
Qin Dynasty 221 – 206 BCE
Han Dynasty 206 BCE – 220 CE
Western Han Dynasty 206 BCE – 9 CE
Xin Dynasty 9 – 25 CE
Eastern Han Dynasty 25 – 220 CE
Three Kingdoms 220 – 280 CE
Wei, Wu, & Shu Han
Jin Dynasty 265 – 420
Western Jin 265 – 317
Eastern Jin 317 – 420
Southern and Northern Dynasties 420 – 581
Sui Dynasty 581 – 618
Tang Dynasty 618 – 907
5 Dynasties and 10 Kingdoms 907 – 960
Liao Dynasty 916 – 1125
Song Dynasty 960 – 1279
Northern Song Dynasty 960 – 1127
Southern Song Dynasty 1127 – 1279
Jin Dynasty 1115 – 1234
Yuan Dynasty 1271 – 1368
Ming Dynasty 1368 – 1644
Qing Dynasty 1644 – 1912

Modern
Republic of China 1912 – 1949
Republic of China (on Taiwan) 1945 – present
People's Republic of China 1949 – present

of meritocracy, that virtue and talent could replace the nobility of blood. This idea ultimately led to the introduction of the Imperial Examination System in the Sui Dynasty in 605 CE. Literate individuals of the lower classes could raise their social status by becoming government officials. This in turn fostered an emphasis on education as a path towards upward mobility.

Confucianism as conveyed by Mencius was an idealistic philosophy based on the premise that people are inherently good. If they internalize patterns of virtuous behavior, they will behave properly to avoid shame and losing face.

The Confucian follower Xunzi (300–237 BCE) thought that people are not innately good but must attain goodness by training their desires and conduct. The practical weakness of the Confucian teachings is that fear of shame alone does not prevent those in positions of power from abusing their position for personal gain and engaging in corruption and nepotism. The implicit relationships between people are not reinforced by explicit contracts that formalize and enforce the rights of the less powerful.

Daoism (Taoism)

The origins of Daoism are attributed to Laozi (Lao Tzu or "Old Master"), who probably lived in the 6th century BCE, but possibly in the 3rd. He is traditionally called the author of the Dao De Jing (Tao Te Ching), the "Way of the Universe," but it is more likely that others developed the text after him. In contrast to the Confucian focus on social structures and obligations, Daoism sought to bring people into harmony with the natural world, the rhythms of the universe, the cycles of the seasons, and the transitions between life and death.

"Portrait of a Thinker" by Sherry Kendrick

The Dao was raised to the level of the cosmic principle, the formless, timeless, and limitless soul of the universe. When combined with the immaterial principle, the Qi or vital energy and breath, it created primary matter, from which all creation evolved. The yang male principle was diluted and formed the heavens, and the yin female principle coagulated and formed the earth. The yin and yang together constitute the Dao, the eternal principle of heaven and earth. The Qi energy that breathes life into creations was later seen by brush painters as the source of their own personal qi energy that would express through their brushwork and give life to the subjects of nature that they were depicting.

The universe is in constant flux as things happen spontaneously according to nature. Everything begins with the Dao and returns to it again. Against the Confucian overemphasis on the yang, willful activity and control of behavior, Daoism emphasized the yin, yielding to the Way of the Universe as the guideline for the individual and society. Discovering and accepting natural laws and not interfering with them should lead to social harmony and contentment.

Legalism

In the debates of the Hundred Schools of Thought, the School of Legalism ran against the idealism of Confucianism and Daoism. The doctrine, formulated by Han Feizi (d. 233 BCE) and Li Si (d. 208 BCE), saw humans as inherently selfish and needing external laws and harsh punishments if they perform illegal actions to keep society orderly. The philosophy aimed to strengthen the state and increase military might so that a ruler could establish a powerful state with central authority.

The Qin Dynasty (221–206 BCE)

The legalist philosophy played an important role in the unification of China once again in the Qin dynasty by the Emperor Qin Shihuangdi in 221 BCE. The country was divided into districts directly under the control of the centralized government and subject to uniform laws and taxation. Transportation was improved by developing a network of roads from the capital and by standardizing the track width between the wheels of carts. Defensive walls to keep out the nomads in the north were strengthened, joined, and extended to form a single wall along the northern frontier. Weights and measures were standardized, and a single coinage was adopted. Government bookkeeping, communication between districts, and education was improved by unifying the regional styles of calligraphy script into a standard official system of handwriting.

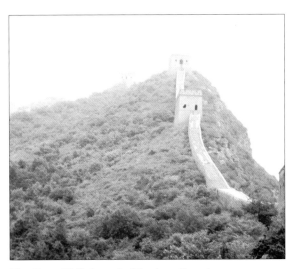

The Great Wall along the Northern Frontier

Although standardization was beneficial, it took on a more totalitarian character when the Qin emperor restricted individual thought and the creative arts to suppress criticism of imperial policy. To make a clean sweep and wipe out the past, including the records of Confucius' teachings, he ordered the burning of all books except those on practical subjects. Scholars who resisted the demand were executed. The loss of the teachings of civilization was greatly resented by scholars in subsequent dynasties.

The First Emperor patronized alchemists in an effort to make himself immortal through a magic elixir, but he died only eleven years after taking the throne. At least his memory has lived on, since he is famous now for the over 7,000 terracotta soldiers found in a pit east of his mausoleum near the city of Xian in Shaanxi province.

The Qin empire had become weak at the center, and subsequent leaders failed after the First Emperor's death. The dynasty no longer had the confidence of its people and lost the Mandate of Heaven when it fell in 206 BCE. The dynasty intended to last for ten thousand generations was over in fifteen years.

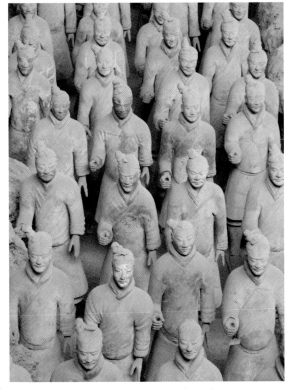

Some of the 7000 terracotta soldiers buried in a mausoleum in Shaanxi province

Yin Yang

The Han Dynasty (206 BCE–220 CE)

In reaction to the Legalism of the Qin dynasty, the Han dynasty emperors officially promoted Confucianism while keeping some features of Legalism that supported centralized rule. The Confucian teachings were expanded upon by Dong Zhongshu (?179–104 BCE) and others to relate them to the workings of the universe. The principles of yin and yang interacted to produce the Five Element (or Five Forces) of earth, wood, metal, fire, and water. These in turn interacted to produce all things and advance the changes in the world in a cycle. Wood moved earth, metal cut wood, fire melted metal, water quenched fire, and the mass of earth overcame water. The Five Elements were seen to correspond to points of the compass, colors, and even dynasties. For example, water (black), the sign of Qin, was defeated by earth (yellow), the symbol of Han.

Chinese astrology rose out of these correspondences. The orbit of Jupiter around the sun was rounded to 12 years. Each year was assigned a Zodiac animal. The combination of yin and yang elements and the Five Elements were assigned to each Zodiac animal. Combining the 12 zodiac animals and the Five Elements produced a 60-year cycle. In other words, it would take 60 years for a yin earth ox combination to occur again. A person's birth year is associated with one combination in the cycle. A person's birthdate was also linked to a lunar month and a corresponding inner animal. The two-hour timeframe of the person's birth was linked to a secret animal. All of these factors were used in determining a person's natural traits so one could be guided to a suitable profession, identify an appropriate mate, and avoid the possible negative behaviors associated with the animal signs. In this way, the Chinese Zodiac was looking to the natural world for guidance and trying to support the Confucian ideals of good behavior.

After the repression of the creative arts in the Qin dynasty, the Han emperors gave artists official recognition and encouragement. However, painting was still considered a craft for recording appearances. Painters did architectural renderings, recorded historical events pictorially, and did portraits of virtuous officials and famous people.

The ancestor portraits of high officials were done in a paint-by-feature style. The artist never saw the subject. A clerk analyzed a person's features and gave the artist numbers. The person might have a #1 nose, #4 eyes, and a #6 mouth. No wonder the portraits typically look very stiff, flat, and grim. The clothes were most important. The sitter could pick the clothes and their colors as long as they were of the period and did not elevate his position. Only the Han emperors were allowed to wear the imperial symbol, the dragon, or the imperial color, yellow. Officials and important people wore squares on their clothes with

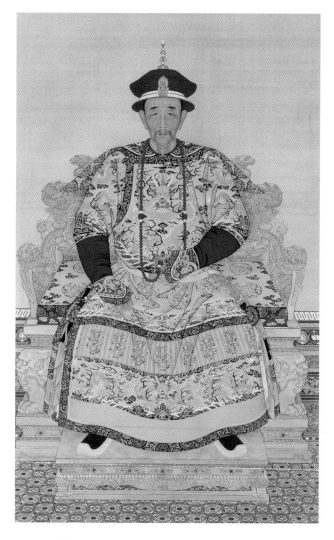

Portrait of Benevolent Emperor Kangxi (1654–1722), Early Qing Dynasty, in the Yellow Dragon Robe of the Emperor

symbols to identify their status. These symbols enabled others to recognize the person and his family so that people could associate only with people of similar status.

The insistence on Confucian ritual ultimately became too rigid for some people. Creative people became more influenced by Daoism as a channel for the more romantic side of their nature.

In the later Han dynasty, agrarian crisis, peasant revolts, and factions at court caused the empire to fall apart into three natural geographical divisions. This led to the era of the Six Dynasties and the end of a unified empire.

The Six Dynasties (222–589 CE)

For a period of three and a half centuries (222–589 CE), China suffered extreme political confusion with the Three Kingdoms, the Jin dynasty, and the Northern and Southern dynasties. Invasions of barbarians in the north for a hundred years drove Chinese aristocrats in the north to migrate southward. They built great independent manors that were sustained by the labor of peasants fleeing from the north or conquered southerners. In this way, people of Chinese descent supplanted aboriginal tribes in the south. The aristocratic families also gave rise to future generals who became emperors in later dynasties based on the southern capital in Nanjing.

The Introduction of Buddhism

Although Buddhism had reached China as early as 65 CE and had established a foothold at the collapse of the Han dynasty in 220 CE, it did not gain wide appeal until about the time of the Northern Wei dynasty (386–534 CE). Confucian literati were no longer in power to oppose it. The central Asian rulers in the north employed Buddhist monks as ritual specialists and political aides and were ready to accept the new religion. Monks also became a part of the cultured elite who had fled to the south. For the common people, Buddhism promised an answer to suffering and provided some comfort amid the constant political turmoil. As an organized religion, Buddhism filled a religious void. In practice, Confucianism focused too narrowly on ethical behavior. Daoism had diverged into philosophical Daoism for speculative minds and religious Daoism as a popular cult of superstition and magic with no edifying perspective. Buddhism had a coherent explanation of life and the universe and addressed human suffering and destiny. The spiritual qualities were expressed by a moving ritual and a rich tradition of art and iconography.

The Mahayana ("Great Vehicle") branch of Buddhism that reached China emphasized liberating all living beings from suffering. The Buddha was elevated to a God-like status as an eternal, omnipresent, and all-knowing liberator. He is accompanied by a pantheon of quasi-divine Bodhisattvas that devote themselves to personal excellence to help rescue others from suffering. The most popular among these in China was the Guanyin, "Goddess of Mercy," who assists those who call out her name in time of need. Statues of the Guanyin are common, and her figure is even sculpted on the top of stone seals used on paintings and calligraphy.

Initially, Chinese artists copied Buddhist art from India in its Indian forms. Then the images were merged with indigenous Daoist motifs. In northern China

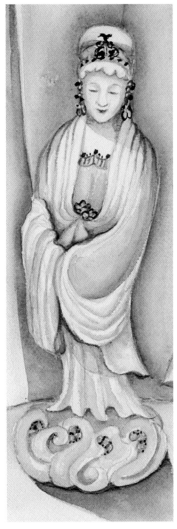

Guanyin, the Goddess of Mercy

in the 4th century, the rulers promoted the painting of Buddhist art in cave-temples. Chinese artists painted murals on walls and caves as the Indians did, but the Chinese murals were more sensitive and expressive. A Sinicized style of the Buddha emerged with a slender waist and a plump face with delicate features. The inspiration and expressiveness of these murals raised the appreciation and status of painting in China.

The scriptures of Mahayana Buddhism were translated into Chinese, and that Sinicized Mahayana was then passed on to Korea, Vietnam, and finally to Japan in 538 CE. The East Asian Buddhism was furthermore divided into a variety of strands. One form that became strong in both China and Japan is the meditative school known as Chan (Chinese) or Zen (Japanese) Buddhism.

The Indian patriarch Bodhidharma founded Chan in the 6th century CE by combining the Buddhist practice of meditation with Daoist concepts, such as the importance of intuition, the insufficiency of words to convey deep truths, and a love of the absurd and unexpected.

The Chan teaching uses but does not depend on sacred texts. It provides the potential for direct spiritual breakthroughs to Truth through the Buddha nature possessed by each sentient being. Through meditative riddles or puzzles or just sitting and meditating, a person can detach the mind from conceptual modes of thinking and perceive reality directly. Enlightenment can occur instantly when a person loosens the grip of the ego and cuts through the dense veil of mental and emotional obscurations. Appealing to intellectuals, the Chan form of Buddhism had a great influence on Chinese calligraphers and painters after the 6th century.

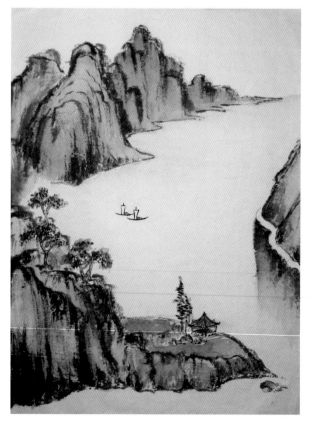

"Landscape Painting" by Sherry Kendrick

The Beginnings of Landscape Painting

Literary fragments from the 5th century speak of the feelings and aspirations of landscape painters. They provide evidence that landscape painting had already emerged as a type of painting on its own worthy of discussion. Tsung Ping (375–443) and Wang Wei (415–443) both wrote about how the artist seeks through landscape painting to convey nature's spirituality so that the beholder can re-experience nature's grandeur. The artist is not just depicting the visible reality but is expressing the spirit indwelling his subject matter. The painters reflect the Daoist view of nature and the role of the artist, like a sage, leading viewers to a connection with the spirit in the natural universe.

At the end of the 5th century, Xie He (Hsieh Ho) distilled the traditional ideas about painting into Six Principles as a basis for evaluating and classifying painters. The first and most important principle involves Qi, the life-breath of everything, animate and inanimate. It can be interpreted as spirit, vitality, or the result of the activity of the spirit. The vitalizing spirit should resound harmoniously through a painting to impart spiritual significance. A painting may convey the outer likeness of its subject, but it fails if it does not manifest the resonance of the spirit of the subject. If the painter seeks the spirit-

resonance, the outer likeness can be obtained at the same time. To comprehend the subject, the artist must identify with it, harmonize his consciousness with it, and see the subject from its own viewpoint. This is the Daoist idea of the identity of the subjective and the objective.

The Sui and Tang Dynasties (581–907)

The Sui reunited China in an effective but short-lived dynasty (589–618). They were able to expand their power into south China, where colonization had brought economic and cultural prosperity. They built the first Grand Canal that enabled them to bring rice from the fertile southern plains to the north to supply the armies and the government. These connections between north and south aided the unification of the country.

The Sui were overtaken by the Li, a family of aristocrats from the northwest who had connections with the barbarians. The early Tang dynasty was marked by military conquests in Central Asia. This was the age of men of action in the cavalry, lovers of horses, and polo playing, as evidenced by the depictions of horses in sculpture and painting. They appreciated other cultures, and other cultures were being influenced by the Chinese also. The Japanese sent monks and scholars to China from 607 to 838 to discover and adopt what they liked in Chinese calligraphy, painting, art, religious thought, and government practices. The Koreans owed even more to the Chinese, with influences starting in the 3rd century BCE through the Han and Tang dynasties. This is how the Japanese adopted Chan/Zen Buddhism, Chinese calligraphy, Chinese pottery, and Chinese brush painting, which is known as Sumi-e in Japan.

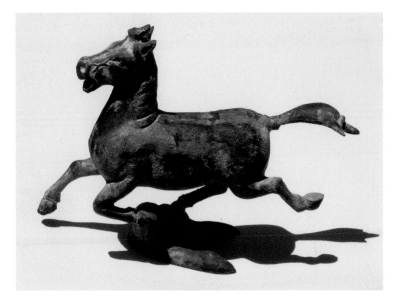

Bronze Tang horse

The Imperial Examination System

The Tang dynasty improved the Imperial Examination System introduced in the Sui dynasty. Although examinations had been used in the Han dynasty, employment as an official also required recommendation and patronage, which were only available to the sons of high dignitaries and the wealthy landed gentry. Under the Sui dynasty, the lower classes had a greater chance to obtain employment. The Sui set up government schools to train the candidates. The Tang continued and expanded the system and added schools in the prefectures. This was part of a strategy to reduce the power of the military aristocracy of the northwest. The system awarded positions according to provincial and prefectural quotas so that officials were recruited from the whole country. This helped to ensure the integration of the Chinese state and reduce the tendencies towards regional autonomy.

The examination system also provided a cultural unity and common set of values based on Confucian teachings. The elites and those attempting the examination all studied the same content. Only about five percent of those taking

the examinations received positions. Those who failed to pass became teachers, patrons of the arts, managers of local projects, and social leaders in local villages or cities. The system ensured that the best and brightest had the chance at a position and encouraged and enabled the pursuit of education regardless of wealth or class.

The literati taking the public examinations formed a new gentry class based on their education. The breadth of the examinations contributed to the building of their moral character as well as knowledge. Before the Sui dynasty, the examinations covered archery and horsemanship, music, arithmetic, writing, and knowledge of the Confucian rituals and ceremonies in public and private life. In the Sui dynasty, the curriculum was expanded to include military strategy, civil law, revenue and taxation, agriculture and geography, and the Confucian classics. As well-rounded individuals, the scholar-gentry participated in cultural pursuits outside of their official duties.

Advances in Painting

Emperor Xuanzong's Kaiyuan era (713–741) was a period of political stability, prosperity, and peace in society, which allowed advances in education, literature, music, painting, sculpture, and religion. The emperor himself was a poet, musician, and actor, and a talented painter and calligrapher. The creation of poetry and painting reached new heights. New styles and types of brushwork sprang up. Two main schools of landscape painting emerged, the Northern School and the Southern School. These terms were coined at a later date by the scholar-artist Dong Qichang (1555–1636), who borrowed the concept from Chan Buddhism, which has Northern and Southern Schools. The schools differed in their use of brush and ink, not by their geographical positions.

Li Si Xuan (Li Ssu-hsün), known as General Li, founded the Northern School. He and his followers preferred strong, severe forms and definite designs that left little to the imagination. They used clear-cut, articulated, and rugged strokes. General Li and his son Li Chaodao (Li Chao-tao) were also noted for using blue, green, and gold in their landscapes. They outlined on silk and filled in with colors. Their precise technique produced beautiful and detailed decorative pieces.

The Southern School of landscape used mainly ink and water with only touches of light coloring. Their strokes were softer, more graceful, and suggestive. The school was founded by Wang Wei, who was a famous poet as well as a renowned landscape painter. He was credited with introducing monochrome ink washes that produced softer and subtler effects. The paintings of the Southern School are less literal and more poetic and imaginative, allowing a greater freedom for the qi energy to express itself. It was said of Wang Wei that his pictures were poems and his poems were pictures. The Southern School was also known as the Literary School as the natural scenes aimed to convey the mood of the dreaming poet.

Before the Tang dynasty, painters did not sign their works. In the early Tang period, artists became individualists as painting came into its own. The artists added modest signatures in very small characters in an inconspicuous place so as to not mar the design. Later, the Song dynasty artists became bolder and signed their name and the date on the base of the painting at the extreme edge.

Into the Song Dynasty (960–1279)

The Tang dynasty gave way to the short Five Dynasties and Ten Kingdoms era (907–970), which was succeeded by the long reign of the Song dynasty (960–1279). From the late Tang and into the Song dynasty, people turned away from the military tradition, hiring mercenaries instead. Rather than military men, the policy leaders were scholar officials interested in polite learning, poetry, and the fine arts. The Imperial Examination System was regularized and extended to draw in more candidates for civil service and thus became less aristocratic and more bureaucratic.

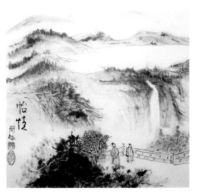

"Scholars by a Waterfall" by Sherry Kendrick

In the later Tang dynasty, painters had started to specialize in singular subjects, such as bamboo, chrysanthemum, or horses. During the Five Dynasties, flower and bird painting became popular, and new painting styles emerged. Xu Chongsi (Hsü Ch'ung-Ssu) created the *Mo-ku* or "boneless" style (without outlines), which has continued up until the present day. The boneless style developed out of calligraphic strokes, which are not of uniform thickness and are shaped more like forms than single lines. This led to a new mastery of the line contour and new graded effects when a brush was loaded with two or three values of ink for a single stroke.

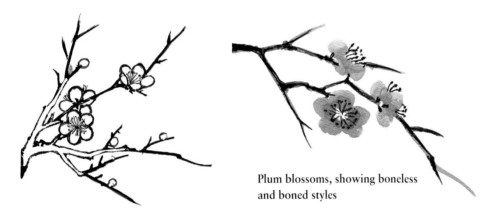

Plum blossoms, showing boneless and boned styles

The Northern Song Dynasty (960–1127)

The Song dynasty is known as the golden age of landscape painting. Many emperors were artists themselves and gave considerable patronage to painters. In the Northern Song dynasty (960–1127), Emperor Huizong (Hui Tsung) was a great painter, poet, and calligrapher. He painted mainly birds and flowers on silk in a realistic, detailed, outlined style filled in with colors. He was famous for the "slender gold" style of calligraphy he developed that looked like twisted wire.

Emperor Huizong wanted court officials to be artists, so the imperial examination required the candidate to illustrate a line from the classics or a well-known poem. Poetry was the "host" and painting was the "guest." A painting could only win praise if it expressed the poetic idea well. The Chinese painter had to be a student of literature, and he was likely to be a poet also, as was Wang Wei.

With the rise of landscape painting and the waning of figure painting, poets started expressing their thoughts more in nature imagery that captured a mood, such as the sadness of departing. The mingling of poetry and painting also led artists to express more moods in their paintings beyond the contemplative, awe-

Mi dots on a ridge

inspiring scenes of earlier artists. Paintings became more introspective and individualistic. In evoking the indwelling spirit of their subject matter, the artists also sought to harmonize that spirit with their own thoughts.

The practice of writing a poem on a painting was started in the Song dynasty by the poet, painter, essayist, and humorist Su Dongpo (Su Tung-P'o). He was talented at painting, poetry, and calligraphy so that he could combine the three arts on his paintings. A contemporary landscape artist, Mi Fei, followed the practice and decorated his paintings with descriptive poetry. The two artists set a fashion that became a lasting element of Chinese art.

Mi Fei was associated with the Southern School and was famous for the soft effects he created through horizontal blobs of paint since known as "Mi dots," "Mi-Fei dots," or "rice dots." The fuzzy dots were dabbed close together to suggest distant vegetation on mountainsides. The effect of softness and distance was increased by the swirls of mists in the valleys and around the mountains.

The Southern Song Dynasty (1127–1279)

In 1127, the Song lost control of Northern China to the Jin dynasty and moved the capital south of the Yangzi (Yangtze) River to Hangzhou. The Court and scholar-officials migrated south over a period of eleven years. Emperor Huizong's son, Gao Zong, became the new emperor. He gathered together in his Academy of Painting the available members of the earlier Academy that had been established by his father. Two of the most famous painters were Ma Yuan (1190–1224) and Xia Gui (Hsia Huei, 1180–1230).

Although Ma Yuan was associated with the Northern School of Landscape because of his fine, delicate lines, he also developed a different type of brushstroke. He started to paint rocks with broad, angular, drybrush strokes now called "axe-cut" strokes. Such strokes gave spontaneous, free-form energy to otherwise precisely carved-out forms.

Together with Xia Gui, Ma Yuan also founded a new style of painting in terms of composition. They used fewer brush strokes to suggest the scene and reduced the solids in the painting to allow for large amounts of empty space at the borders and in the sky. The painted subject is less observed for its own sake and functions more to set off the open space.

Ma Yuan's son, Ma Lin, took this style even further. His paintings suggest the stark minimalism characteristic of Japanese Zen Buddhist paintings. Indeed, the Japanese have been avid collectors of Southern Song paintings. The Japanese learned to paint in the Chinese style, mostly following the Northern School and favoring Xia Gui and Ma Yuan as their models.

This style no longer expresses the timeless and changeless aspect of nature found in earlier paintings. It conveys a sense of the transitoriness of a brief, intensely-felt moment in time. A sudden shower comes on, the sun sets, or a gust of wind blows the trees. The poetic equivalent might be a Japanese Haiku that evokes a feeling in the moment through a few carefully selected images. The sense of transi-

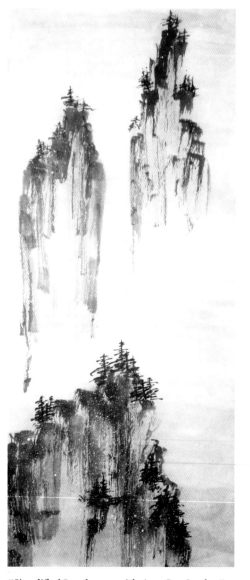

"Simplified Landscape with Axe-Cut Strokes" by Sherry Kendrick

toriness seems to reflect the Buddhist emphasis on man and nature caught up in an endless chain of being, with a lurking sadness and suffering, from which they need to be liberated.

After the Tang dynasty, where foreign cultures were appreciated, the trend was away from Buddhism and back to Confucian classics. The philosophy had to account for the challenges put forth by Buddhist metaphysics and Daoist thought. After considerable debate, a new philosophic framework was developed based on the views of Zhu Xi (1130–1200). The new philosophy became known in the West as Neo-Confucianism. The Confucian concept of self-cultivation extended to seeking knowledge of the Great Ultimate (as in Daoism) and sudden complete enlightenment (as in Buddhism).

Such was the practical convergence of the three major philosophies by the time of the Song dynasty, that the tiny figure in the pavilion below the towering mountains in a landscape painting could be a Confucian scholar, a Daoist hermit, or a Buddhist monk. Indeed, the scholar-official often thought of himself as a Confucian by day, attending to government affairs, and a Daoist by night, engaging in his meditative painting.

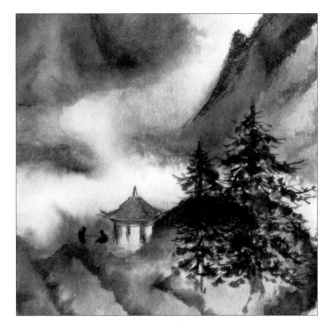

Neo-Confucianism expressed in Song dynasty landscape painting

Amateur Painting and Gardening

The fashion for painting as a hobby spread among literary men during the Song dynasty. They painted the Four Gentlemen—plum, orchid, bamboo, and chrysanthemum—to express their gentlemanly character to the world. They invented a new style of painting orchids in ink, without color, which emphasized the starkness and linear quality of the plant. They spent time observing nature, the formation of petals and leaves, how a plant grows, to better know the spirit of the subject matter they painted.

The move of the capital to the milder southern climate of Hangzhou may have increased the interest in gardening. The nearby city of Suzhou grew as a convenient retreat for scholars, officials and merchants. Gardening increased during the Song dynasty and reached its height during the Ming and Qing dynasties. Landscaping became an art with established masters.

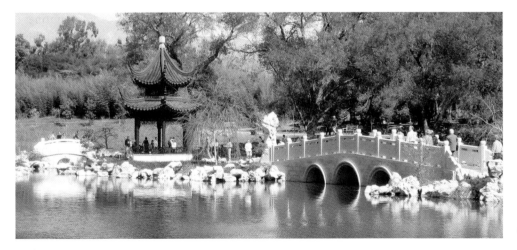

The Chinese scholar's garden

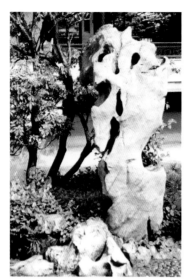

Taihu Rock

The Chinese scholar's garden was the combination of a landscape painting and a poem with symbolic plants and architectural elements. The garden was a retreat to a stylized, miniature form of landscape where the scholar could reconnect to his spiritual nature. The plants represented virtues that reminded him of his own strengths. Bamboo is strong but flexible. Pine represents longevity, persistence, tenacity, and dignity. Flowering in the winter, plum blossom represents renewal and strength of will. Chrysanthemum symbolizes splendor and joviality. The chrysanthemum is also associated with a life of ease and retirement from public office. Retired scholar-officials bred different varieties of chrysanthemums and trained them to grow in different formations.

Like a landscape painting, a garden had rocks and water. The water was in the form of lakes and streams with bridges crossing over them and rocks with waterfalls. The rocks were mounds or decorative Chinese scholar's rocks. The sculptural Taihu rock was especially prized for its fascinating shapes carved out by wind and water. It is only procurable from Tai Lake, just west of Suzhou. During the Song dynasty, Taihu rocks were the most expensive objects in the empire.

The architecture included pavilions for various purposes, inner and outer walls, and covered walkways for protection from sun, wind, and rain. The walls had moon-shaped doorways and lattice windows in the shapes of different objects, such as apples, pears, circles, squares, and pentagons. The pavement might consist of alternating black-and-white tiles. The principles of yin-yang and feng shui and the symbolism of objects and forms governed the design and placement of every element.

Literati Painting in the Yuan Dynasty

In 1215, the Mongols led by Genghis Khan defeated the Jin rulers in north China and captured Beijing. The watery terrain of south China and the resistance of the Southern Song prevented Genghis Khan's son, Kublai Khan, from gaining control in south China until 1271. The last disappearance of Song rule in the far south was completed by 1279. In the new Yuan dynasty, the Mongols dominated the military and administrative spheres and did not trust the Chinese, who held mainly lower posts in the administration. This forced a large number of scholar officials into early retirement and to the bottom of the social scale.

"Mongol" by Sherry Kendrick

In their leisure time, the literati did calligraphy, wrote poetry and literature, made paintings of birds and flowers that they had raised, practiced horticulture and flower arrangement, made and played musical instruments, and studied philosophy. They formed mutual support groups, where the wealthier helped those less well off. Paintings often served as a means of repaying a benefactor.

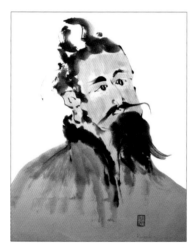

Excerpt from a painting by Wang Meng "Ge Zhichuan Relocating." Form and texture dominate.

The literati brought the formal expressive qualities of calligraphy to their practice of painting. The eight basic strokes were adapted to depict the stalks, joint rings, and leaves of bamboo. Drybrush strokes gave rocks rough shapes and volume. The speed and energy that made calligraphy an art form was transferred to the lines of monochrome ink paintings of plants. In the boneless style, with no outlines, an artist could render an object quickly and spontaneously to capture the energy and essence of the moment. This was a new way of instilling the qi energy into the painting and satisfying the first principle of the classic Six Principles that still governed Chinese painting.

In landscape painting, the goal was no longer to paint the illusion of external realities but to make brush-created appearances that convey the artist's personal and unique style. The style became the ultimate substance of the work. The surface texture and line became the source of interest. The "Four Great Masters of the Late Yuan"—Huang Gongwang, Ni Zan, Wu Zhen, and Wang Meng—created works that sizzle with the energy of their brushstrokes.

The Ming and Qing Dynasties (1368–1912)

Weakness at the center and peasant rebellions ultimately brought the Yuan dynasty down. Chinese rule was restored and consolidated in the Ming dynasty, which lasted for nearly three hundred years (1368–1644).

The Ming painters inherited the two distinct and irreconcilable traditions of the Song and Yuan dynasties. The Song painter used the style he inherited to achieve an objective representation. The Yuan painter developed his own style to achieve the freedom of subjective expression. Any new style that the Ming painters could come up with would be linked to either of these two traditions.

The Che School and Academy painters imitated the Song painters in works that had decorative appeal but little spiritual depth. They conceived of the Song, particularly the Southern Song, as being of a single style. The Wu School continued the Yuan style by following the traditions of the individual styles of great Yuan masters. The Che School professionals eventually became more like the Wu School literati. In both schools, painting became a conversation with the past, expressing personal statements on ancient styles. The idea of copying past masters led to actual fraud in trying to pass off later paintings as original Song paintings considered more valuable. Ming copies of earlier painters still cause problems for museums trying to authenticate paintings. Sophisticated tests of materials are required to determine the actual age of a painting.

The Manchu conquered China in 1644 and established the last dynasty, the Qing dynasty (1644–1911). In this period, the art included many Western influences, eclectic designs, and copies of earlier works. Genre paintings of plants, animals, and still lifes with fruit and vegetables became popular. These were simplified paintings, stressing the essence of the subject and its relation to nature rather than photographic reality. The vitality and harmony of the rendering were more important than technique. These modifications in style carried over to the present time.

Enduring Principles

Through the ages, Chinese painting showed consistent features that distinguish it from classical Western ideas of painting and design.

- The artist paints the inner spirit of the subject or expresses his inner spirit through his style. Realism is subservient to these goals.
- A painting can be done in outlined (boned) or free-form (boneless) style.
- Compositions are asymmetrical, and odd numbers of flowers, leaves, and other groupings support asymmetry.
- Using asymmetry enables triangular areas of open space that keep a picture simple and peaceful.

Chapter 2

Treasures of the Painter

Like Western artists, Chinese painters have their own tools, materials, and forms of expression. The calligrapher and the artist use the basic tools called the Four Treasures:

- Brush
- Ink stone (for grinding the ink)
- Ink stick
- Paper

Without these basic tools, you cannot paint. As a beginner, you may not want to invest in expensive tools until you see that your interest is sufficient to pursue the hobby. As in Western painting, however, better equipment helps to produce a better product. For example, you can select a detail brush and landscape paper for a landscape painting, or a large brush and wide, absorbent paper for a dramatic Zen painting.

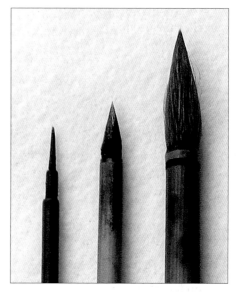

Basic painter's brushes

Brushes

Brushes come in many types, depending on the following characteristics:

- diameter (number of hairs)
- size of handle
- type of handle
- tapering shape
- length of hairs
- type of hair
- softness or stiffness of the hair

The tapering shape of the hairs when wet is very important. No other types of brushes, such as Western watercolor brushes, have the tip action necessary to produce strokes properly.

The painter may use a variety of brushes depending on the types of strokes desired. You need to learn to judge the size of the brush and the kind of stroke it will produce. The scale of the strokes should relate to each other and to the subject. You can safely use ¾ of the hair when pressing down or sideways.

The calligrapher needs brushes that are fuller at the base and taper to a long point. The more hairs in the brush, the more ink that can be fed slowly to the point of the brush and the less often you have to reload it, which disturbs the train of thought.

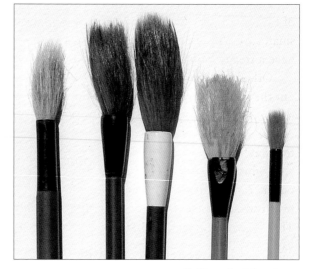

Calligrapher's brushes

Types of Handles

Bamboo Handles—Almost all oriental brushes are made with bamboo handles. Bamboo is plentiful and easier to make into a brush handle than wood. Bamboo grows into many diameters, and the size and number of hairs used match the diameter of the bamboo stalk.

Wooden Handles—A few special brushes are made with wooden or even plastic handles. These are very large brushes with many hairs in bundles. The painter usually uses these types of brushes to make large washes on backgrounds or to write large characters in calligraphy. Western-type brushes made with wooden handles have a metal ferrule that holds the hairs and also holds the metal to the wooden handle. The advantage of the wooden brush and the metal is that the metal will not swell when wet for long periods of time, and the hairs will not fall out like they do in a wet, swollen, bamboo brush. The disadvantage is that the metal can tear the paper if you press too hard trying to use too much of the hair length.

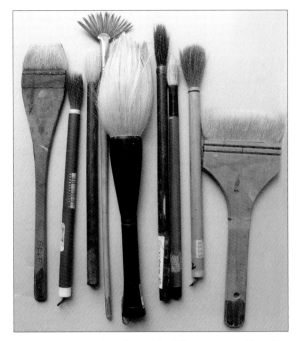
Brushes with different types of handles

Types of Hair

Chinese brushes are usually referred to as hard or soft. Even combination brushes can be hard or soft. The basic distinction is brown fur—hard, white fur—soft. Brushes can be made from many unusual hairs, such as the soft hairs inside a kitten's ear, mouse whiskers, or dog tails. The majority of brushes found in shops are made from goat, rabbit, wolf, raccoon, beaver, deer, horse, badger, and sometimes squirrel. In many cases, a brush is made with a combination of hairs, where each type of hair serves a purpose. For instance, rabbit hair makes a very soft brush that bends and does not hold a shape, but adding a core of a firmer hair enables the painter to control it better.

Oriental papers are very fragile when wet so brushes with soft outer hair are preferable to preserve the surface of the paper. Soft rabbit hair brushes are used to make wet wash areas and the soft petals on flowers.

For outlining and detailed strokes, you want to use a stiffer brush. Some of the stiffest brushes are made by splitting the edges of bamboo rings into small slivers of fiber so as to resemble the hairs of a brush. The maker must have a steady hand and be very skilled at slicing the bamboo stalk.

Other stiff brushes are made by burying bamboo stalks in dirt to digest out the soft material, leaving only fibers. These brushes are stiffer than animal hair brushes. You can use them to stroke the flying manes on horses, to make tails that reach out into space with fine separations, and to create rocks and textured areas. For such effects, you can also use a brush made out of horse hair, which is a strong, coarse hair that bounces when pressed against the paper. You can also use a horse hair brush to make "flying white," where the brush stroke is streaked with white where the ink is absent in some areas. This streaked, dry brush effect is desirable in some cases to add interest and variety. A horse brush is also used for painting horse manes and tails and rooster tails.

Soft rabbit brush for washes

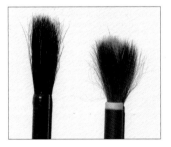
Left to right: Horse hair brush; beaver and squirrel hair brush

Large goat hair brush with barbs

Type	Hairs	Uses
soft	rabbit, kitten's ear, soft sheep and goat	Flat, extended brush used for bamboo, washes, shading, and blending backgrounds.
medium soft	soft: rabbit, goat, and sheep outer hairs; firm: badger, wolf	flowers, birds, graded petals, animals, details
medium	badger, wolf, weasel, chicken feathers	orchids, bamboo, stems on plants
medium hard	medium: coarse goat; hard: wolf, split bamboo	outlining, details, calligraphy, fine lines, landscape
hard	horse, wolf, split bamboo	stiff, sweeping strokes, horse tails, large calligraphy

Names Painted on Brushes in Chinese

Name	Used for
landscape	rocks, trees, lines, calligraphy
cloud	dots and flowers
orchid/bamboo	orchid, bamboo, calligraphy
mountain horse	strokes for mountains
leaf vein	fine details
clothes line	strokes in clothing
plum blossom	dots and details
flower bird	flowers and birds
Shiguan	soft when wet, stiff in ink
Yang Xu	large washes adding color
rat hair	drawing details
bird of paradise	painting tiny details
sweet melon	painting tiny details

Some brush hairs hold more liquid than others. A large calligrapher's brush made of goat or sheep hair or hair with barbs will hold half a cup of ink. This type of brush is used to paint large characters, such as those seen in front of shops or in banners. Because of the quantity of ink needed in these cases, where the quality of the ink is not so important, you would normally use pre-ground, liquid ink. For most types of painting, ground ink is preferable. The brushes available may be Japanese or Chinese. Some Japanese and Chinese brushes are similar with different names, and some have the same mix of hairs. Some people in China paint without a brush. They use a fingernail grown long and stiffened so that it can hold the ink like a quill pen. These nails produce a special long, thin kind of stroke that a brush cannot do. The nail helps with lines and getting ink to the place you want to use it. Hand painters also use the side of the palm, the side of the little finger, and the base of the thumb.

Names for Brushes

Many brushes have names written on them to indicate the type of painting for which the brush is used. For example, "landscape brush" is used to paint the rocks, trees, and lines found in landscapes, and "orchid/bamboo" is used to paint orchid and bamboo. These versatile brushes can also be used for calligraphy. Other brushes without names are often referred to by their purposes or appearance: squared-tip bamboo brushes, detail brushes, wash brushes, and calligraphy brushes. Those who have used various brushes and know their uses can identify all of these brushes by their appearance since these tools are important to the artist's production.

Collecting Brushes

With so many brushes available, a painter likes to use the brush that helps produce the most desirable effect. The old masters from China, however, could use almost any brush to good effect, as they had total control and could use their skill with any brush. Experienced painters can use the orchid/bamboo brush for both large strokes and detailed strokes with the tiny tip of the brush. Until you become so skilled, it is nice to know some brushes can help you in your practice of the strokes. When you progress and find that you desire to be a true literati scholar practicing the fine arts of China, you may want to invest in exotic bamboo brushes with black bamboo handles and gold lettering. These are collectors' items, and many of the true scholars are also collectors of precious treasures. As a student, you will start with the simple, inexpensive tools. As you study and appreciate these tools, a beautifully shaped brush hanging from your brush rack will be very enjoyable.

Caring for Brushes
Preparing a New Brush

A new brush has a plastic case that covers the cone of the brush to protect it. After you remove the plastic case for the first time, discard it because placing it on the brush again disturbs the hairs. New brushes are also treated with a

glue solution to hold the bristles in shape. Before you use the brush, you need to soak it in water to remove the glue and soften the bristles. Swish the brush back and forth to run the water through the bristles to rinse out the glue.

Washing a Brush

Wash a brush carefully in water to preserve its hairs and handle. Stroke the brush against the side of the water container to remove the excess moisture or lay it on a paper towel to help dry the bristles.

- Never thump a brush up and down to clean it as this not only softens the end of the bamboo but can also break off the ends of the bristles.
- Never try to squeeze the moisture out with your fingers on the bristles, as the oil on your fingers will spoil the hairs of the brush.
- Never leave a brush soaking in the water, as the bamboo can swell and loosen the bundles of hairs.
- Never wash a brush in soap even if it is stained.

Storing a Brush

Press your brushes on a paper towel to help them dry out faster before storing them.

- Store each brush by hanging it on a brush rack with the bristles hanging down. This method preserves the end of the bamboo and allows the moisture to drain from the tip.
- Some students store brushes horizontally in a split bamboo rolled mat. This method allows the hairs to breathe, but if the bristles are wet, they take a long time to dry and sometimes the roll gets mildew.
- Some people store bamboo brushes vertically in a tall container with the bristles upward. However, this method lets the moisture drain downward into the bamboo, which can loosen up the glue and cause the cluster of hairs to fall out. If the cluster of hairs falls out, wrap a thin thread around it, put white glue on it, and put it back into the bamboo while the bamboo is still wet. When the bamboo dries, it will shrink a little around the bristles again and the glue will hold it together.

Brush rack

Liquid Ink

In addition to brushes, you will need ink. The traditional method involves grinding your own ink using an ink stick on an ink stone. You may be tempted to buy one of the forms of liquid ink currently on the market, but, unless you are doing a large painting with a large, thirsty brush, this ink is not desirable. It is thinner than the ink you can grind on your stone and it can be too shiny when it dries. On very thin papers, it does not hold a line as well as regular ground ink.

Although it is very convenient not to have to grind your own ink, in using prepared ink you have deprived yourself of the five minutes of quiet centering in preparation for the discipline of the soft martial art of painting. During the ink grinding process, you can quiet your mind, plan the composition, review the strokes to be used, become one with the subject, and thus become better able to depict the essence of the subject rather than simply its pictorial outlines. All of this, besides getting rid of distractions, is part of the process and discipline of painting and should not be passed over lightly.

Ink stone with lid

Ink Stones

The graininess of the ink is determined by the coarseness of the grain in the surface of the stone. Very fine textured ink is ground on a very fine-surfaced stone. As a beginner, you will probably use a grainier synthetic ink stone made from ground minerals and molded into the desired form with a grinding surface and a well to hold the ground ink. Some ink stones have large round wells, which can hold a large quantity of ink. Some round stones have lids to keep the ink from evaporating during the day and in hot weather. When you are painting large areas and washes, you need an ink stone with a larger well. For landscapes, you use dilution dishes to dilute and create several values of gray. Most landscapes are linear with many brush strokes and small areas of graded washes.

The best ink stones are made of the fine-grained Duan stone that come from Duanxi (Tuan-chi) in Guangdong province. Collectors are constantly looking for sources of desirable ink stones. North China has several sources of fine-grained stones with beautiful hues or very subtle colors. When chosen, such stones are usually carved by an artisan into the shape of a leaf, a frog, a bug, or a water lily. These ink stones are truly the precious treasures of the literati scholar. They are kept in wooden boxes to protect them from breakage. They are made of fine-grained stone, but they are brittle and will break if dropped.

Ink Sticks

Ink is produced by grinding an ink stick with a few drops of water on the surface of the ink stone. Later, the ink can be diluted with small amounts of water to lighten the shade.

Ink sticks are normally made from ground charcoal or soot collected from burning charcoal. The soot is mixed with scented oils and glue and poured into a mold to dry. The combination of ingredients determines the smoothness of the ink on paper, the tint of the ink when diluted, and the smell of the ink during use. Ink sticks made from charcoal mixed with pine resin and glues make coarser-grained inks. Ink sticks made from soot mixed with glue and fragrant oil from fir and/or pine resins make finer-grained inks. The best ink sticks have very fine particles. There are different grades of fine particles depending on how the wood is burned and collected. Ultimately, the quality of the ink on the paper is determined by how long you manually grind the ink. Some glues are made from deer horns, cows, and fish, each of which lends a different quality to the ink. Some inks leave a very shiny, smooth finish, while others are absorbed into the paper and leave a matte finish. Some combinations of ingredients, such as lamp black or soot, produce a brownish tint when diluted into washes. Others, such as soot and red pine, produce a bluish cast when diluted. Some artists use colored ink sticks, each of which needs its own stone for grinding so the colors do not mix. One of the desirable colors is called Ming green.

The type of wood used to make a charcoal base imparts an inherent fragrance to the ink stick. The most pleasing ink sticks to work with are made from soot and fragrant oils, as the perfume of the oils escapes while grinding the ink stick on the stone. Each family that makes ink sticks uses their own distinctive fragrance.

Ink sticks vary in their outer appearances as well as in their ingredients. In addition to collecting beautifully carved ink stones, true appreciators of the

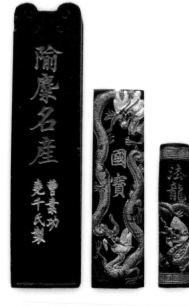

Fancy ink sticks

artist's treasures enjoy acquiring ink sticks of various sizes and shapes. The ink sticks are usually pressed into a mold containing impressions and designs, some of which tell stories of heroes and myths from Chinese history. In most cases, even the cheapest small stick used by beginners has touches of gold or silver foil and some calligraphy. Larger ink sticks may have scenes of historic events with colors applied in addition to the usual gold and silver. Some of the sticks are as large as three inches by eight inches (7.6 x 20.3 cm). Most of the large, fancy ink sticks never get used, and some are put in display cases for all to view.

Calligraphers prefer fine-grained natural stones and ink sticks that grind into a fine, powdery ink. This ink produces a clear, decisive line when stroking small characters. When ink is not used, it tends to evaporate and changes its consistency. It is said that old ink is used to restore old paintings, while new, freshly ground inks work best on new, fresh paintings. In most cases, you should not try to rehydrate and use old ink that has evaporated. The ink becomes very grainy and makes streaks. The essence and fragrance of the ink only comes out when it is freshly ground.

White Watercolor Paint

To paint white plum blossoms on tea-tinted paper and white chrysanthemums on colored rice paper, you can use Chinese opaque white watercolor paint.

Paper

Now that you have learned about the brushes and the ink stones on which to grind the ink stick, you are ready to select the substrate for the ink.

Paper vs. Silk

In ancient times, people used leaves, split bamboo sticks, or silk made with early weaving techniques. Early silk was not very absorbent, so the ink and paint had to be painted on both the front and back. Then paper was invented from vegetable sources in 105 BC. The invention of paper was most important, as paper was more absorbent than silk and thus was much easier to paint on. Later, the silk weavers treated the silk so that it was a little easier to use, but paper became the choice even as far back as the Tang dynasty. Many still painted on silk, however, even though it was coarse and harder to paint on.

Types of Paper

The process of making paper evolved from the use of different materials and the mechanical process of collecting the pulp on the screens to dry. Depending on the mix and quantity of materials and the type of screen, different kinds and thicknesses of paper are produced. You may be impressed by the variety of Oriental papers and their feel to the fingers.

Sizes

Some artists have particular goals and need different sizes of paper. For instance, scrolls require long pieces of paper while album sheets are much smaller. Hand scrolls, although narrow, may be 60 feet (18.3 m) long. Fans require only small sizes of paper.

Specialty Papers

Hand-made, specialty papers may contain embedded objects, such as leaves, bugs, shiny foils, and strands of colored fibers, or may have a color or bands of color. Some may be thick and textured and embossed. These papers are used for special paintings, decorative purposes, and letters. They are collected by those who appreciate fine hand-made papers and one-of-a-kind sheets.

Colored Papers—Some papers are bleached white as they are dried in the sun on the screens. Other papers have a creamier color depending on the process and materials used. Some papers are tinted with pastel colors and are quite effective when using intense black ink. Colored papers tend to be very absorbent because dying the paper makes it wet for the second time. All papers become more absorbent each time they are wetted and allowed to dry. Some papers take the rich black ink and leave a velvety black or shiny surface. Some people choose papers because of the ink quality on that type of paper. Depending on the project at hand, you choose the proper paper, brush, and the dark or pale ink to be used, knowing there can be 16 different values of black ink color, although most painters use only 10 values. For the Chinese, these values of ink are what they call colors or tones, and they are used to accent or to blend just as in using color.

Tea-Tinted Paper—For a more striking composition with white plum blossoms or chrysanthemum blossoms, you can use paper tinted light to medium brown with a tea wash. Use strongly-brewed black tea or instant tea mixed with water to make a dark brown color. With a large, flat, soft wash brush, paint long strokes across the rice paper to produce an even dark background. As an alternative, soak the paper in a tea solution in a large pan or basin. Wait for the paper to dry before applying white watercolor paint or ink. Of the colored rice papers available, the tea color paper is most authentic, as it looks like old silk that has turned brown with age.

Rice Papers—In most cases, thin papers are used for ink painting. Such papers are called "rice papers," although they do not contain rice fibers, which are very short and do not make good papers. They are probably called rice papers because people associate rice with the Oriental cultures and the term identifies the papers with Oriental painting. The papers are actually made from long strands of vegetable fibers, like grasses and fibers from mulberry plants left after the silk worms eat the leaves.

Practice Rolls—As a beginner, you will probably want to use a roll of inexpensive practice paper made with mechanically pressed pulp. Practice rolls come in various widths and surfaces, with typical widths of 12, 15, and 18 inches (30.5, 38, and 45.8 cm). The paper is thin and white and almost like tissue paper. Usually, it has a slick side and a more absorbent, rougher side. A white felt cloth put beneath the paper absorbs any excess ink that may bleed through the paper. As the ink dries, the paper tends to pucker. Almost all oriental papers require backing. Beginners should have their paintings professionally backed. It is difficult to handle the paste and paper to prevent lumps and wrinkles, and it's easy to ruin good paintings.

Relative Absorbencies of Papers

Some Oriental papers have more glue in the mix or a glue coating on the surface to

make them less absorbent. The paper will have a smooth side and a coarse side. The smooth side has been treated with starch or alum to reduce the possibility of ink running. Papers with both sides coarse are untreated and are called raw paper.

Some papers are very soft and absorbent, while others are very slick with little absorbency. A range of papers have absorbencies in between these extremes. Each type of paper is used for a specific way of painting. For instance, the paper called "glass" hardly absorbs anything. The ink floats on the surface, so it can be picked up onto another very absorbent paper to provide special textural effects. None of the papers allow pencil sketching to plan a composition. The paint does not cover pencil lines, and erasing the lines peels up the fibers of the surface, which affects the paint. The artist composes the painting carefully in mind while grinding the ink and uses ink from the beginning.

Using Practice Paper—The very absorbent practice papers teach beginners to use less ink and to become aware of the pressure on the brush and the quality of the ink. It takes practice to judge the amount of ink to load, the wetness of the brush as it touches the paper, and the swiftness of the strokes. You will find it easier to start painting on the slick, less absorbent side of your practice roll paper until you learn to control the brush and the moisture. Then you will want to test your skill by trying to paint on the rougher, more absorbent side of the paper to see if you can still control the moisture and keep it from oozing out into the soft paper.

Using Sheet Papers—As you graduate from practice paper to sheet papers, you probably want to try Shuen paper, which is more absorbent than the thicker, slicker, and more popular Double Shuen paper. The extra absorbency will allow you to achieve more subtle effects by blending values of ink and using transparent washes. As you practice and learn to control the brush and the moisture, you will want to try out other types of papers and experiment with different washes on different types of papers.

Retouching—Thin papers tend to absorb the ink at the very touch of the brush. If you try to darken a stroke by retouching it, the paper will cause the ink to ooze out uncontrollably. For this reason, you need to plan the painting before starting to paint. The time for planning is during the ink-grinding process as you meditate on centering and visualizing the painting you plan to paint.

Accessories

In addition to the four treasures of the artist, a few other items can help you to organize the painting process better.

Essential Accessories

The essential accessories enable you to manage the ink, water, paper, and brushes effectively.

Felt Pad—An important item is a felt pad or several layers of cloth on which to lay the paper to paint. The pad should be absorbent to catch ink and water dribbles and to pick up excess moisture coming through the thin paper. Whatever the cloth

Relative Absorbency of Paper

Type	Absorbency	Usage
raw rice paper	very absorbent	wet landscapes, thrown ink
Shuen	absorbent	blending values easily, transparency. (work quickly, it runs)
practice roll	absorbent	practice in controlling water, working quickly
Double Shuen (thicker than Shuen)	less absorbent	all-around use, most popular
cotton	coarser and less absorbent, less sensitive	wet on wet, more matte finish
Ma	springy, less absorbent	landscape and figures
Jen Ho	less absorbent	landscape, mists, and lines
sized raw rice	not absorbent	crafts
glass, fully sized	no moisture absorbed, ink floats on top	ink transfer effects

under the painting, it should be a light color to help you see the correct values of the ink. Even though a light-colored cloth shows the stains from the ink, a dark cloth would make the values hard to judge. The felt pad is typically beneath the entire working area to protect the table from ink and water.

Water container

Water container—A water container with three sections can help to keep the brushes clean. As a beginner, you may want to use three small containers rather than investing in a large water holder. Use one large section or container for washing dirty brushes by swishing the hairs back and forth quickly. Use a second, smaller one to get the last remnants of ink out of the brush. Use a third small section to hold clean water to mix with the ink when making dilutions.

Dilution Dishes—One way to test the ink values is by using a small, flat white dish to dilute the ink. Flat dilution dishes are handy when it comes to mixing washes for backgrounds or a lighter value of ink than that in the well of the grinding stone. Usually having three dilution dishes helps.

Paper Towels—Keep a paper towel or paint rag handy to press against the paper quickly when you get it too wet. Paper towels and the absorbent cloth under the painting paper can sometimes absorb some of the excess moisture on the paper. You can also use paper towels to squeeze out excess moisture from the brush. You can use a paper towel or a scrap of the same type of paper on which you are painting to test an ink value before putting it on the paper. Some artists hold a piece of paper towel in the left hand to take excess water from the brush.

Paper Weights—The paper must be taut to take the ink properly. When you roll out the practice paper on the cloth to the length desired, you need to use paper weights to keep the paper taut and to keep the roll from bouncing closed or slipping. The

Cast metal paper weights and stones

literati used ornate paper weights with tassels, some even in precious metals. As a beginner, you may want to gather some flat, smooth stones to hold the corners down. Stones do the job and are not so heavy to carry around. Cast metal paper weights are more aesthetically pleasing than stones. Some have dragon symbols.

Optional Accessories
The optional accessories are convenient and attractive items that are well-designed for their purposes.

Brush holder

Brush Holder—A brush holder helps prevent a wet brush from rolling and making an undesired trail across the table or, even worse, across your painting. Brush holders are made of clay, wire, stone, or wood. They usually have four places or indentations on the top of the piece in which the handle of the brush can sit. Brush holders can also be collectors' items. Some are in the form of the five sacred mountains brush holder, which has five undulations that hold four brushes in place. This type of brush holder is handy if you are working with several sizes of brushes in a single painting.

Brush Rack—A brush rack is ideal for storing brushes between painting sessions. Many brushes do not have a loop for hanging. You can make a loop and tape it to the end of the brush for hanging.

Bamboo Roll—If you travel with your supplies or attend an oriental painting class, you may find it easier to carry your brushes in a bamboo roll. These rolls are like place mats made of match stick-like pieces of bamboo that roll up easily. They let air in to the brushes and help them to dry so they do not get mildew.

Bamboo roll

Water Dripper—A water dripper or a dipper is convenient for adding small amounts of water to the ink stone as you grind the ink and use up the moisture. Calligraphers who use small amounts of ink and small stones may want to add only one drop of water at a time by using a dipper or tiny spoon-shaped tool. When you use a larger stone, you need to add more drops but usually not more than 5–10 depending on the size of the well.

Water drippers have two holes, one to let air in and one to let water out. When you put the dripper in a container of water, the dripper fills up with water in one hole and the air escapes out the other hole. When you use the dripper, put one finger on the air hole and let in only enough air to let the drops come out one drop at a time. Water drippers are also collectors' items and may be in the form of a small teapot, a melon, a vegetable, or a frog. Containers with such shapes are not water drippers if they do not have two holes to control the water.

Ceramic water dripper with mouse

Training Tools—Two other accessories that you might have on the table, especially in the beginning, are a raw egg, a styrofoam egg, or a piece of paper towel scrunched up like an egg and a flat rock. Use these items to test yourself to see if you are holding your hand and brush correctly. You put the egg in the palm of your hand to keep you from holding the brush too tightly. You put the flat stone on the back of your hand to make sure your hand is horizontal and not rotated to the right. It is important to keep your arm horizontal to the table and not resting on it.

Face Screen—The Chinese are aware of disturbances and typically have a spirit screen just inside the front door of a house to keep the devil or evil spirits, who travel in a straight line, from coming into the house. Similarly, the painter who has centered himself and does not want to be distracted puts a face screen directly in front of him at his work space. The face screen may be a slab of marble or jade or a carved wooden design that should not be distracting in itself. The screen should be at least a little larger than the height and width of your face. If you are easily distracted, you should have a larger screen. The largest screens are around 1.5 by 3 feet (0.5–0.9 m) in size. The screen should be placed directly in front of you on the other side of the painting paper. The process of painting is an internal meditation and anything on the outside area interferes with the meditation.

Advanced Accessories

Advanced accessories are those that a painter collects over a period of time because they are useful, traditional, and beautifully made artworks in themselves.

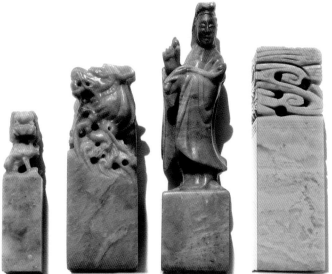

Paste Ink and Seal—Later, when your work is of such a quality that it warrants a signature, you may want to acquire a personal seal. The seal may have characters similar to the sounds of your name, or your teacher may give you a Chinese name or character.

Most of the seals are carved out of stones, such as marble, carnelian, sandstone, or jade. Jade and marble are harder to cut, so the easiest and cheapest seals are cut out of sandstone or even synthetic composites. Skilled craftsmen carve out blanks with zodiac animals or figures, such as the female Bodhisattva Guan Yin shown in the photo. Even more skilled sealmakers do the more delicate work of carving out the personal seal. Seals are also collector's items. The quality of the calligraphy in the seal

Seal stones

is the most important feature. The skill in carving the details of the calligraphy, the quality and interest of the stone itself, and the carving on the top of the stone are all part of the appreciation of a seal.

Red paste

The bottom of the seal is pressed into the red oil cinnabar paste dish and pressed onto the paper. Calligraphers, who in China are considered of higher rank than painters, might use a dark red paste ink. Today, painters use a vermilion ink to stamp their names on the painting below the calligraphy of their name. A name without a seal was once considered incomplete. Many old paintings have many seals, not just the painter's, as it was a custom for each owner of a painting to identify ownership by putting a seal on it rather than a name.

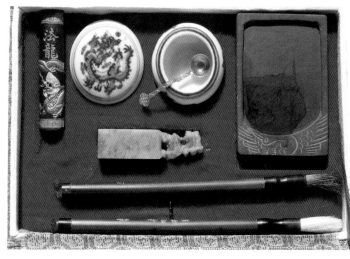

Calligrapher's kit

Calligrapher's Kit—A calligrapher's kit used only for signatures or short texts contains all the necessary tools in a small, convenient, easy-to-carry package. A kit includes an ink stone, an ink stick, a water container with a spoon, two brushes with different kinds of hair, a seal, and a paste ink container. All of the items in the kit are small, as the calligrapher uses small quantities of ink for signatures. For calligraphy practice, and writing, calligraphers use a lot of ink and require larger ink sticks and stones. The paste ink dish and seal shown on the right both bear the imperial dragon symbol. The dish with spoon is used to add a spoonful of water to the grinding stone.

Getting Supplies

Before getting started with painting, you need to find sources for supplies and then get the items on your shopping list.

Sources of Supplies

Finding good quality Oriental art supplies may be a challenge, depending on where you live and the resources available. Here are some search strategies:

- Look in the telephone book for Oriental art supply stores.
- Ask about Oriental art supplies in Western art supply stores.
- Call a local community or junior college to see if they have any art teachers or Oriental studies teachers who may know where to get supplies locally.
- Contact any Oriental brush painting society, Chinese school, or Chinese calligrapher or painter you can find locally and ask them for sources of supplies.
- Check the resources listed in the appendix in the back of this book.

Avoid buying supplies in Oriental import gift shops. The quality of the brushes sold is usually inferior so that the brushes are difficult to use. Save yourself unneeded frustration by buying good quality student supplies.

Shopping List

To get started, you need to get at least the four treasures and a few basic accessories. In the beginning, you should use medium-sized brushes on large enough paper to not cramp the size and form of the strokes. Working on too small a scale makes it harder to train the arm, to get motion into the stroke, and to express the feeling of the qi energy.

Four Treasures
- A small detail brush, a medium firm brush, and a large brush of the "orchid bamboo" type, which is soft with a firm core
- A medium-sized practice roll of rice paper
- An inexpensive synthetic ink stone with a medium-to-large ink well
- The most expensive basic small ink stick available

Basic Accessories
- A light-colored felt pad or folded cloth
- Three small containers for water
- Three flat dilution dishes
- Rocks to hold the paper roll open
- A water dripper, eye dropper, or tiny dipper or spoon
- A roll of paper towels
- A pad of newsprint for practicing strokes and exercises
- Hide glue (available in hardware stores)

Arranging the Tools

Now that you have been introduced to the tools of the painter, you must find a convenient arrangement on the table to handle them easily. You need a working area at least three feet (one meter) square. If you are right handed, it is easier to have the tools on the right. If you are left handed, you will find it better to have the tools on the left so that you do not have to reach across the paper with a wet brush. The painter's table shown includes the maximum array of equipment and how it would be arranged. Typically, not all of these items would be used at one time.

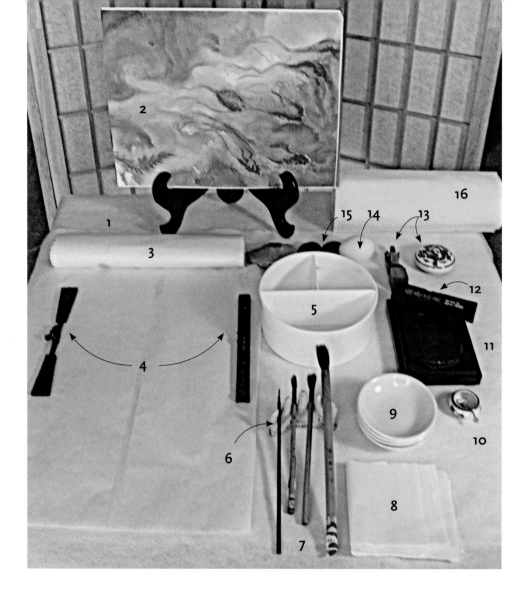

1. Light-colored felt or several layers of cloth beneath the entire working area

2. Face screen directly in front of you and at the farthest place on the table to keep devils and evil spirits from disturbing you

3. Roll of practice paper weighted at each end, to the left of the tool area in front of the face screen

4. Paper weights on each side of the roll to keep the paper open

5. Three-compartment water container or three jars

6. Five sacred mountains brush holder, or a folded paper towel instead

7. Brushes held on five sacred mountains brush holder, or a folded paper towel

8. Folded paper towel mat for spills and testing brush moisture

9. Three dilution dishes to make ink dilutions

10. Water dripper for supplying drops of water on the ink stone

11. Student ink stone

12. Ink stick on corner of ink stone

13. Seal and paste ink dish

14. Styrofoam egg to test tension in palm

15. Rock to use on back of hand to test position

16. Roll of paper towels

Chapter 3

Beginning Steps

Holding the Brush

The Chinese artist holds the brush differently from the way a Western artist holds a brush, more like chopsticks but not exactly.

1. Pick up the brush between the thumb and the first finger and let the second finger go next to the first.

2. Put the third finger behind the handle of the brush and let the little finger rest against it. It is important to feel comfortable with the third finger behind the handle.

3. To feel how the thumb and the third finger counter each other, push the thumb back while you push the third finger forward. The other fingers just help to stabilize the position of the brush.

Most of the time you hold the brush vertically and try to keep the tip of the brush in the center of the stroke. In holding this vertical position, you bend the hand back toward the wrist. You should also try to become comfortable with this bent-hand position.

You hold the brush in other positions depending on what you are painting. These positions correspond roughly to the compass points towards which the tip of the brush points.

In each of the following positions, the brush is still held between the third and fourth fingers. Only the rotation of the wrist changes.

North

North Point—Hold the brush vertically and then let the brush reach out directly in front of you at a 45-degree angle from the paper. This is the position for making strokes on flower petals.

East Point—Hold the brush vertically and then turn the hand over to the left so that the tip of the brush shows from under your little finger at a 45-degree angle from the paper. This position allows you to paint in a circle, especially a circle of flower petals.

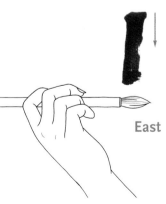

East

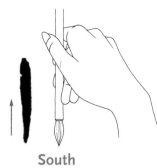

South

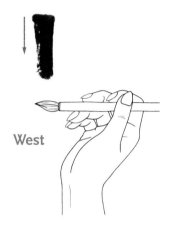

West

The four general types
of strokes

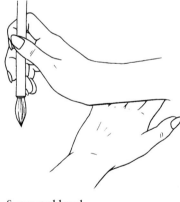

Supported hand

South Point—Hold the brush vertically and then bend the brush under your hand so the tip of the brush is at a 45-degree angle from the paper so that you can make a back stroke. This position is used in painting stems and trunks.

West Point—Hold the brush vertically and then roll the hand and brush to the right so the thumb is on top and the tip of the brush is to the left at a 45-degree angle from the paper. This side-of-the-brush stroke is used a great deal, such as for making bamboo stalks.

The painter typically uses four general types of strokes:
- Tip of the brush pulling back
- Side of the brush flat dragging sideways
- Brush loaded with ink pressed down with force
- Brush loaded with water pressed down so the ink oozes out

Other types of strokes use different techniques:
- **Small detailed strokes:** Hold the brush vertically with the fingers close to the bristles and the hand bent back slightly. This is a very controlled position for details.
- **Long strokes:** Hold the brush closer to the top of the brush to allow for long arm-hand-brush stroking.
- **Medium-sized strokes:** Hold the brush in the middle area between the bristles and the top. These are the most common strokes.
- **Forward and backward strokes:** Hold the brush firmly between the second and third fingers and push back with the second finger and forward with the third finger.

On rare occasions, when you feel the need to steady the right hand on small strokes, you can let the heel of your hand rest on the table or lay your left hand flat on the table under your wrist. The left hand as a prop thus raises the wrist to the normal position but gives a little stability so that the hand and arm do not drop and change a delicate stroke. This technique is used by calligraphers who do $\frac{1}{4}$ to $\frac{1}{8}$ size characters. This technique is not an acceptable practice for doing larger strokes, however.

Positioning the Body

The hand that holds the brush is an extension of the arm, which is controlled by the heart and the mind. They all work together to allow the qi energy and the spirit of the brush stroke to be fully expressed. Almost all the strokes are made using the whole body, the arm, and the hand to move the brush. This unity of motion not only produces beautiful strokes but rewards the artist with a kinesthetic sensation that is very pleasing.

Getting in position

Use a chair that allows your feet to be flat on the floor. Position yourself firmly in the chair with a straight back leaning forward slightly. This places you above the paper ready to make true vertical strokes.

Keep in mind a list of "straights" to help you maintain the proper position:

- Straight **head**
- Straight **heart**
- Straight **chair position**
- Straight **body**
- Straight **brush**

In spite of the "straights," the whole positioning should be *relaxed*.

Testing the position

The wrist and elbow should be level and parallel to the table. To test the position and the right relaxation, you can use an egg and a rock:

1. As done in China, you can hold a raw egg in the palm of your hand as you hold the brush to ensure a nice round pocket that is relaxed. If you are not sufficiently relaxed, the egg will break.

2. Balance a rock on the back of your painting hand to make sure the hand is parallel to the table and not rotated to the right.

3. Position the elbow above the table horizontal to it. The elbow and arm move as a unit that starts from the shoulder. To make sure that the elbow does not drop, put a rock on the elbow to keep the elbow level with the table.

These techniques provide a formal discipline in which you can learn to relax and still hold the positions unconsciously while painting. To help the process, rub your hands together a few times until they get a little warm and then place your palms over your eyes. In this position, you can relax the tensions of the previous positions and their unfamiliar feelings and accept the new idea of the body as an adjunct of the brush. Visualize the straight positions as a relaxed, normal way of painting. This approach will be a great help in painting the strokes correctly and beautifully, expressing the qi energy.

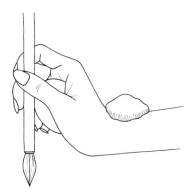

You can use an egg and rock to test your position

Grinding the Ink

Although some artists use pre-ground ink in a bottle, the quality of the finished product is not as desirable. The ink is thinner and oozes into the absorbent papers, and when it dries, it lacks the lustrous dark sheen of ground ink. In addition to these disadvantages, the artist loses the important physical and mental preparation to center and focus the mind so that the qi can be expressed. You need to be able to follow the discipline of grinding the ink to be able to reach the state where the mind, arm, and brush can work as a unit and can execute the proper strokes with the spontaneous and desired qi.

The amount of ink you need to grind and how frequently you need to grind more depends on several factors:

- **Type of painting**—Calligraphy requires only a small amount of ink, while broad washes and large paintings may require a generous supply.
- **Size of brush**—A large brush can absorb an entire puddle of ink while a small brush holds very little and must be reloaded more often.
- **Size of ink stone**—A small ink stone for calligraphy may hold only a half teaspoon of ink while a large ink stone may hold a quarter of a cup.

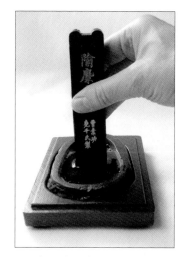

Grinding the ink

Grind only as much ink as you think you will use in one painting session. Do not try to reuse ink that has been sitting for a long time or that has dried up. Old ink becomes grainy and loses its shine after it dries on the paper. Fresh ink works best.

To get a good black ink, grind the ink stick about 250 times. The grinding should take 5–10 minutes depending on the amount of water used. During the automatic grinding process, you can quiet the thinking process and fall into a meditative state. This is where mind, body, and heart come together. Towards the end of the grinding, when you are relaxed and quiet inside, you can think about the strokes you might want to use when you start to paint. Some artists plan the whole painting while in this state of consciousness. They even visualize the painting and paint it in mind as a practice for the actual using of the brush strokes.

1. Dip a medium-sized brush in a container of water and then stroke it against the side of the well in the ink stone to transfer water to the ink well.

2. Repeat loading the brush with water and stroking it against the side of the ink well about 4–5 times until the well contains about a tablespoon of water. If you have a water dripper, fill it with water and use that instead to fill the ink well.

3. Hold the ink stick in a vertical position with your thumb facing you and your arm and elbow parallel to the table. Rotate your arm in a small circle clockwise 6–8 times with the ink stick in the air to get the feel of the grinding motion.

4. Rotate your arm in a counterclockwise direction in the same way a number of times. Which direction feels smoother and easier? Women tend to prefer grinding in the counterclockwise direction. Choose the direction in which you feel more relaxed. It is sometimes said that grinding in the counterclockwise direction can chase evil spirits away.

5. Dip the ink stick in the water in the ink well and bring some water up on the bed of the ink stone.

6. Rotate your arm holding the ink stick firmly in a vertical position and grind it in a circle in the water on the bed of the ink stone. Do 4–5 rotations and then dip the ink stick back into the ink well to bring up more water to grind with.

7. Continue grinding in this way until all the water is mixed into sticky ink.

Loading the Brush

Loading the brush is a routine ritual that you learn to do step-by-step to ensure the right amount of ink and water for the type of stroke you are going to make. The brush should be evenly loaded, and the hairs in the brush should be aligned with the direction of the stroke and tapered into a point.

1. Choose a brush of the size you need. Before loading a brush, always wet it first with water, stroke it on the side of the water container to drain out the

water, and tamp out the moisture on a paper towel. All the hairs need to be completely damp to work together. If you have too much water, you dilute the ink too much.

2. Use the brush to bring up ink from the ink well onto the bed of the ink stone.

3. Hold the brush at its center parallel to the bed of the ink stone with the hand rotated to the right.

4. Stroke the brush from left to right in the ink on the bed of the ink stone as you roll the brush away from you and then towards you with your thumb.

5. Continue stroking and rolling the brush away and back with your thumb until it contains the desired amount of ink. Stroking the brush from left to right fills it with ink and rolling the brush aligns the hairs. Touch the tip of the brush against the side of the stone to remove any dribbles.

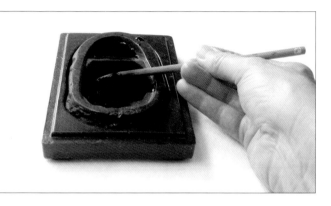

Loading the brush

Get acquainted with the brushes you will be using as a beginner. Practice some strokes on a newspaper with each brush to learn how to handle the brush. Load the brush correctly to see how much ink it holds and test the amount necessary to make a stroke without the ink oozing out onto the newspaper. Reload the brush and stroke it against the side of the ink stone or blot it on a paper towel and test it again. One of the greatest mistakes a beginner makes is using too much water. You need enough ink to complete the stroke but not so much that the edge is not precise and strong. Practice loading the ink with several sizes of brushes.

Washing the Brush

Thumping a brush in water or leaving ink to dry in a brush can cause the bristles to break. Clean your brushes properly after use to protect the bristles.

1. Wash the brush thoroughly by swishing it back and forth several times in the largest container of water. Never thump the brush up and down.

2. Swish the brush in the middle container of water to get rid of visible residue.

3. Rinse the brush in the clean water to make sure the brush is clean.

4. Stroke the bristles against the side of the water container to remove the excess water left in the brush.

Grid Exercise — "Breaking the Ink"

Some teachers insist on doing warm-up exercises at the beginning of every session, not only to warm up the body physically, but also to relax and prepare the mind

for the session ahead. The first of these exercises is to make a grid with horizontal, vertical, and diagonal lines. This exercise helps you to control the pressure on the brush, to move the arm and body to execute long and large strokes, and to control the moisture. This exercise is sometimes called "breaking the ink." You will also come to recognize some of the sixteen values of black-and-white ink dilution that painters try to mix.

Making the Vertical and Horizontal Lines

1. To start, mix a good puddle of ink in the well. With a large brush, pull enough ink onto the surface of the ink stone to flood the surface.

2. Lay a medium brush into this ink, with the tip to the left, and roll the brush forward by pushing your thumb forward while dragging the brush to the right to keep the point. Then rotate the brush backwards to the center still dragging to the right. This should be a well-loaded brush, perhaps with too much moisture, so stroke it against the side of the stone to remove the excess. Touch the tip to a paper towel to see how moist it is.

3. With the brush in a vertical position, with the wrist back, make a six-inch (15.2 cm) vertical stroke downward on practice paper using arm motion and firm wrist and fingers, trying to keep the same pressure on the brush so it will make a line of even width.

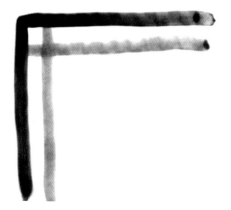

4. When you reach the bottom, use the same loaded brush and make a six-inch (15.2 cm) horizontal line across the top of the page to the right, trying to keep the line straight and of even width. This is the upper left corner of the grid.

5. Now dip only the very tip of the brush into water to dilute the ink slightly and stroke against the side of the container to remove any possible drips.

6. With the brush vertical, make another line six inches (15.2 cm) long parallel to and to the right of the first vertical line. When you reach the bottom, use the same brush to make the stroke across the top as before.

7. Again dip only the tip of the brush into the water to dilute the ink and stroke to get rid of any drip. Again make the vertical and the horizontal lines at the side and at the top with the same loaded brush.

8. Continue making horizontal and vertical lines, just adding water to the brush, until you have eight lines. Notice that the upper left corner is much darker than the lower right, which has the diluted ink.

Making the Diagonal Lines

1. Reload the brush as in the beginning, rotating it forward and back while stroking to the right.

2. Make a diagonal line that connects the left end of the second horizontal line to the top of the second vertical line.

3. Similarly, with the same brush, make a diagonal line that connects the top of the next-to-last vertical line to the right end of the second horizontal line.

4. Dip the tip of the brush into the water to dilute the ink and stroke off the excess.

5. Connect the next two strokes of the grid diagonally on the left and with the same brush connect those on the right.

6. Continue every two strokes and dilute with a little water each time you do a pair.

7. Continue painting and diluting until you reach the lower right corner of the grid.

8. Stop and let the paper dry. Save the grid for a later exercise.

Notice that the grid has dark ink in the upper left corner and pale ink in the lower right corner. When painting strokes with diluted ink, you will find that the paper makes a difference in the absorbency of the ink. For practice exercises, you can use the practice rice paper roll, or you can use newsprint, which is much cheaper. With the cheap paper, you can practice the strokes necessary in paintings and feel better about wasting 8–10 pages on exercises.

Enso Exercise

Enso is the Japanese form of making circles that teaches you how to control your mind and your arm movement in making strokes. Sages who have studied enso claim to be able to tell much about people and their traits from how they paint enso. The sages analyze the form of the stroke, the width of the stroke caused by the pressure on the paper, and the dilution of the ink as it runs out in the brush. This is much like handwriting analysis.

Practicing the Arm Swing

1. Hold an unloaded brush vertically.

2. Above the paper, swing your arm and body in a clockwise direction, making circles about five inches (12.7 cm) in diameter. Swing the brush around in a circle about six times. Try to keep a constant pace so the circle will be more rounded. Think of your hand and brush as an extension of your arm, so that your arm is making the circle, not your wrist. If you use your wrist, it is difficult to make the end of the circle meet the beginning well.

3. Next try making the circles in a counter-clockwise direction. Practice these circles a few times and decide which direction is more relaxing and more smoothly flowing to make the circle. Choose the direction you like best.

Practicing Enso

1. Bring some ink up from the well of ink onto the surface of the stone.

2. Remembering the procedure for loading the brush, load the brush and stroke off the excess ink.

3. It is important to take a breath just before you start the circle. Hold your breath while swinging your arm, hand, and brush at a steady speed to make a five-inch (12.7-cm) circle in the air. Then lower the brush and make the circle on the paper, letting out the breath as you finish the stroke meeting the opposite end.

4. With the same loaded brush, swing your arm in a smaller circle inside the larger one. Note that it is harder to make a smaller circle, as it takes finer arm control. Make sure that the ends meet and that you use your arm for the smaller circle, not your wrist.

5. On newsprint, make many more ensos in pairs, a large one and then a smaller one inside, until you feel comfortable with the stroke.

6. Try some spiral strokes, starting with a small circle and working out to a larger circle.

Now that you have practiced the ensos and spirals on newsprint, you are ready to put three circles on top of the graphed grid you have just completed.

During a practice session, you will find just how important it is to warm up and coordinate the arm, body, and mind and to focus your attention on the task ahead. With all of these factors in line, you will no doubt make beautiful enso.

Painting Enso on a Grid

To improve your powers of concentration, use the grid you made earlier as a background for making ensos.

1. Practice arm swings above the grid and accustom your eyes to how a circle can sit on the grid.

2. With loaded brush, take a breath, swing your arm and touch the paper to make a circle, letting out the breath at the end.

3. Make two smaller circles within the larger circle.

Practicing Curved Strokes

Swinging your arm to make curves can help you to paint orchid leaves and tall grasses. To put qi energy into long strokes like these, before you start the stroke, take a breath and then let out the breath as you make the stroke.

1. Load a large brush with the dark mix of ink.

2. Take a breath, start the stroke at the bottom left of the page, swing your arm upward and to the right, and let out your breath as you finish the stroke.

3. For the second stroke, start at the bottom to the right of the first stroke, swing your arm up and to the right and downward.

4. Continue making curved strokes that start at the bottom left as shown in the example.

5. After you have completed strokes starting from the bottom left, make strokes from the bottom right to the upper left and downward, as shown in the example. Remember to take a breath before each stroke and let it out as you make the stroke.

Line Exercises

Line exercises help you to gain control of the width, direction, and energy of a line, and how it expresses the qi energy. You need to practice to have control of all of these factors to make a strong, expressive line.

Making Vertical Lines of Different Widths

1. Load a medium brush with ink and stroke the tip against the edge of the stone to remove excess ink and avoid a dribble across the paper.

2. Hold the brush vertically directly over the paper with elbow high so that arm, body, and hand can move together downward. Take a breath. Using only the tip of the brush and steady, very light pressure from the arm, hand, and brush, make a thin vertical line about three inches (7.6 cm) long, trying to keep it the same width by controlling the pressure.

3. The brush holds quite a bit of ink, so now try another vertical stroke using a little more pressure evenly dispersed to make a wider line of consistent width.

4. With the same brush, make a third, wider line using more pressure, but keeping the line an even width.

Making Horizontal Lines of Different Widths

1. Go back to the ink on the stone and reload rolling forward and to the right and then back and to the right to keep the tip in the center of the stroke.

2. With the brush in a vertical position, take a breath and move the arm, hand, and brush as a unit sideways from left to right with only slight pressure to make a thin horizontal line.

3. Using more pressure, try a horizontal line with greater width by adding more pressure to the brush.

4. For the third stroke, press much harder so you can make a broad line.

Making Lines with Variable Pressure

1. Go back to the ink well and add some ink to the surface of the stone so you can reload the brush by rolling and stroking.

2. This time try a horizontal stroke using variable pressure on the brush. Start with the brush in a vertical position, take a breath, then press down, lift, and press down again. See if you can control the width and narrowness as you make a long line down the page.

Making Wavy and Undulating Lines

1. Load the brush and stroke off excess ink on the ink stone.

2. On the same page, make gently wavy horizontal lines by using variable pressure and moving your arm slightly forward and back.

3. Make vertical and horizontal undulating curves by moving your arm, not your hand, and applying fairly even pressure.

Press-and-Lift Exercise

It is important to control the pressure of the brush on the paper. More pressure makes a heavy line, while lifting makes a narrow line. The press-and-lift technique is used for leaves, stems, trees and flowers.

1. Load a medium brush with black ink.

2. Holding the brush vertically, press to make a blob, lift, drag, and press, lift, drag, and press, and so on, to recreate the top line seen in the image.

3. For the next line, do the same thing except lessen the pressure on both the press and the lift parts of the stroke.

4. Continue lessening the pressure to create the thinner and thinner lines in the example.

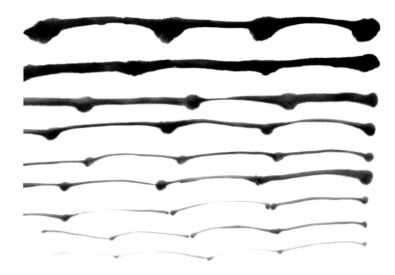

Making Broad, Graded, Horizontal Lines

1. Wash the brush thoroughly and remove any excess water.

2. Load only the tip of the brush with ink. Tap the side of the brush against the edge of the ink stone slightly to mix the water and ink.

3. With the hand in north position, lay the brush down with the tip pointing up. Stroke and drag the brush horizontally to make a graded line.

4. Make several graded lines for practice.

Special Curved Strokes

Special curved strokes are named after what they are used for in a painting. Often a number of strokes are used in a single image. For example, a painting of a deer uses the deerhorn stroke, the dragged dot, and the bone-shaped stroke.

1. Load the small brush with dark ink.

2. Hold the brush in a vertical position and try to copy the curved lines.

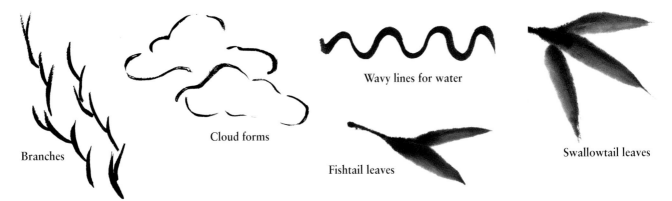

Branches

Cloud forms

Wavy lines for water

Fishtail leaves

Swallowtail leaves

Making the S, N, and W Strokes

A few other strokes that are commonly used are the S, N, and W strokes, so called because they resemble the letters S, N, and W. The S-curved strokes are used in chrysanthemum, sunflowers, and certain leaves. The N stroke can be used for making more pointed endings, as on petal points. The W stroke can be used on outlining flower petals to accent the ruffled edges or to make the bottoms of waterfalls.

1. Load the brush and stroke off excess ink.

2. Holding the brush vertically and using only the tip, copy the S, N, and W strokes illustrated, paying attention to the curves and variable widths.

The S, N, W strokes are used for outlining flowers and leaves

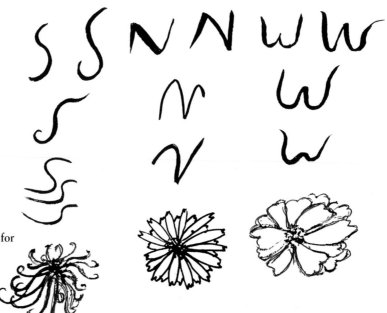

46

Flower Exercise

The flower exercise teaches you to use the different positions of the brush and to make a stroke with the swing of the arm. The lines you make can be the petals of a flower and as such could have a large center flower area like a sunflower.

1. Wash the brush thoroughly by swishing the brush in the water. Stroke it against the side of the container to remove the excess moisture.

2. Drag ink onto the surface of the ink stone. Roll the tip of the brush forward and backward in the ink, dragging it horizontally across the stone. Tap the side of the brush against the edge of the stone to mix the ink with the moisture left in the brush.

3. North Point. Hold the brush vertically, tilt your hand back so the tip is out in front at about a 45-degree angle, and lay the brush flat and drag to the center. The upper edge will be dark, and the lower edge will be light.

4. East Point. Rotate the hand to the far left so the brush comes out under the little finger. Move the hand and arm toward the left, making a stroke to the center.

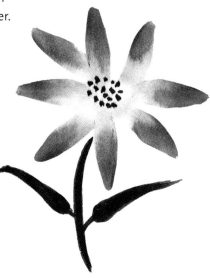

5. South Point. Rotate the hand forward so the brush is under the hand at the bottom of the page. Make a stroke from below up to the center.

6. West Point. Next rotate the hand to the far right so the thumb is on top. In this position, stroke from left to right toward the center.

7. Modify the hand positions slightly to make petals in between the first four petals.

8. Stroke the brush across the ink stone and pick up fresh black ink.

9. Holding the brush in a vertical position, press directly down and quickly to make a small round dot. If you press too hard, it will be asymmetric. If you wait too long, you might get a tail on one side. Make a few more dots to fill the center area, practicing how to make dots correctly. Add a stem and leaves.

It is important to learn to use the four positions as they are used in other types of painting. For example, you make a stalk of bamboo in the West Point position, with the hand rotated to the right and the brush horizontal to the paper dragged upward. You use the North Point position and out-in-front stroke for stems on flowers.

Mixing Values of Ink

During the Tang dynasty, art academies arose along with a new interest in painting. Painting became accepted as more of an art form, although if you were also a calligrapher you had more respectability. You could take government tests to gain the title of artist. You had to be able to mix sixteen different values of black ink between clear water and black, which is a very difficult task.

1. Fill a dilution dish half full of water.

2. Pick up the medium brush and touch the tip very lightly onto the ink stone with black ink to pick up a little ink.

3. Mix the ink with the water in the dilution dish and make a one-inch (2.5-cm) vertical stroke on rice paper.

4. Use the same mix and add another touch of black to make a darker value. Paint another one-inch (2.5-cm) line beside the first one.

5. Continue adding black to the mix in this manner and painting lines until you get a fully black line.

You have learned how to hold the brush, how to load it, and how to make horizontal, vertical, and curved strokes with the hand in various positions. These exercises have prepared you for learning the basic strokes of the calligrapher. The calligrapher was considered the greatest of artists. All of the basic calligraphy strokes are used in painting, so it is important to practice these strokes.

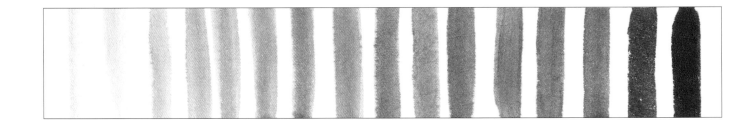

Chapter 4

Exploring Calligraphy

The Evolution of Calligraphy

In Chinese history, writing characters with a brush, or calligraphy, has been considered the highest art form. It takes great skill and years of practice to be able to create characters that are beautiful and expressive. Painting was initially considered a craft practiced by technicians. When literate intellectuals brought their calligraphy skills to painting, the brush strokes in paintings became more expressive. Paintings became more philosophical, poetic, and symbolic rather than representational or decorative. This change in character raised painting into an art form that was more highly esteemed. The great artists in Chinese history were always great persons: accomplished scholars, calligraphers, painters, and musicians. Knowing how to control the brush to make the strokes in calligraphy is essential to learning to become a good painter.

The art of writing in China started nearly four thousand years ago. Different notations and picture-characters were invented to record notes and express ideas. These developed into various scripts that made writing easier and more graceful. The need for the emperors and government officials to keep records and communicate with each other was a major driving force behind the invention and standardization of scripts and the formation of a literate class within society.

Pictograms

Picture-characters of objects or animals, known as pictograms, were the prototypes for the Chinese characters we know today. Pictograms were used on notched sticks during the reign of the Yellow Emperor Huangdi (2679–2598 BCE) and on bronze tripods in the Xia dynasty (2100–1600 BCE). During the Shang dynasty (1600–1046 BCE), priests and shamans prepared "oracle bones" to foretell the future for the emperors and others. They engraved picture-characters on tortoise shells or the shoulder blades of animals to represent questions. Then they put the bones in the fire or the hot sun where they would expand and develop new cracks. The shamans then interpreted the cracks as answers to the questions.

Based on modern archaeological finds from all over China, researchers estimate that about 5,000 different symbols and pictograms were used. They were written in vertical rows from right to left, which is still the way characters are written today.

Oracle bone

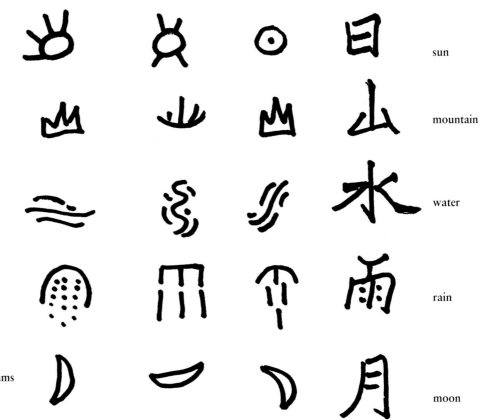

				sun
				mountain
				water
				rain
				moon

From pictograms to characters

Zhuanshu or Seal Script

The Shell-and-Bone Script continued to be used on bronzes in the Zhou dynasty (1046–211 BCE). During the same period, a new system of characters later referred to as the Large or Great Seal Script, Dazhuan, emerged. This script had broader, curvier lines with even thickness. It has been found engraved on bronzes, stone drums, and in a copybook of a Grand Recorder named Zhou from about 800 BCE.

Great seal script—Painting brushes and ink were also invented in the Zhou dynasty, and people began to write on large leaves, cloth, silk, or strips of bamboo tied together. The new media allowed more intricate scripts to be written.

During the Qin dynasty (221–206 BCE), the emperor's Prime Minister, Li Si, developed the Lesser or Small Seal Script, Xiaozhuan, as an official system of handwriting. It was based on the Great Seal Script and contained more than 3,000 characters. It unified the various styles found in different states into a standard script that helped to improve communication and learning. It also brought visual uniformity because each character occupied the same amount of space in an invisible square.

Great seal script

Small seal script—Li Si also developed a method of creating new characters by combining an earlier pictogram with a phonetic to produce a two-part character known as a pictophonetic. Using this method, by 200 CE, scholars had invented over 10,000 characters for the Small Seal Script. Most of the characters that evolved into modern characters were pictophonetics, where the combined image and sound of a symbol determined its meaning. The image and sound of a symbol could change over time, which could change its meaning. The First Emperor of the Qin dynasty built a large pond called Lan Ji and a palace (Gong). These characters

Small seal script

modify the last character, Dang, which means an eaves tile of an important building. All of these characters would only have appeared on the surface of a real eaves tile made of clay. This medallion might be a souvenir of the pond and palace.

The Small Seal Script (now referred to as simply Seal Script, Zhuanshu) is still used today in the engraving of the seals that are stamped onto paintings. Seal characters can also be found in decorative uses, such as in window designs.

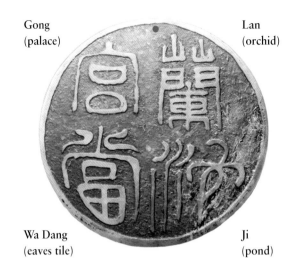

Gong (palace)

Lan (orchid)

Wa Dang (eaves tile)

Ji (pond)

Lishu or Clerical Style

Although the Small Seal Script was a unified system, clerks and officials found using it slow and laborious. Cheng Miao (240–207 BCE) of the Qin dynasty devised a shorthand version of the script that was easier to write. The curved and rounded lines of the seal script were made into straight and angular lines that could be executed more quickly. Called Lishu or Clerical Style, where "Li" means "clerk," this style became an official style during the span of the Western and Eastern Han dynasties (206 BCE–220 CE). The Clerical Style is still commonly used as a type-face for decorative purposes, but it is not often written.

In 105 CE, the court official Cai Lun invented the paper-making process. Fibers from bark, hemp, and silk were wetted, pressed together, flattened into thin matted sheets, and dried. The long, fresh fibers of the mulberry tree became preferred for making paper. Paper allowed more extensive writing, the composition of books, and greater use of calligraphy. Paper became widely used as a writing medium in China by 200 CE. and helped to spread literature and literacy. The paper-making process spread eastward through Asia and the Middle East over the centuries and did not reach Europe until the 12th Century CE.

Lishu script

Kaishu or Regular Style

The Lishu style continued with variations through the Eastern Han dynasty and into the Three Kingdoms and Western and Eastern Jin Dynasties (220–420 CE). By the 4th century CE, a standard script emerged whose regularity of design earned it the title of Regular Style. Kai means "good model." It kept the square-ness and precision of Lishu but made it simpler and faster to write. Kaishu became a typical style of Chinese calligraphy used for everyday purposes. Students are taught Kaishu first to get a feel for correct placement and balance. Writing the script requires great care and correctness with no abbreviation, omission, or linking of strokes. The script is used for business, government, schools, painting, and poetry. Over the centuries, different calligraphers have developed individual types of Kaishu without losing the essential qualities of the style.

"Happiness" – Kaishu script

Running script

Xingshu, Running, or Semi-Cursive Style

At the same time that Kaishu was being developed, the Running Style came into practice because it allowed faster, freer, more expressive movement. Xingshu paralleled Kaishu so that every Regular Style character had a Running Style character. The difference between the styles is similar to the difference between hand printing and longhand writing in the West. The Running Style characters flow more quickly and usually join the strokes and dots. Yet, just as in longhand, the characters should still be formed carefully enough that they can be legible to readers. Because Running Style is easier and more artistic, it has become more popular and practical for everyday use than Regular Style. It is often used for poetry and inscriptions on paintings and for personal notes, letters, and journals.

Golden Thread or Iron Wire

Running script—The Running Style allows more personal expression just as longhand writing in the West reveals much about a person's character, state of mind, or physical condition. One famous form of Running Style was made by the Emperor Huizong in the Northern Song dynasty (960–1127 CE). He was a talented poet, calligrapher, and painter who promoted the arts during his short reign. His distinctive script, called "Golden Thread" or "Iron Wire," is characterized by thick and thin angular strokes and sharp, pointed ends. The energetic lines resemble gold filament twisted and turned. The overall effect of a strong, angular delicacy distinguishes the script from other forms. The variation is not just the style of the artist but is an actual learned variation of Xingshu.

Caoshu, Grass, or Cursive Style

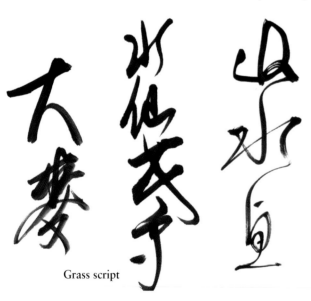

Grass script

Caoshu developed alongside Kaishu as an even more hurried and sketchy form of the Running Style. The strokes are more curved, elongated, and linking together like long strands of twisted grass. An entire character can be made without lifting the brush. The characters are frequently illegible and intended for artistic expression rather than clear, literal communication. Cursive script is not considered acceptable for writing on a painting because of its illegibility. A person who can read the Running Style cannot be expected to read the Cursive Style without training. Modern calligraphers and painters often like the Cursive Style for its more abstract forms and musical rhythms, almost like the patterns made by ribbon dancers.

Public Scripts

Several other types of scripts are used for publications and displays. The printed script is a formal, standardized script that is used on printing presses and in the form of electronic fonts. The banner script has massive, simplified strokes suitable for large banners to be read from a distance. The calligrapher wields an oversize brush standing over the banner paper laid on the ground. The square script, also known as the Song Dynasty form, has a squared-off, chiseled look that evokes the early days of crude brushes and paper. This script makes an emphatic statement appropriate for posters and banners.

Even in printed works, personal calligraphy style plays a role. A newspaper seeks to have an esteemed person with a well-recognized calligraphy style make the title logo for the paper to bestow honor and prestige upon the paper, something like a celebrity signature.

Character Formation

In the early development of the character system, it was found that an idea could be intensified by repeating a character. For example, putting together two of the characters for "tree" represents the concept of a forest, and three tree characters represents a dense forest.

More complex ideas could be represented by putting together combinations of characters. Many characters are grouped together in a dictionary because they all share the same character part, called a "radical," and then have different other parts. For example, the characters for different kinds of trees all have the tree character as the first part of the character.

One of the guidelines for painting trees is that the left side of the tree has longer branches than the right. Not only does this principle apply when you paint any type of tree, but you can especially see this in the characters for the types of trees.

tree

forest

dense forest

The Eight Basic Strokes

Nail Stroke

With a vertical brush, push the tip slightly upward and then immediately downward, making an even-width stroke. Lift the brush and trail it off to make a point.

Descending Stroke

As in nail stroke, use the reverse stroke to establish the head of the stroke and press downward and slightly to the left to make the body of the stroke. Lift the tip to make a point.

Trailing Stroke

With a vertical brush tip, move slightly to the right, pressing more to broaden the stroke. Roll the brush slightly away from you to make the heel and lift it quickly to make a point.

Left Dot

Load the brush well and stroke the hairs to align them. With the brush vertical and the tip slightly to the left, lay the brush down, turn the tip to the left, and lift it to make a blunt point.

Rightward Dot

Position the tip of the brush to the right, lay the tip down slightly, and press to the width desired. Lift the brush without making a point.

Pecking Dot

Lay the tip down diagonally parallel to the table, push the side of the brush to the lower left corner, and lift the brush quickly to make a point.

Bone

Start to make a horizontal nail stroke to the left. Continue with a horizontal nail stroke to the right and then come back to the left. The action is similar to doing a horizontal figure eight with the loops on the ends on top of each other.

Vertical Hook

Start out the same as with the nail stroke. On the end, flip the tip to the left and upward.

Practicing calligraphy using the basic strokes sets you up for using the same strokes in the subjects you will want to paint, such as orchid, bamboo, plum blossom, chrysanthemum and pine, which are the most popular subjects among Chinese painters.

For beginners, the Kaishu standard text is the easiest to learn and can be beautiful when the strokes are done in proper relationship to each other. Learning the basic Kaishu strokes is essential before trying to make the characters, as you must have control of the brush and the ink.

The calligrapher's strokes are always done in rich, well-ground black ink. The calligrapher uses a calligraphy brush with special hairs and a wide base to hold more ink. These brushes are flexible yet stiff enough to keep a point, as the tip is the part of the brush that makes the strokes.

The eight basic strokes are based on the simplification of the strokes used in ancient script. Many characters use repetitions of the same standard strokes, as seen in the chart with the eight basic strokes. For example, the character for "eternity" is composed of six of the eight basic strokes. The sequence of strokes for a character is sometimes shown in a Chinese dictionary.

Practicing the Eight Basic Strokes

Practice the strokes shown in the chart by following the directions given. The tips may help you to be successful in a shorter time.

The basic strokes are combined into standardized characters representing words. After you have practiced the individual strokes, try putting the strokes together for the character for "eternity." The directions for the strokes in a character are written from the top down and from left to right, alternating sides as the character is developed.

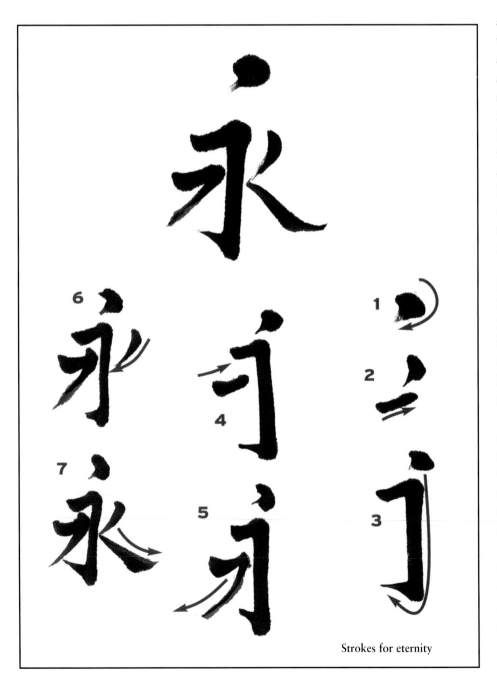

Strokes for eternity

54

Writing in Columns

The Chinese write their characters in vertical columns from the top to the bottom, and the columns move from the right to the left.

The ideal is to line up the characters in straight columns with each character under the one above and with equal spaces between the separate characters. The calligrapher starts with a well-loaded brush and uses light pressure on the paper so the stroke will not drain the tip of the brush too quickly. After five to six characters, the ink in the brush will be used up, but one should not let it run dry. After reloading the brush, the calligrapher moves gently with the tip so the ink will match the intensity of the previous character. In some scrolls, you can see the places where the brush was reloaded, as the ink is intense and sometimes has blobs, which is very distracting. The ideal is to have a fairly even darkness to all the characters. Sometimes variations in value add an expressive quality.

Using a Grid

To use the strokes in the Kaishu standardized script, people learn to space and proportion the brush strokes by copying examples of characters within a grid. Each character is balanced within a square as a guide to assist you in observing and memorizing the all-over balance of the character. The characters for the numbers are shown in a grid with diagonal lines. Another type of grid consists of nine small squares.

Using a computer or a ruler, you can make copies of grids to practice on, or you can buy preprinted grids at Chinese stores. Practice placing characters in each type of grid and observe which type makes it easier for you to position the strokes.

Characters written from top to bottom, right to left

Tips for Practicing the Strokes:

- Use a calligraphy brush if you have one or else a medium-sized, fairly stiff brush.
- Load the brush properly so the hairs will move as a unit and be better controlled on the small calligraphic strokes. Lay the brush sideways onto the ink on the ink stone and drag it to the right while rolling the body of the brush forward and back. Then lift and move it to the left, and roll and stroke to the right again.
- Sit properly at the table with only the tip of the brush ready to touch the paper to make thick and thin strokes.
- Hold the brush vertically, press slightly at the beginning, and lift quickly to make a tapering tail.

Writing Numbers

Many of the eight basic strokes are used in the numbers 1 through 10. To gain expertise in writing the strokes, practice making the characters for these numbers. Use the lines in the examples to guide the placement of the strokes within a grid. For example, notice that the top bone stroke for the number 2 is above the central horizontal line while the longer, lower bone stroke is below the same line. Notice how the dots or diagonal strokes are related to the diagonal lines for the numbers 6 and 8.

1	2	3	4	5
6	7	8	9	10

The strokes for the number 4 create a type of box. The first stroke is the left vertical side of the box. Leave a gap in the upper left corner between the first and second strokes. The second stroke starts at the upper left, goes straight across, and turns a corner to go down. Twist the brush when you turn the corner to make a flat edge. Always include such a gap when painting rectangular forms to let the evil spirits get out. Add the left and right dots as the third and fourth strokes. Complete the box with the fifth stroke, the horizontal line at the bottom.

The numbers 11 through 19 are written using 10 followed by the number to be added to it. 11 = 10 + 1, 12 = 10 + 2, and so on. For numbers with more than two digits, the teen numbers require a 1 before the 10 as a placeholder. 0 may also be used as a placeholder for the 100 position. For example, 2010 is written as 2 + 1000 + 0 + 1 + 10. 2011 is written as 2 + 1000 + 0 + 1 + 10 + 1.

The numbers can be written from left to right in Western style. To write the year on your painting in Chinese style, stack the characters from top to bottom along the side of the page.

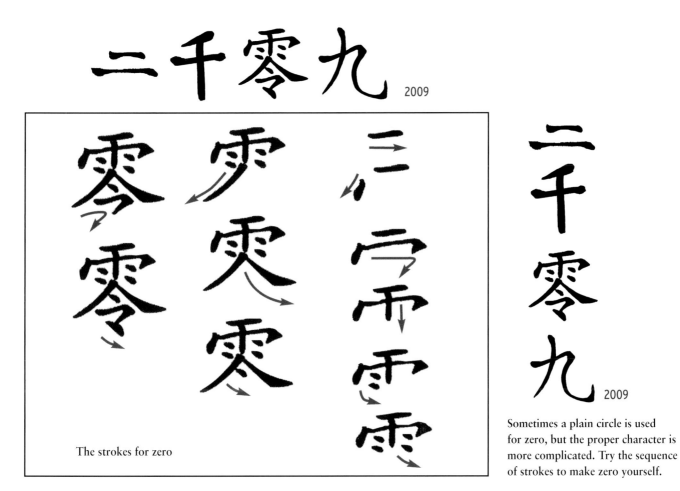

2009

The strokes for zero

2009

Sometimes a plain circle is used for zero, but the proper character is more complicated. Try the sequence of strokes to make zero yourself.

Writing Characters for Subjects

When you have practiced the basic strokes and can make the strokes for the character for eternity in order from top to bottom, practice the characters for some of the subjects covered in this book. Remember to follow from right to left.

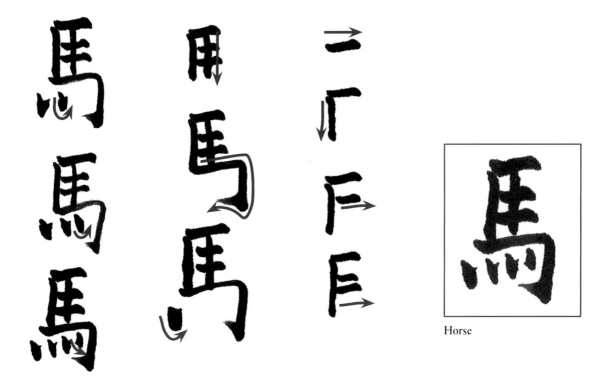

Horse

竹

竹

Bamboo

菊

Chrysanthemum

Pine

58

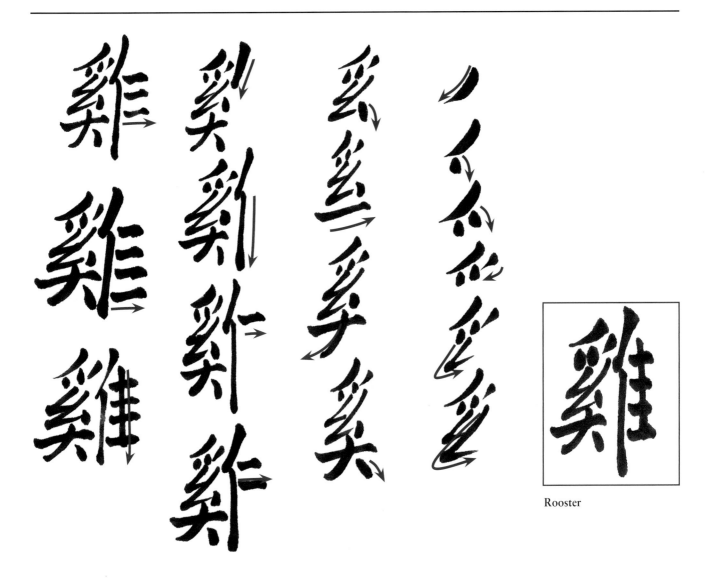

Rabbit

Rooster

A positive name seal with seal script characters in a square

A positive mood seal with Kaishu characters in an oval

A positive mood seal without a border with a simplified Kaishu character for "peace"

A positive zodiac seal with a goat/sheep in a circle

A positive seal with Lishu characters in a square

A negative seal with a character

Using Seals

Since the Song dynasty (960–1279 CE), a painting usually included the artist's signature and personal seal. The calligraphy was judged as much as the painting. An artist with poor calligraphy had a fine calligrapher write on his painting so that the painting would be held in higher esteem. Calligraphy was considered the highest art form.

Sometimes a teacher or mentor gives a proficient student a name that describes the student's personality—such as "pretty orchid," "sensitive," or "appreciative"—or else a name made from the sounds of the student's given name. Some artists have seals made from this name. In addition to name seals, "mood seals" are used to add another character to the painting, to direct the eye around the painting, and to repeat the red color in the painting.

Early calligraphers used a toxic dark red paste ink to identify them as calligraphers and not be confused as artists. In modern times, only the non-toxic vermilion paste ink is used for seal printing. The red color comes from an oil mixed with ground cinnabar and soaked into silk fibers.

Many old paintings have many seals, but these identify the past and current owners of the painting, not the artist. A painting may have had many owners and many seals visible in all different sizes and shapes. Some emperors had seals up to four inches (10 cm) square to show their status, and government officials had seals somewhat smaller. The handles of some stone seals have a carved dragon, a zodiac animal, or a Guan Yin.

Types of Seals

Seals are made by carving into semi-hard stones, marble, or wood. Soft sand-stone is popular because it is easier to carve. The seal can be large or small, positive or negative. The size of the seal should be relative to the size of the calligraphy and the painting—a large seal for large calligraphy in a large painting and a small seal for small calligraphy in a small painting. Most seals are square or rectangular, although some are round or oval. Some have an irregular shape, but most are slightly off square. A positive seal, when pressed into the paste ink, prints the strokes of the name in the red color. A negative seal is incised into the base stone so that, when printed, it leaves a white character with a red background.

A seal can be incised with ancient script, standard script, or designed symbols, but the most common is seal script. On the left are examples of different kinds of seals.

Placement of Seals

When you are grinding the ink, you plan in your mind the arrangement of the items to make a pleasing composition. Included in this arrangement is the use of your name in calligraphy and a seal. Placing these items is crucial in making the composition complete. They can help to expand the flow of the line and balance the use of space. The seal is usually under the name, to either side of the name, or offset to the side of the second character in the name if there are space constraints. Sometimes no signature is used in ink. Use the name seal with the signature alone, or use a pair of positive and negative name seals together.

If you are not a good calligrapher, have a better calligrapher do your name or use only your seal.

The Chinese use space in a special way, viewing the objects in a composition as if they are within an imaginary form. The objects might form an S shape, an X shape, or a triangular shape. The name and seal can complete an S shape by extending the flow at the end of the curve, complete a triangle at one of the low points, or complete an X-shape, as two triangles put together, at any of the two low or two high points.

Usually you put your name seal at the "back door" of the painting, which is the opposite side from where the objects in the painting, such as flowers or branches, reach outward. You can also put a seal in the painting to enhance the shape of an object.

Titles or captions in calligraphy can also be used next to the name and seal or deliberately separated from them to enhance the whole of the painting. Mood seals are usually used apart from the name and seal to repeat the red color in the composition.

Learning the strokes for your name is very important, as your name in calligraphy tells your level of competency as a calligrapher and as an artist. It is impressive to see your painting with the calligraphy of the subject, your name, and your red seal. The calligraphy gives your painting a true Chinese flavor.

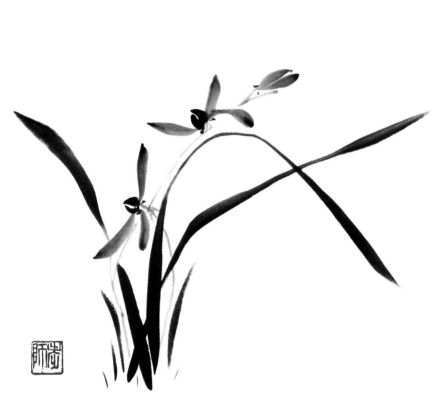

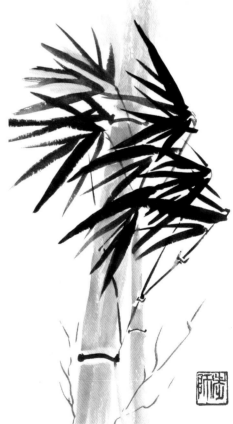

Placement of seals at
the back door

Chapter 5

Painting Bamboo

竹 Bamboo is one of the Four Gentlemen, along with orchid, plum blossom, and chrysanthemum. It is also one of the Three Friends of Winter, along with plum blossom and pine. It is an exotic plant that we associate with Asia, but it can grow anywhere where the weather is suitably warm and moist. There are over a thousand varieties of bamboo that come in sizes from ¼ inch to 18 inches (0.6 to 45.8 cm) in diameter. They all have in common a woody culm or stalk, where most culms are hollow, divided by walled nodes. The colors can vary greatly, from yellow and green to black, brown, and red. Some are blotchy or mottled with spots of darker color. Some varieties have spines at the joints, and others twist like a corkscrew. With all of this variation, how can we paint bamboo? Chinese painters do not paint the real bamboo but a composite of types that form a traditional idea of generic bamboo. This bamboo is simplified, stylized, and standardized to represent a particular aesthetic.

Wild and weedy bamboo growing out of rhizomes under rocks sug-gests youthful energy and new beginnings. More commonly, tall stalks of bamboo symbolize a stately gentleman, sturdy but flexible, bending but never breaking.

Bamboo, like orchid, can be painted in boneless or free style without outlines or boned with outlines around the leaves. The boned style is necessary when painting on silk, but it is more limited in qi energy expression than the boneless free expression of the stroke. Since it almost never grows alone, bamboo should be painted with more than one stalk unless you are doing a simplified Zen-type composition.

There are several ways to paint the bamboo stalks, its branches, and twigs. After you have practiced the way of the masters, you will probably choose a style you like doing or you may combine two that you can do well. The technique is important, but getting the spirit of the plant and its qi energy and expression is more important. Since bamboo is such a popular subject, you should concentrate on producing strong, decisive bamboo strokes to say you understand the spirit and can produce the qi energy that makes the painting exciting and fun to do.

Boned and boneless bamboo

The Structure of Bamboo

Bamboo is easily recognizable as a tall, sturdy plant that grows in groves. Rarely does a single plant grow alone, and painters rarely paint only one stalk. The roots or rhizomes of bamboo spread out and produce new stalks that form very large groups if left to their own resources. During the wet, warm season, plants are known to grow as much as a foot (30.5 cm) a night. They grow so fast that you can hear them make a "shuh" sound.

A small bamboo sprout forms a main stalk from which other stalks develop. The main stalk is held together by a joint at the end of each stalk, and branches grow out from the joints. The stalk at the bottom of the plant has sections that are close together and that tend to grow farther apart as the plant grows. The small branches that hold the leaves grow out from the joints alternating from one side of the stalk to another. When young, the branches have leaves that grow upward. As the branches get older and taller, the leaves tend to grow outward and hang out and downward. These groups of 2–5 leaves usually form umbrella clusters in one type of bamboo. In other species, the leaves grow out on both sides of a stem and upward.

A stalk has a series of sections that can be a foot (30.5 cm) high or taller, depending on the size of the plant. Bamboo does not bend in the stalk area. However, in a continually blown area, the joints tend to give way on one side, which makes the bamboo appear to bend, but only at the joints. The plants are very flexible and survive the elements. They blow in the strong wind but never break because of the construction of their stalks. The leaves blow in one direction, and a painter may exaggerate this directionality to convey the force of the wind.

Bamboo leaves in the rain look narrower because they fold up slightly to let the water run off.

Bamboo against the moon creates a romantic mood. One story says that in ancient times a famous princess saw a shadow of a bamboo branch on her screen and considered it most beautiful. As a result, the silhouette of bamboo has been depicted against the moon, as reflections in water, and as a screen to suggest other objects half hidden behind it.

Clockwise from top: Up bamboo from rhizomes of mature stalk; Bamboo in rain and Bamboo in wind

Bamboo against the moon

Bamboo in snow

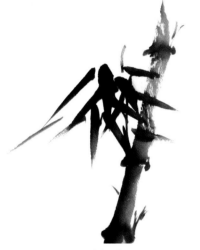

Hidden leaves

In the winter, snow can gather on the surface of bamboo leaves. The snow is painted with white paint in spots on the black leaves.

Clusters of bamboo leaves that overlap and are half hidden can be exciting. Things that are half hidden are like surprises. You do not know where the other piece is and what you are missing. This approach is used a great deal in Oriental art for the mystery involved. In painting plants and trees, the artist traditionally suggests that the branches are coming off the stems in all four directions even when the ones at the rear of the plant are not really seen.

Preparing to Paint

Prepare your equipment and yourself before starting to paint:

- Prepare diluted, medium gray ink in a dish to have sufficient amounts to load the brush many times.
- Be sure the paper is tall enough to be able to fit the bamboo stalks on the page, perhaps 12–18 inch (30.5–45.8 cm) paper vertically.
- Put weights along the edge of the paper so that it will not move when you drag the brush upwards, or use your left hand to anchor the page.
- Be ready to paint all three of the stalk sections with the same load of ink in the brush. You do not want to go back and reload the brush, as that creates an undesirable difference in value and wetness in the next stalk section.
- Sit in a straight position bending slightly forward, feet flat and body centered in a comfortable position. Become quiet, centered, and focused so as to express the qi energy that reflects the vitality, strength, and flexibility that is the essence of bamboo.

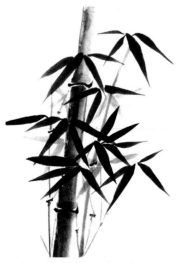

Branches in four directions

Sizing Stalk Sections

To paint bamboo stalks properly, you need to understand the way the plant grows and the order and length of the strokes for the sections of a stalk.

1. The first stalk in the lower part of the page is the shortest.

2. The next section of the stalk is longer than the first.

3. Each section above becomes progressively longer. The skinny, new growth at the top has sections closer together.

4. Branches grow only out of the fifth joint and above.

5. The top section may run off the top of the page. The top section of the main stalk should have enough ink to make the edges even if the brush is running out of ink. If it leaves areas of white showing, that is all right. The effect is called flying white and adds interest.

Look at the picture and see how the stalk lines up as a single stem of a plant. There should not be any curves, but the all-over stem can slant slightly. The main stalk is very straight and stiff but it is flexible at the joints, which allows for stems to slope slightly. This is one of the reasons we can build a composition with a variety of stalks to give more interest.

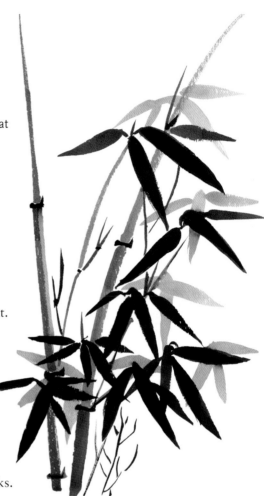

Practicing Boneless Bamboo Stalks

Painting boneless bamboo begins with painting the stalks. Wide stalks are more common and are painted with a different technique from narrow stalks.

Practicing Wide Stalks

A wide, boneless bamboo stalk is painted with the side of the brush, starting from the bottom of the stalk and moving upward. Practice painting a wide stalk with three sections.

1. Load a large brush with medium gray ink and tap off the excess.

2. For the lowest section, hold the brush in vertical position, rotate it to the right so that all of the brush lays down on the page, push the brush up a little and then down off the page at the bottom.

3. For the section above, leave a joint space, stroke down a little with the side of the brush, stroke upward making a longer section than the bottom one, and then stop and stroke down a little. The little overlapping strokes at the beginning and end of the section give the stalk the look of an animal bone.

4. For the top section, leave a space, push down a little with the side of the brush, and then push the brush up and off the page or let the brush run out of ink. If the brush is fairly dry, you get an interesting striated effect.

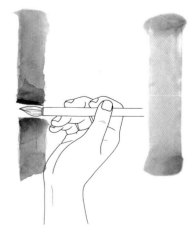

Adding the Joint Rings

The joint ring is a horizontal hook that is painted between the sections of boneless bamboo. A joint ring should fit nicely between the two outer edges of the main stalk. If it is too wide, it will not look like it is a part of the joint. When making tall compositions of bamboo, you may create the illusion of looking up at the plant by curving the hook stroke upward in the center. On the other hand, you may like to curve the cross stroke of the hook downward, also making the hook flip downward, but be consistent. Do not use both techniques on the same painting.

Some painters are very spontaneous about putting the hook strokes in while wet so they merge with the stalk into the joint. It is not desirable for the strokes to be too wet, because they may run. Some are made with a loop on the left side, while others are noted for their exaggerated lift at the end. The way you make joint rings is said to show your personality.

Practice this stroke to make it compatible with the size of the main stalk. One can tell a sloppy painter when these are out of sync. These hooks are always painted with dark ink to have contrast with the stalks and to repeat the dark ink value of the leaves, which are in the front of the painting being the hosts.

Practicing Narrow Stalks

Paint a narrow, three-section bamboo stalk with the tip of the brush, starting from the toe of the stalk and moving upward.

1. Load a large brush with medium gray ink and tap off the excess.

2. Holding the brush in a vertical position, make a narrow stroke from the bottom up, stop, press, and lift.

3. For the next section, leave a space below the first, press, drag a little, press, and lift.

4. For the next section, leave a space, press, drag a little as it goes off the page and lift.

5. With a detail brush and dark ink, make the joint strokes between the sections.

Practicing Shadowed Stalks

A shadowed stalk looks rounded and three-dimensional. Follow the instructions for painting the wide stalk except change the first step:

1. Load the large brush with medium gray ink, dip the tip only into dark ink, and tap the brush against the dish to mix the ink slightly.

2. Continue painting the three stalks sections with the brush on the side. The dark ink on the tip grading into the gray makes the shadow. Practice loading the brush and applying proper pressure as you stroke to get the effect you want.

Practicing Boneless Bamboo Leaves

It is important to paint a bamboo leaf with a proper, pleasing shape. The greatest width is down from the top and then the leaf tapers slightly down to a point. The leaves should be widest ¾ of the way up and then taper to a point at the end. The easiest way to achieve a good shape is to keep the tip of the brush in the center of the stroke. The size of the leaf depends on the size of the brush and the pressure you use. Use your arm rather than your fingers. Moving your fingers makes the brush curve and produces uneven leaves.

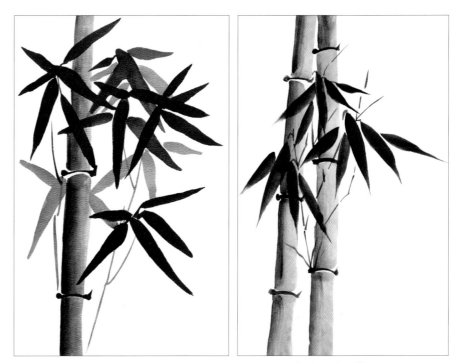

Shadowed stalks

1. Load the large brush with rich, black ink.

2. Hold the brush vertically and take a breath. With the tip centered, push up slightly with the tip, come down, lay the body of the brush downward to give width, and then lift immediately, let out the breath, and taper out to a point. With a vertical leaf, the stem is covered.

3. Practice making single leaves. Keep the tip in the middle of the stroke and lift to a point by using your arm.

4. Practice directing the arm in different directions so strokes can fan out in a half circle. With a leaf at an angle, push toward the body of the leaf to create a little stem before making the leaf.

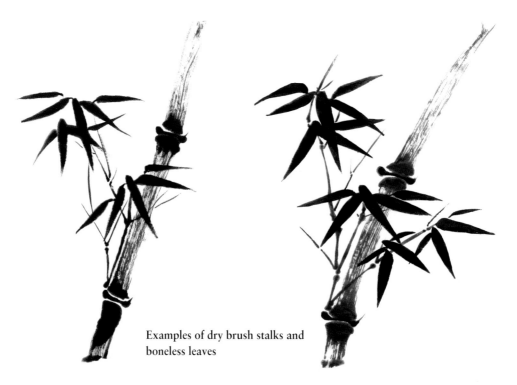

Examples of dry brush stalks and boneless leaves

Principles of Painting Boneless Bamboo Leaves

- Be aware of the contact of the brush on the paper.
- Use your free hand to support the paper as the push of the brush upward can also take the paper in that direction.
- Lift the brush quickly in making the leaf strokes to get a clean stop.
- Use all the hairs, not just the very tip of the brush, and keep the tip in the center of the stroke for leaves.
- Remember to take a breath before every stroke, hold it, and release it gradually on completing the stroke. This is the secret for getting the qi energy and vitality and life into what you are painting and for making straight lines and points.
- Take your time to master bamboo. Students in Asia study bamboo first in their career to learn control and to express energy. Some study only bamboo for five years before they know bamboo and are ready to move on to other subjects.

Practicing Leaf Formations

Bamboo leaves fan out at different angles, but a leaf formation usually has no more than five leaves. The new leaves first grow upward and other leaves unfold as the cluster develops. Fewer than five leaves means that the leaves are under development or hidden behind the stalk. The fully unfurled leaves tend to droop slightly and make an umbrella for the leaves that are younger, lower, or in close to the stalk.

The goal is to make each leaf formation in a painting different. Variety adds interest and asymmetry and accents the overall composition.

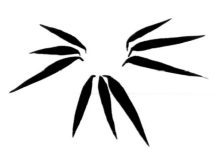

Directions for leaves

- Vary the number of the leaves in a leaf formation.
- Vary the sizes of the leaves.
- Vary the darkness of the leaves.
- Vary the angles and directions of the leaves.

- Do not paint leaves parallel to each other or too far apart from each other.
- Control the shapes of the leaves so they are not too long, too fat, too curved, or too angular.

To avoid the pitfalls in arranging leaves, learn to paint some of the common leaf formations before you start making your own. The formations vary depending on the number of leaves, going from one to five leaves.

1. Look at the following arrangements of the five leaf formations. Practice painting the leaves in each formation.

2. Practice your own formations. Start by using one leaf in various directions. Then use two leaves in different directions.

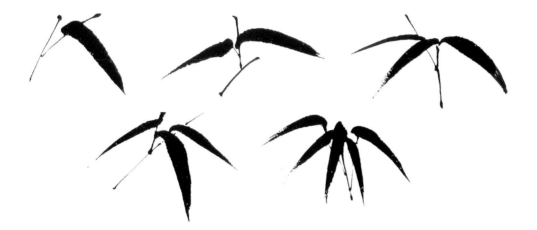

3. Continue making different formations using three, four, and five leaves. Remember to vary the sizes, shapes, angles, and separations between the leaves.

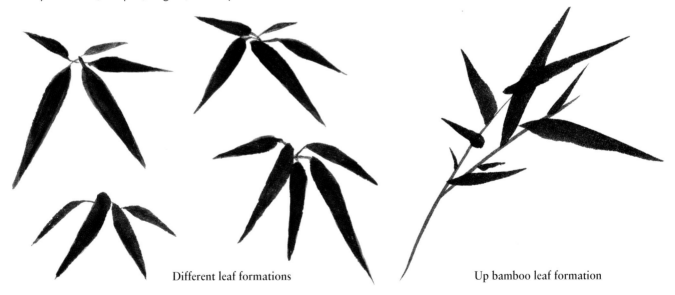

Different leaf formations

Up bamboo leaf formation

4. Up bamboo takes on different leaf formations from the down-turned bamboo leaves. Try copying the up bamboo leaf formation shown above.

Practicing Leaf Clusters

All of the leaf clusters come off the small branches coming out of the main stalk, either to the right or left at the joint, never from both sides, but alternating as the joints grow upward. The main leaf of the host cluster should be larger and pointed slightly upwards. The others group around the host cluster as guests and associates.

1. Try to copy the simple leaf cluster shown at right, being aware of the differences in the sizes of the leaves and the larger size of the host cluster.

2. Copy the more varied clusters in the painting below at left to familiarize yourself with different sizes and angles of leaves in clusters.

3. Up bamboo can have its own leaf clusters in a composition. Try copying the following up bamboo leaf clusters shown below at right.

Practicing 3-D Boneless Leaves

A three-dimensional effect is important for bamboo as well as with flowers and all trees. One technique for suggesting that leaves are in front of the stalk is to leave a gap in the main stalk where the forward leaves cross over it. After you have arranged the stalks on the page in an interesting way, you need to consider how to group the leaves in clusters and layers. Look at examples done by the old masters in museums and in books and copy them.

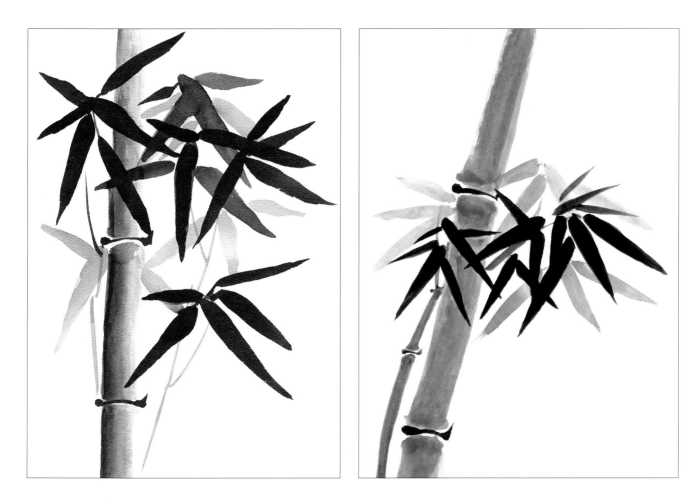

Usually, two branches grow alternately off the main stalk, only at the joints, and the leaves on the small branches may overlap each other. The leaves in the front of the page are usually painted the darkest, while the leaves behind are painted in lighter values of ink. Painters aim for three layers of tones to create an illusion of depth in a plant.

Sometimes the leaves cross over the main stalk, but do not try to paint the leaves when the stalk is very wet or the leaves will bleed into the stalk. Leaves that go behind the stalk should be paler in ink value. Allow for three values of ink to suggest that the pale leaves at the back are at a 90-degree angle from the main stalk.

1. Make a medium and a light mix of ink.

2. Copying one of the examples shown, paint three overlapping clusters of leaves using three different tones to represent different layers.

3. Using one of your practice stalks from a previous exercise, paint clusters of leaves. Use a main host group and several guest clusters. Let some leaves cross over the main stalk and behind. Vary the tones of the leaves to create a sense of layers and depth.

Practicing Branches and Twigs

Bamboo branches grow off alternating sides of the main bamboo stalk. Branch forms are stylized and named.

Use stalk and leaf practice pages for practicing branches and twigs.

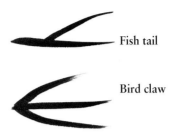

Fish tail

Bird claw

1. Load a medium or detail brush with dark ink, depending on the scale of the painting and the width of the branches or twigs you want.

2. To make a branch coming off a stalk, stroke the brush vertically upward toward a leaf cluster keeping the pressure equal so the width of the branch will be even.

3. Make twigs coming off the branch to attach to the leaves. Since twigs grow from the joints outward, paint twigs growing at angles to the right and left. Try making 2–3 twigs coming out from one position on a branch. Make some longer or shorter to be able to group the clusters. Practice painting the twigs as thin lines broken with dots at the break to show joints. Learn to control the pressure to get even strokes.

4. Add a little joint ring between the dots at a joint.

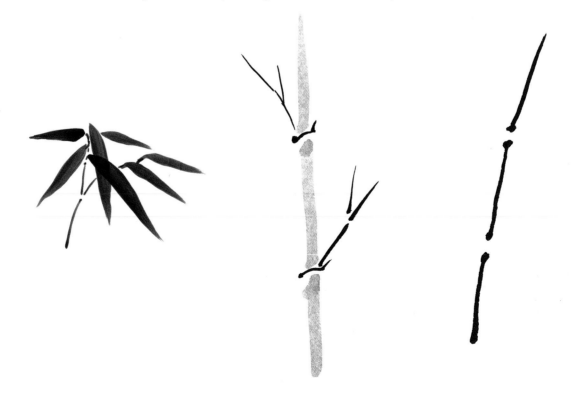

One way to make straight strokes for the smaller branches and twigs is to turn the paper to a horizontal position instead of the usually vertical stroking to the section. Some people find it easier to make straight strokes in this direction. However, it is usually not considered good technique to move the paper to better accommodate the brush stroke. You should be so well-practiced that you can make any stroke necessary from the upright page in front of you without turning the paper.

The leaves grow along the side of a twig, and three leaves grow off the end of a twig. A small stem comes off the twig to the broad end of the leaf.

1. Load the detail brush with dark ink.

2. Near where a twig attaches to a leaf cluster, paint small, curving stems to show that leaves are connected to something, even if the twig is not visible.

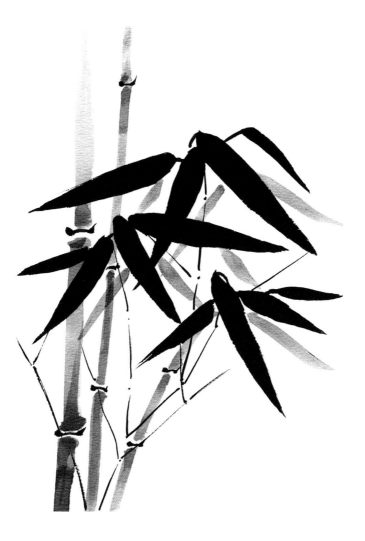

Painting a Boneless Bamboo Composition

The composition to the left has a wide main stalk slightly tilted to the right with a narrow, straight stalk to the left of it. They both start at the bottom to the left of center. The stalk sections get longer as the stalk grows upward.

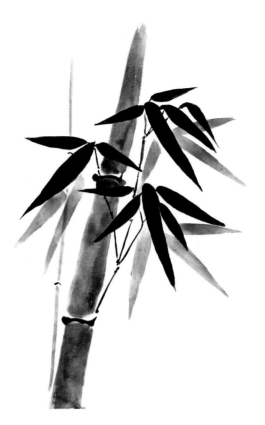

Painting the Wide Stalk

1. Mix a large puddle of middle gray ink. Load the large brush well with the mix. Rotate the hand to the right so that all of the hairs of the brush lay down on the paper.

2. Near the bottom left of center lay the brush down, push up, and then push down off the page.

3. Leave a space above the first stroke, lay the brush down, push down a little, and then push up to the top of that section and push down a little.

4. Leave a space and follow the same procedure make another section that may go off the top of the page.

Painting the Narrow Stalk

1. Load the middle-sized brush with medium gray ink.

2. Hold the brush vertically near the bottom of page to the left of the wide stalk, push up, and then push down and off the page.

3. Leave a space above the first section, press down and then up and then down again to make the second section.

4. Leave a space above the second section, push down and then up and off the page or until you run out of ink.

5. Use a small brush vertically loaded with dark mix. Using the tip only, make a horizontal hook stroke representing the joint between the stalks. Make them fit the space not touching the painted areas. Make smaller hooks for the small stalks.

Painting the Joint Rings

1. Load the small brush with dark ink.

2. Hold the brush vertically and with the tip make a horizontal hook between the joints. Make the strokes fit the space, not touching either side or extending beyond the width of the stalk on either side.

Painting the Leaves

Look at the picture and notice where the three clusters of leaves are in relation to the stalks. Two of the clusters have five leaves, one has three, and each leaf cluster is slightly different, as are the spaces between the leaves.

Start painting the clusters at the top, then left, and then right so your hand does not touch the leaves while painting the other leaves.

1. Load the large brush with dark ink.

2. At the top cluster, start with the largest and dominant leaf. Put the tip on the paper, press slightly and lift gradually to make a tapering out to a point.

3. Plan where other leaves will go and paint them left and then right.

4. Notice that the left cluster crosses over both stalks. Make the dominant leaf large enough to match the dominant one in the top cluster, and vary the spaces between the leaves.

5. For the far right cluster of leaves, make a dominant leaf stroke that is in a different direction from the other dominant ones. Vary the spaces between the other leaves.

6. To make the whole group look more three-dimensional, load the large brush with light gray ink and add large leaves behind the clusters to make it look like there are clusters behind the front ones. Place them differently from the front ones.

Painting Branches and Twigs

1. Load the detail brush with dark ink.

2. Paint the branch that comes off the main stalk.

3. Paint the small twigs that come off the branch and up to the leaf clusters. Some parts of the twigs may not be seen.

4. Paint the small, curving stems that connect the leaves to the twigs.

Practicing Boned Bamboo Stalks

The other way of doing bamboo is in the outlined or boned style. This technique is more rigid and time-consuming, but it emphasizes the structure and strength of the bamboo and has a decorative appeal. You can paint entire compositions using outlining and add ink values for color. Another style of boned bamboo stalks taught by some teachers has flat joint lines and joint rings.

Boned bamboo stalks differ from boneless bamboo stalks in a few ways:

- Each stalk section is outlined on the sides and top and bottom, leaving only a slight open space for the joint.
- The top and bottom lines curve up and down, and curves of adjacent sections fit closely together.
- No joint stroke is used between the joints.
- The side lines are closer in the middle of the section and get broader as they reach the joint.
- Short vertical lines near the top and bottom of a section suggest creases and curves in the bamboo circumference.
- The overall effect makes the bamboo look closer to human or animal bones.

Practicing the Curvy Joint Lines

The stylized curves where one stalk section meets another adds elegance if you practice to align them gracefully.

1. Prepare a piece of newsprint for practice.

2. Load a detail brush with black ink.

3. Starting with the lower curve, hold the brush vertically and paint a shallow curve down, up, down, up.

4. Paint the upper curve parallel and slightly above the top curve, leaving equal spacing between the curves at all times.

5. Where the lower curve changes, paint a small vertical line down the stalk to suggest the crease in the bony bamboo.

6. Make a similar line upward on the lower stalk but offset it so that the two are not aligned.

Practicing Stalk Sections

Paint the outline of a stalk section starting with the bottom section.

1. Prepare a piece of newsprint for practice.

2. Load a detail brush with black ink.

3. Starting at the bottom of the page, hold the brush in the vertical position and swing the arm upward to make the left side of the stalk.

4. Swing the arm upward from the bottom again to create the right side of the stalk parallel to the left side.

5. Paint the curvy joint lines for the top of the lower stalk and the bottom of the upper stalk.

6. Add the small vertical lines off the curves, slightly offset from each other.

7. Paint the next section of the stalk slightly longer than the bottom section, painting first the left side and then the right, and then add the curves and the small lines.

8. Paint the sides of the top section slightly longer than the middle section and let the section go off the top of the page.

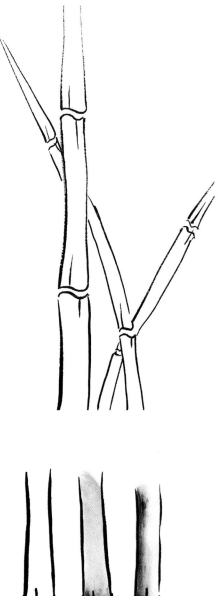

Practicing 3-D Stalks

You can color in the stalks in two different ways to create different effects. Use only one method within the same painting. With each method, use the small brush and stroke carefully to keep within the outlines.

Top and bottom shading

Load a small brush with light gray ink, hold the brush vertically, stroke down near the bottom of the stalk section, stroke up to the top of the stalk section, and stroke down a little. This creates the dark areas at the top and bottom of the section as with boneless stalk sections. In this case, you create the effect with a vertical brush rather than with the brush held sideways.

Side shading

Load a small brush with light gray ink and fill in the entire section outline with a light gray wash. After the wash is almost dry, add a vertical light gray wash line to one side of the section to create a shaded effect.

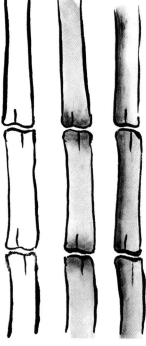

Practicing Boned Bamboo Branches and Twigs

In boned bamboo, you outline the branches and use a single line for the twigs.

1. Load a detail brush with black ink.

2. To make a branch coming out from a joint, paint a line from the joint out and up.

3. Carefully make another line close to the first line and tapering in to meet it to end the branch.

4. To make a twig at the end of the branch, paint a single tapering line coming off the branch.

5. For thin twigs with sections, paint single lines with gaps in between them as you do for boneless twigs.

Practicing Boned Leaves

Boned bamboo leaves are outlined and can optionally be colored in with single flat washes or multiple washes to create shading. Different values of washes make leaves look closer or further away. Vein lines can be added to suggest the fibrous texture of the leaves.

1. Load a detail brush with black ink.

2. Hold the brush vertically at the top of a leaf and make a curved line on the left and then a curved line on the right that come together in a point at the bottom.

3. Go back to the top of the leaf and paint a vein line down the center.

4. Reload the brush and roll the hair forward and back on the ink stone to realign the hairs and make a very fine point.

5. Gently touch the tip of the brush held vertically to the paper to make fine texture lines.

Practicing Boned Leaf Formations

Boned leaf formations are similar to boneless leaf formations. The same principles apply: vary the number and size of the leaves, the angles and space between them, and the darkness for 3-D effects. Outlining leaves requires a different type of judgment about spacing the two curved lines to make a pleasing, balanced leaf.

1. Load a detail brush with black ink.

2. Practice painting the leaf formations with one, two, three, four, and five leaves. Remember to make the center leaf of the five-leaf formation larger as a host leaf.

3. Add a thin line down the center of each leaf to make a vein.

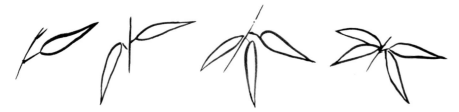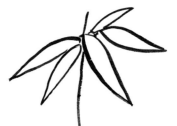

Practicing Boned Leaf Clusters

Painting the overlapping leaves of leaf clusters offers a special challenge using the boned style. The leaves are not transparent. You need to plan which leaf is in front and leave spaces for its overlapping when you paint the leaf behind it. Otherwise, the leaves appear to be intersecting rather than overlapping.

1. On scratch paper, plan two leaf formations, where one overlaps the other slightly.

2. Load a detail brush with black ink.

3. Start by painting the largest, host leaf.

4. Paint the next leaf as a smaller guest leaf to one side of the host leaf.

5. Paint two more guest leaves in various positions to complete the leaf formation.

6. Paint the second leaf formation. Where one leaf overlaps another, interrupt the lines for the back leaf so they do not cross over the lines for the front leaf.

Practicing 3-D Boned Leaves

You can color boned leaves in two different ways to create different effects. Use only one method within the same painting and also make it consistent with the stalk method used. With each method, use the small brush and stroke carefully to keep within the outlines.

Front and back shading

Use a medium to dark wash for the front leaf formation, and use a light wash for the back leaf formation to suggest distance. You can also use a combination of light and dark washes for leaves within a formation to suggest some are closer than others.

Leaf shading

Use a light gray wash on all the leaves. After the wash is dry, add touches of another light gray wash at the top of each leaf to create shading. You can also use multiple thin washes to create subtle effects. By controlling the relative values of the leaves, you can also mix leaf shading with front and back shading.

If the leaves are not colored too darkly, you can add fine dark lines for veins using the tip of the detail brush. Start the lines from the top of a leaf and allow them to get thinner and disappear towards the bottom.

Painting a Boned Bamboo Composition

The strategy for painting a boned composition is to paint the leaves before the stalks so that the leaves can appear to be in front of the stalks. The leaves are not entirely opaque as in boneless bamboo, so the lines of the stalks would show through if the stalks were painted first. After painting in the stalks, the next step is to add the branches and twigs that connect the leaves to the stalks. The final step is to fill in the leaves and the stalks to add depth and shading.

Painting the Right Leaf Clusters

1. Plan the positioning of two leaf clusters to the right and above the joint of the right stalk, where one cluster is dominant and in front of the other.

2. Load the detail brush with black ink.

3. Holding the brush vertically, outline the dominant leaf in the front cluster, and then outline the other leaves of the cluster, making them smaller and at different angles.

4. Outline the dominant leaf of the cluster behind the front cluster, interrupting the lines as needed to place them behind the front cluster, and then outline the other leaves of the cluster similarly.

Painting the Top Leaf Clusters

1. Load the detail brush with dark ink.

2. Starting with the top, dominant cluster, outline the dominant leaf and then outline the other leaves around it, varying their sizes and angles.

3. Paint the cluster to the left of the dominant cluster by outlining the dominant leaf and then adding the other leaves, interrupting the lines where they go under leaves of the dominant cluster.

4. Paint the cluster to the right of the dominant cluster by outlining all of the leaves carefully as they go under the leaves of the dominant cluster.

Painting the Stalks

1. Load the detail brush with black ink.

2. Holding the brush vertically, start at the bottom section at the left stalk and stroke two parallel lines upwards at an angle towards the left, flaring out slightly at the joint.

3. Paint the curved lines and small vertical lines for the joint as practiced.

4. Paint the second section side lines similarly, going at an angle, and make them slightly longer than on the bottom section.

5. Add the curved lines and small vertical lines for the joint.

6. Make the third and top section continuing the angle and even longer than the second section and let it go off the page.

7. Paint the smaller stalk on the right using the same techniques but going off at an angle towards the right.

Painting the Branches

The two stalks have long branches coming off their lowest joints.

1. Load the detail brush with dark ink.

2. To paint the branch off the right stalk, stroke carefully two parallel lines from the joint towards the right to create the first branch section, leave a space, stroke two more parallel lines for the second section, and add two interrupted parallel lines that go under the leaf clusters.

3. To paint the branch off the left stalk, stroke two parallel lines upwards from the joint to create the first branch section, leave a space, and add two interrupted parallel lines under the leave clusters for the second section.

Painting the Twigs

Twigs come off the joints on alternating sides. They connect the leaf clusters to the joints of the branches, add detail interest, and help to define the triangular composition.

1. Load the detail brush with dark ink.

2. Holding the brush vertically, paint the solid line that connects the first right leaf cluster to the joint on the branch. The twig for the second leaf cluster is hidden.

3. Paint the twigs that connect the left leaf clusters to the branch.

4. At the base of the right stalk, paint a small sprouting of twigs coming out of the ground.

5. Paint a similar sprouting of twigs at the base of the left stalk and add some small boned leaves for interest.

Painting in the Leaves

The dominant leaves and leaves in the front clusters are painted darker to stand out and come forward in space.

1. Load the small brush with a medium to dark gray ink mix.

2. Paint within the outlines of the dominant leaves in the dominant clusters.

3. Clean the small brush and load it with a light to medium ink mix.

4. Paint within the outlines of the leaves in the clusters behind the dominant clusters.

5. When the ink is dry, load the detail brush with dark ink and paint in a center vein or a series of fine veins on the leaves.

Painting in the Stalks

This composition uses top and bottom shading of the stalks, but you could use side shading if you prefer.

1. Load the small brush with a light gray ink mix that is lighter than the light leaves.

2. Hold the brush vertically, stroke up from the bottom of the right stalk to the top of the stalk section, and stroke down a little. From just above the bottom of the second section, stroke down, stroke up to the top of the section, and stroke down a little. Stroke down and up for the third section. Stroke upward in between the leaves to continue the section off the top of the page.

3. Use the same techniques to make the top and bottom shading for the sections of the left stalk.

4. Use a pale ink to fill in the branches.

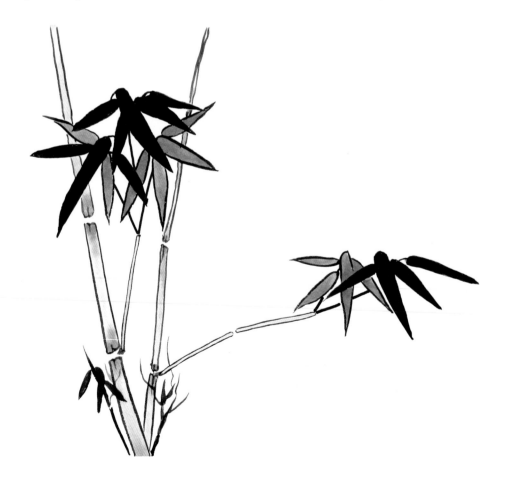

Creating Your Own Bamboo Composition

Composition is especially important in bamboo, as bamboo is a tall and stately plant full of vitality and motion. The artist needs to be able to express these characteristics to truly paint bamboo.

Open space is very important in Oriental art because the open spaces are a part of the composition and are needed to contrast with the busy painted areas. Many compositions are based on a triangle using four spaces to create a vacant corner.

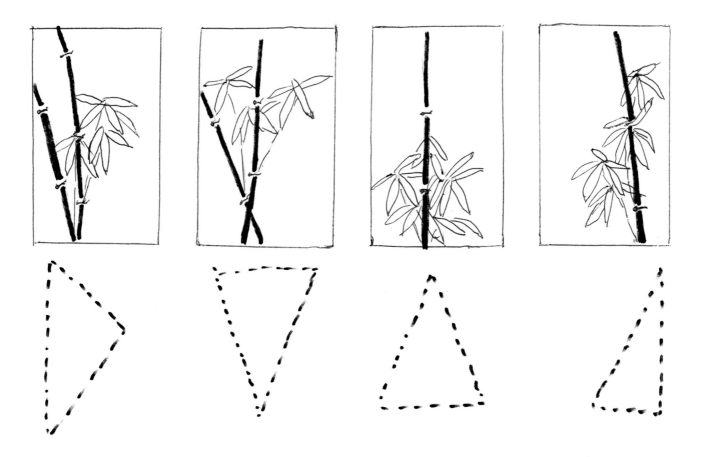

One of the pleasing compositions contains a strong host stalk accompanied by a small one and perhaps a middle-sized one. The host is near the center of the page with the medium one perhaps going behind and the small one at the side. This gives an opportunity to create depth with the smaller stalk crossing behind. The host should always be the largest, the darkest, and in the most prominent position.

The host should not be placed exactly in the center of the page. Instead use the center space as a guide and place the host cluster somewhere along the outer edge, up or down, left or right, but not in the center of it. From this first choice, the other leaf clusters can be placed.

With all the variations of bamboo and the endless compositions of the old masters, you can spend years enjoying the kinesthetic sensation of stroking the huge stalks of the plant and the quick, lifting strokes to make the leaves.

Chapter 6
Painting Chrysanthemums

菊 Along with orchid, bamboo, and plum blossom, chrysanthemum is one of the Four Gentlemen. It is a flower of proud disposition, standing strong against the cold winds of autumn, weathering the frost and cold of the climate. It is also associated with joviality, a life of ease, and a person who leads his own life.

China is known as the flowering country. The Chinese cultivated and developed hybrid flowers centuries ago, and these plants now grow all over the world. The literati and the retired officials of the government found pleasure in growing and developing many varieties and colors of chrysanthemum. They also enjoyed painting these flowers and were instrumental in having flowers be accepted as the subject of fine paintings. They painted the flowers in black, white, and gray, and it was a challenge to create interesting paintings without color. The painters understood not only the essence of the flower but also the importance of the bud, which contains the life force, the fragrance, and the qi spirit. There are about 37 varieties of chrysanthemum, many of which were hybridized by the literati. Some of these have been called Chinese asters. Many of the species were indigenous to Honan Province.

Early treatises described the medicinal uses of dried chrysanthemum flowers. They were used as a tonic, a sedative, a cosmetic, an eye wash, and an aid to counteract drunkenness. The ashes were used as an insecticide.

The character for chrysanthemum is composed of three radicals. The top set of strokes represent grass. The long curving stroke means to wrap up or around. The strokes within the curve represent rice. A chrysanthemum bud or flower viewed from above resembles grains of rice.

The chrysanthemum flower in full bloom was a popular emblem used on collars and belt buckles in the army. It is considered the symbol of the Emperor of Japan and suggests the rising sun. The chrysanthemum came to Japan from China around the 6th century when Japanese monks visited China and brought back many ideas and symbols. In Japan, the chrysanthemum is the most popular flower used in Ikebana flower arrangements.

The Chinese calendar associates a type of flower with each month depending on when the plant blooms. Chrysanthemum is the flower for the tenth month, in the autumn, even though many varieties grow well in late spring and through the summer and into late fall. During the tenth month, the people celebrate the chrysanthemum festival with flowers, dance, and music.

Because of the popularity of the flowers, some public buildings have strongly rooted plants with many varieties of chrysanthemum grafted to the stalk, producing a variety of types and colors of flowers. This grafting may represent the diversity of the people of China. One wall may have as many as ten different colors and varieties growing from the main root.

One interpretation of the diverse and popular chrysanthemum

Varieties of Chrysanthemum Petals

Artists paint chrysanthemum petals of various shapes and at different stages of development and opening.

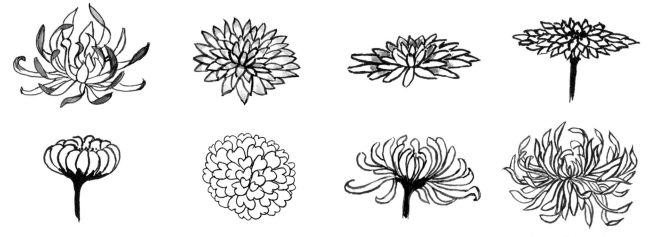

Chrysanthemum blossoms manifest a variety of forms

These examples show the various petals painted in the boned style, but they can also be painted in boneless style. The shapes of the blossoms change as they develop and open up. The flowers can also face in different directions and angles to add more interest to a composition.

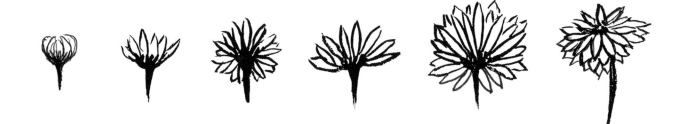

Composition

No matter what variety of chrysanthemum you want to paint, you have to start with a general idea of positioning the plant and its flowers on the page.

Somewhere the painting should have an open space in a triangular form. The objects should be arranged asymmetrically using a set of three, five, or seven. Make each object a different size and shape. The objects should form a triangle.

Usually, you paint a large flower, called the host, with perhaps a slightly smaller, full flower, and then maybe several buds. It is desirable to have one or two flowers with a bud in a painting. The three flowers make a triangle, and the overall composition with the leaves is a triangle.

After painting the flowers, you usually add 5–7 leaves, where each leaf is slightly different in size and shape. In planning the leaves, you think of where the stem on the plant will come off the flower moving down to the bottom. After you paint the leaves, you add the stems and vestigial leaves alongside them.

Position flowers in different states of bloom to form triangular compositions

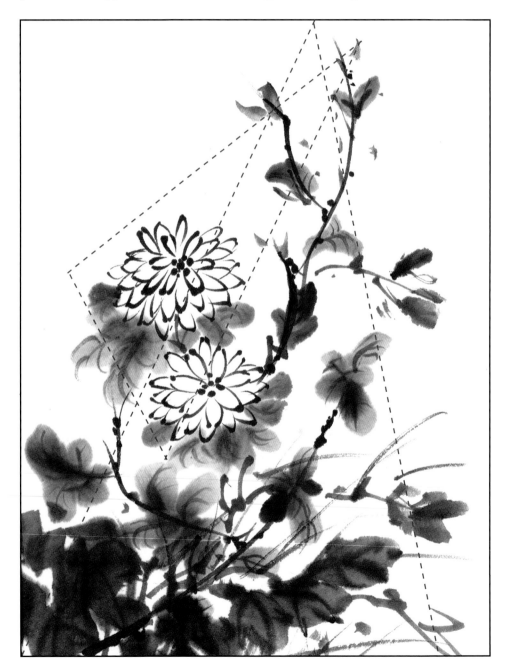

Practicing Boned Petal Strokes

This exercise uses a style of boned stroke with a dot on each end of the petal. Using a dot can help you to make better curves for a petal. Some teachers instruct students to make the lines meet so that a dot is not used. Try doing that only after you can control the brush better and make curved lines rather than lines that are too straight in coming to a point.

1. Use a detail brush and dark ink. Use the brush in a vertical position. Press lightly to make a dot and swing the arm to the left to make a curved line. Go back to the top and make another dot and swing the arm to the right to make a curved line. This should look like a curved petal tapering in toward the bottom. Some teachers like to keep the top dot separate while others let them touch to make more of a point.

 The base of the petals is held together by a peduncle, which has a stem and connects the blossom to the stalk of the plant. Notice how the petals radiate out like a fan.

2. Load the small brush with dark ink and make the central petal. Move to the left and make another petal that curves into the center area where the peduncle is located. Move to the right and make a third petal. With black ink, make a cup-shaped peduncle to hold the petals.

Planning the Fanning of the Petals

Draw a circle and divide it into four parts. The center part where the lines cross will be the center of the flower. That center can be off to one side if the circle is more of an oval shown at an angle. When you paint the petals, fan them out from the center, as shown in the second diagram.

1. To make an opening blossom, start like the bud and make one row of petals cupped in to the peduncle. Behind this row make a few short petals in between the petals in front row. This is the bud opening up and showing the back row of petals. Between the front row and the back row, add a few dots. This is where the center of the blossom is located.

2. Imagine a circle around which the petals fan outward. Divide this circle into four parts. Depending on the rotation of the circle, these four parts will vary in size and direction. Mark the center to the left and below the center. This will give the orientation of the petals from this off-center flower. From this center, make a short row of petals around the ring touching each other. Add a few dots in the center to remind you where the center is located. Add another ring of petals around the first ring making the top ones shorter and the bottom ones longer.

3. To make a fuller flower, add a few small petals between those in the second row. Those to the left and downward are longer.

4. Now that you can paint the petals for the flowers, plan a composition for putting the flowers together.

Practicing Boned Leaves

The leaves for the chrysanthemum vary in size and shape. Some tend to curl up on the ends and look short. Others fold in the middle and are narrow like a profile of the leaf. In nature, they have a variegated edge and a triangular shape, but in painting they may be stylized.

Chrysanthemum leaves have five sections, a center portion and two areas on each side of it. In the profile, the long vein is for the center portion and alongside it are two short petals. A vein is painted down the center of each portion. The outline can be left plain, or you can paint a wash within the outline.

1. Using a small brush with dark ink held vertically, outline the five parts of a leaf facing you.

2. Paint the vein down the center of each portion.

3. To put a wash, use pale gray ink and carefully paint in one side of the leaf.

4. Use a darker gray ink to paint a wash on the other side of the leaf. Another method is to paint both sides of a leaf light gray and put a darker wash down the center vein.

Facing leaf

5. Outline a profile leaf with parts.

6. Use a pale gray wash on the two top sections.

7. Paint a darker gray wash on the center section seen on the right.

Profile leaf

Painting Boned Flowers and Boned Leaves

This picture has three boned flowers and boned leaves. The composition has a triangle, asymmetry, and open space.

Make the flowers first

1. With a detail brush with dark ink held in a vertical position, start with the circle of dots in the center and outline the full blossom on the upper right.

2. To the left and lower, outline an opening flower.

3. To the right and lower, outline an opening bud.

Add the leaves

1. Near the center, outline a full leaf facing right.

2. Below this leaf and to the left, outline another full leaf.

3. On each side of the center full leaf, outline a profile leaf.

4. Lower and to the right of the center full leaf, outline a profile leaf.

Chrysanthemum has small, vestigial leaves under the flower and along the stem. The stems are outlined to go from under the flowers curving to the bottom. The stems have interruptions where the leaves connect, and they also have bumps and ridges.

Add the stems and vestigial leaves

1. Use the detail brush with dark ink in a vertical position and paint a single line coming from under the top right flower, under the center leaf, and down to the bottom of the page.

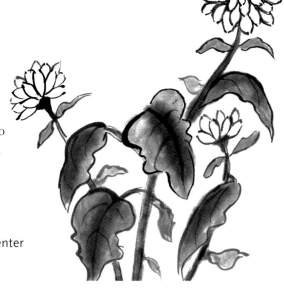

2. Go back to the top and make a second line close to the first line at the top and moving further apart toward the bottom to make the stem thicker there.

3. At the top of the stem under the flower, outline the profile for a vestigial leaf on either side of the stem.

4. Further down the stem, add more outlines of vestigial leaves.

5. Make stems and vestigial leaves for the other two flowers using the same procedure.

The outlined composition with the flowers and outlined leaves can be left that way or light washes can be added. For the flower, make it darker in the center of the petal. The leaves have a center vein where you can put a darker gray to suggest that the leaf folds down in the center. The stem of the plant has dark and light areas due to the leaf joints and vestigial growth. With a detail brush held vertically, add the thin lines to represent the veins of the leaf.

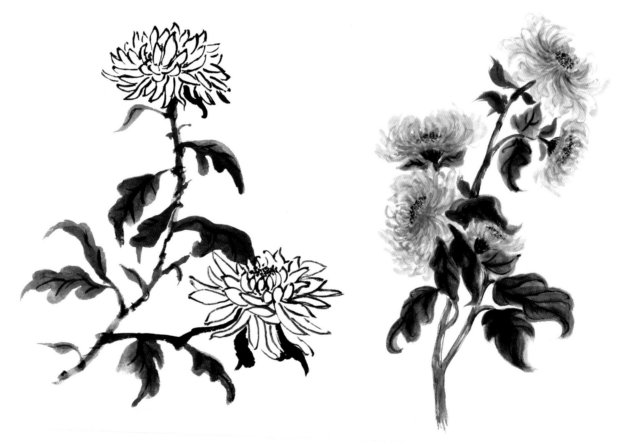

Boned flowers and boneless leaves Boneless flowers and boneless leaves

Boneless Chrysanthemum
The freeform or boneless style can be used to paint several types of chrysanthemum, such as those shown. The popular spider variety is especially dramatic with its curling petals swirling outward from the center. This lesson teaches how to paint spider chrysanthemum.

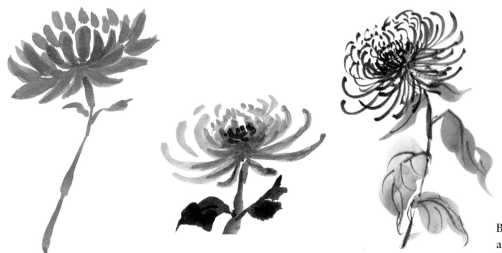

Boneless petals paired with a variety of leaf types

Practicing Boneless Petal Strokes

The petal strokes for spider chrysanthemum resemble the letter C, or sometimes an S for more curly varieties.

1. Using a medium brush in a vertical position with gray ink, make a dot at the outer edge of a petal and then swing and lift the arm to make a curling petal toward the center in the form of a broad C.

2. Make many Cs going from the left to the center and then from the right to the center. Try all sizes. The petals are very long on the outer edges and smaller near the center.

Practicing Boneless Flowers

1. When you feel you can control the size and curl of the C stroke, try making a bud.

 Place a few dots of black where the center of the flower will be. Make a short row of small Cs curving to the dots. This makes the front row of petals. Reload with gray ink and make Cs curving inward from the left to the center and from the right to the center. This makes a back row of an opening bud. Add a few at the top to round up the bud top.

2. Next try an opening flower.

 Make strokes as for the bud with a few dots of dark ink. After the two rows of tight-curled Cs, change to paler ink and add a longer row of Cs curling on the left to the center and curling from the right to the center. Because the flower is opening, add longer Cs at the bottom of the flower coming in below the center and out at the sides.

3. Finally, make a fully-opened flower. The full flower is similar to an opening flower, but it has another row of Cs behind the center group and longer and lower curved petals at the sides and below.

 Make strokes as for the bud with a few dots of dark ink. Put another row of Cs behind the center group. Then make longer and lower curved petals at the sides and below.

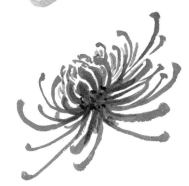

Practicing Boneless Leaves

The boneless leaves are the same shape as those used in the boned chrysanthemum, but they are not outlined. The press-and-lift brush stroke is used to make the leaf sections.

1. To make a full leaf, use a large brush with medium ink held vertically. Press and make a stroke to the left and lift. Make a stroke next to it shorter than the other that curves at the end to the right. This makes one side of the leaf.

2. Load the brush and starting at the top on the right, press and lift to make the center of the full leaf. Make another stroke shorter than the first to the right. To the right, make a shorter stroke that curves to the left.

3. To make a profile leaf, paint a stroke at the top of the leaf representing the first section of the full leaf but rotated slightly to the right. Make the next stroke to the right down slightly shorter. Make the next leaf to the right shorter and curve it under. This represents the center section of a leaf shown in profile.

4. While the leaves are still slightly wet, use a detail brush with dark ink to paint in the veins down the center of each leaf section. The wetter the leaves, the fuzzier the veins will be. The drier the leaves, the sharper the veins will be.

Boneless spider blossoms and boneless leaves

Painting Boneless Flowers and Boneless Leaves

Now you can paint a composition with a bud, an opening flower, a full flower, and leaves. The flowers should make a triangle with different spaces between them. You should have 5–7 leaves, and each leaf should be slightly different in size and shape.

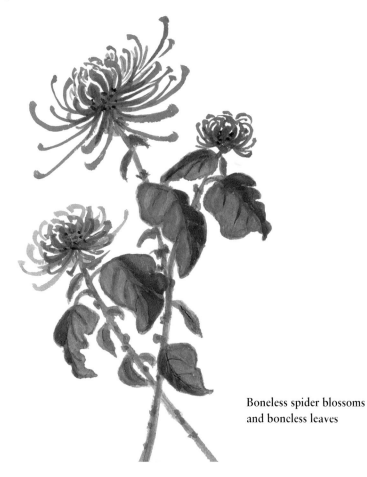

Boneless spider blossoms
and boneless leaves

Paint in the flowers as you have practiced them, starting with the bud. The opening flower should be at a different level from the bud and to the left of it. The full flower should be larger above the others and off center.

Make the flowers first

1. Paint a bud at the right above the center of the page.

2. Paint an opening flower below the bud on the left side of the page.

3. Above and between the bud and opening flower, paint a full flower tilted to the left.

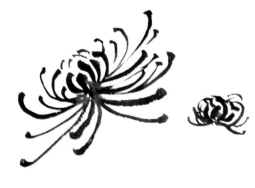

Add the leaves

1. Paint a large full leaf near the center of the page.

2. Make another full leaf above and to the right and another full leaf below and to the left.

3. Add a profile leaf under the bud.

4. Add a profile leaf under the opening flower.

5. Make a profile leaf towards the bottom of the page.

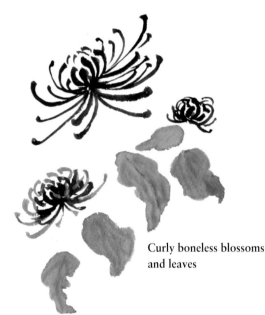

Curly boneless blossoms and leaves

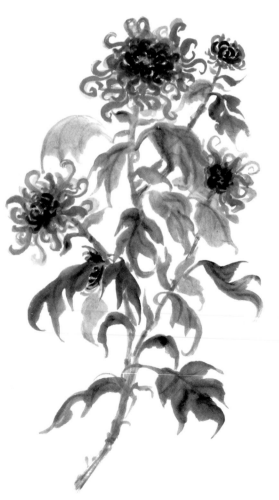

Add the stems and vestigial leaves

1. Using a medium brush with medium dark ink held vertically, stroke under the bud and under the leaf to make a stem to the bottom of the page.

2. Under the full flower, stroke a line under the leaf down to join the stem on the right.

3. Under the opening flower, stroke a separate stem that crosses over the other stem to the bottom of the page.

4. Make small strokes to connect the leaves to the stems.

5. When the flowers are connected with a light stem, add darker vestigial leaves of different sizes along the empty spaces along with dots of darker color to represent the sections of the stalk.

6. The stems of chrysanthemums have ridges where very small leaves come off. Add some dots and lines to represent these leaves.

Painting White Flowers

To paint white flowers, you can use outlines as in boned strokes or else use white paint on a tinted or tea-stained paper, making single stroke petals. The white paint must be thick enough to cover the tint of the paper.

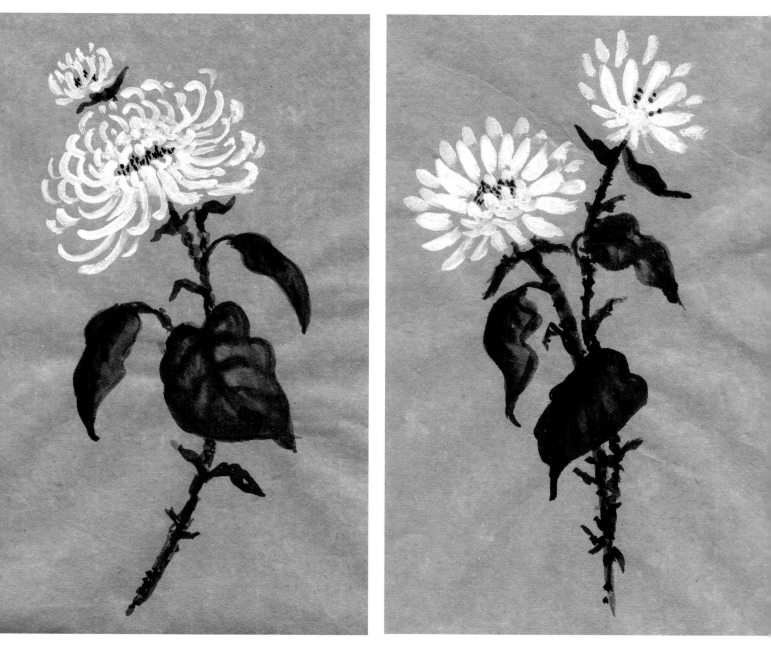

White chrysanthemums on tea-tinted paper

Chapter 7

Painting Pine

Pine is one of the Three Friends of the New Year along with plum blossom and bamboo. Because pine is an evergreen, the Chinese consider it a symbol of longevity, along with fir. Pine is also considered a constant and purposeful friend. It is planted around graves as a symbol of protection. Pine sap is alleged to turn into amber after about 1,000 years. White pine is found only in China and is highly revered. In Japan, black pines are planted near the entrance of the house as a symbol of protection to the house because of its sense of power. Pine takes on a human quality symbolically. It represents ideal human qualities such as longevity, sturdiness, a sense of constancy, and a beneficial influence.

Pine is cultivated as an ornamental plant and for utilitarian purposes. Pine is useful as a building material, for construction of boxes and furniture, and as a source of fuel, which has led to forests being denuded. Pine soot is used in making ink sticks. Pine needles can be used for making baskets, for insulating, and for packaging. Pine cones are decorative, contain seeds that are very tasty, and can also be used for firewood.

Sugar pines grow tall and symmetrical unless branches are broken or stunted.

Black pines are used to create asymmetric garden design trees in Japan. Many Japanese have a black pine near their front entrance. In Oriental painting, asymmetry is thought to be more interesting in trees and in miniature trees as in bonsai. These are trained to create a certain asymmetric arrangement. In a painting, the artist tries to arrange trunks, twigs, and needles to give a related but asymmetric view.

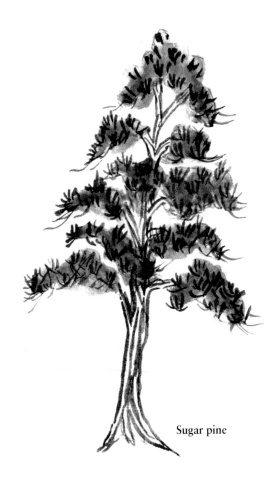

Sugar pine

Bonsai pine

Pine twigs with their clusters of needles sometimes suggest the legs and claws of the dragon and because of the sense of power the tree expresses these are sometimes called young dragon branches.

Some people say they can feel the power of the pine tree's energy when they stand under it. If one leans against or hugs a tree, it is very strong. Because these trees are strong and have this sense of strength, they can weather the storms even when branches have been hit and broken by lightning.

Viewing Pine

Trees tend to grow in a symmetrical way. When a tree is broken, it is usually trimmed to correct the shape of the tree. The branches are cut back to the trunk, which leaves scars. These scars become a feature the artist paints to add interest to a trunk that has few variations to hold the attention of the viewer. Otherwise, the trunks are parallel and bend slightly depending on the direction of the sun.

Some gardeners also shape the other branches of a damaged tree to make use of the handicap in a positive way and to give the silhouette an interesting, asymmetrical shape. Pine is so admired and cared for that in Japan they espalier the branches on horizontal frames so that the tree will grow horizontally and make an arbor type shade tree.

As with plum blossom, painters often show a close-up of a branch hanging down or coming from the side. The modern aesthetic accepts the branch going outside the frame of the painting, the partial view of the subject, and the asymmetrical composition this often creates.

Most of the Oriental painters paint pine in a more natural way, expressing the tall, stately gentleman of character with his branches reaching out in the four cardinal positions of the compass. Within this style, the branches can vary in size and attitude reaching up to the sun or depressed by the heavy clusters of needles and pine cones.

Pine trees are also painted with the branches weighed down with snow. Some times it is a very light clustering of fine flakes sitting on the tip of the needles. At other times, the branches may be weighted down with heavy massed areas of snow.

Pines are many times painted as a silhouette against the moon or sun, which requires the artist to choose an interesting arrangement of the branches and twigs.

Pine in snow

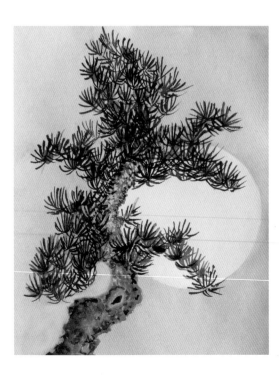

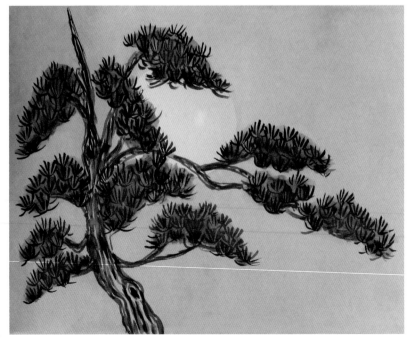

Silhouetted pine puts an interesting arrangement of branches into the "spotlight"

Practicing the Boneless Trunk

The bark of a pine tree is rough and has a scaly appearance that adds interest to the painting, especially when a branch is bent and gnarled.

1. Load the large brush with medium gray ink, dip the tip into dark ink, and tap the brush on the side of the dish to slightly mix the ink colors.

2. Start at the bottom of the trunk above where you will put the scar. Rotate your hand to the right so that most of the brush touches the paper.

3. Make a close zig-zag stroke going back and forth as you move the brush up the trunk and define its curve. The double-loaded brush creates shading on the left and highlights on the right. The choppy stroke creates texture and energy.

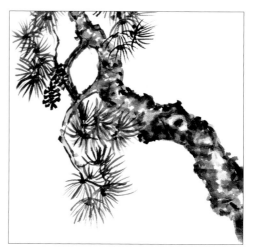

4. While the ink is still slightly damp, load the small brush with a darker ink and use the tip of the brush to outline large areas of bark patches. As the paint is slightly damp, the harsh line should ooze into the back lighter ink color and give the illusion of cracks in the rough bark.

5. Paint the roots below the scar.

6. Add dots along the edge in black with the tip of the brush. These suggest rough, scaly bark in profile or patches of moss or lichen.

Practicing Pine Branches

Some pine branches are large, simple "arms" of the tree. Smaller branches or twigs may cross over each other to add interest and perhaps make an opening called a "Buddha's eye."

1. Load a medium brush with medium dark ink.

2. On a trunk that you have painted, extend some branches to cross over others, making irregular twists and turns.

Deer horn stroke

3. Add some fine line twigs to the branches.

Small branches are sometimes painted using the "deer horn" stroke, which resembles an antler.

Branches with deer horn stroke

Practicing Needle Clusters

Some species of pine have large clusters of needles that hang down like a ballerina's skirt.

Some species have clusters of needles that radiate from a center and grow downward along the end of branches.

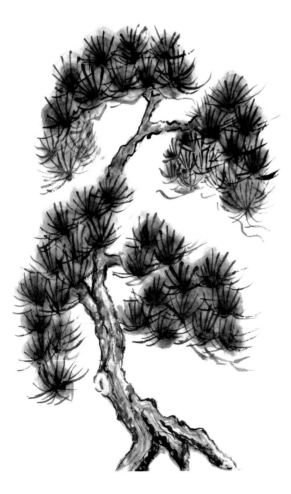

In the species most often painted, the needles grow in the pattern of a half wheel or slightly more. Each wheel overlaps the wheel next to it in a diagonal up or down position. This pattern holds the rows together and creates the effect of clusters.

The needles are more closely clustered on the outer twigs and more sparse as they get to the main trunk. The center of the cluster usually is vertical with the rest of the group fanning outward and even below the halfway mark when there is room and they seem to be falling downward.

Needle wheels are typically painted in asymmetrical clusters along diagonal lines. You can achieve a better composition if you

plan the positions of the half wheels of needles. Often a wash is put behind the needles to help define the shape and density of the clusters on the branches. You can use the wash to plan your needle clusters.

1. Prepare a very pale ink mixture.

2. Bring out one of your practice trunks and plan the positions of the needle wheels.

3. Using a medium brush loaded with pale ink, paint blobs onto the areas where the wheels would be.

When the areas are blocked out and the ink is dry, cover the areas with the half wheels. Paint rows of overlapping half wheels going diagonally upward or downward.

1. Load a detail brush with black ink.

2. Start with the cluster at the top of the tree and make a dot to mark the center of the top half wheel.

3. Hold the brush vertically, start at the left outer edge of the half wheel, and paint a needle by stroking inward to the center. Continue adding needles from left to right, each going into the center of the wheel.

4. Make the next half wheel adjacent to and slightly overlapping the first.

5. Continue to stroke wheels downward in diagonal rows, following the outline of the pale wash behind. Working from the top down to keep your hand from getting in the way as you move allows you to see the pattern better.

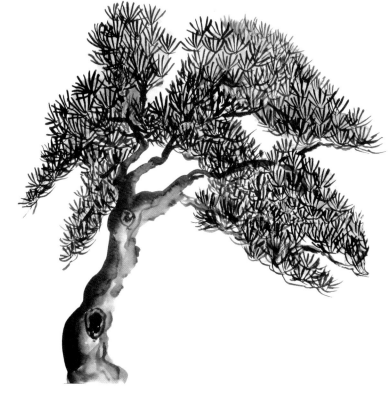

6. Paint additional wheels, allowing space so some clusters on the outer edge are large, and those under the branch are more sparse and have fewer needles and smaller clusters. If you want a larger scale depending on the size of the trunk, paint from the outside inward toward the center of the wheel.

7. When one group is finished, go back and add some extra curving out strokes on the sides and bottom of the cluster to make it appear open and with some needles hanging out.

Pine cones add interest
to branches

Painting Pine Cones

A detailed painting of a tree may also have pine cones hanging from the branch in clusters. Leave a space where two or three pine cones can hang vertically.

A pine cone is made by using the dragged dot stroke used in calligraphy. The main body of the stroke is on the outer edge and the tip drags to the center. If a larger cone is desired, you can put another stroke in the center not dragged as far and it will fill in the vacant space between the outer strokes.

1. Load a medium brush with black ink.

2. Starting with the left outer row at the top, touch the paper with the tip of the brush and drag slightly sideways to the right, making a dot with a tail.

3. Continue making dragged dots for the left outer row. The cone is fatter in the middle, so make the dots closer to the spine as they get to the bottom of the cone.

4. Make dragged dots for the right outer row.

5. Make the inner left row, and then the inner right row.

6. Add dots down the center to join the dots into a cone shape, and add a stem at the top.

7. Add a pale ink wash in the center of the cone to make it look solid.

Painting a Boneless Composition

This boneless pine tree composition uses the techniques for boneless trunk and needle wheels.

Painting the Trunk

1. Double-load the large brush as you did for the boneless trunk exercise.

2. Note that the bottom of the trunk has a scar. Start just above the scar and paint the main part of the trunk using the zig-zag technique. Lift the brush to leave a space for the needles to cross over in front of the trunk.

3. Use only the end of the brush to make the narrow top part of the trunk.

4. Reload the brush with medium dark ink.

5. Holding the brush vertically, make root strokes to the left and right up to and around the scar. Then make the middle root shorter and up and around the right side of the scar. The right root is longer to help balance the left curve of the trunk.

6. Load the detail brush with dark ink.

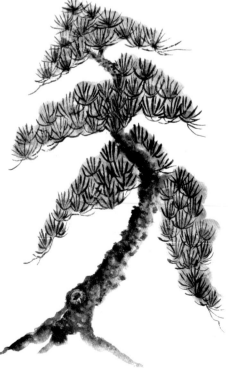

7. Add a black dot in the middle of the scar.

8. Make some moss dots along the outer edge of the trunk. With the tip of the brush make some curved strokes to represent scales.

Painting the Needles
This composition has five large clusters of needles.

1. Use a pale ink mixture to block out the needle areas as in the practice exercise.

2. Let the areas dry before proceeding.

3. Use the detail brush with black ink to paint the clusters of needles in the blocked-out areas, following the method used in the needle exercise. Start at the top of tree and at the top of each cluster and work down diagonally.

4. Add the extra curving needles on the sides and bottoms of clusters.

5. Add branches to attach the top needle cluster to the trunk.

Practicing the Boned Trunk
The boned style uses lines effectively to show the gnarled and textured trunk with bark scales and scars.

1. Load a small brush with medium dark ink.

2. Hold the brush vertically, take a breath, start at the left bottom and make wiggly lines curving to the right and then to the left to one side of the trunk.

3. Reload the brush and continue making lines next to each other following the curved lines you started with.

4. Go back to the root area and mark off three pieces of root with the tip of the brush.

5. Make lines up the right side of the trunk, making sure to leave an open oval area for a scar. Go around the scar and up further.

6. Add lines to make short branches where the clusters of needles will go. Many clusters will overlap the branches, so do not paint in long, detailed branches and twigs until the clusters have been painted.

7. Add more wiggly lines to make bark scales but leave white areas that represent the light on the scales.

8. Load the detail brush with dark ink and outline the scar. If you made it a broad oval, add a dark oval inside it and leave a light rim.

Painting a Boned Composition

This boned pine tree composition uses the techniques for boned trunk and needle wheels.

1. Paint the main part of the trunk using the boned trunk technique, adding the three roots and two scars with dark centers.

2. Paint the main branch that splits off the trunk to the left. Leave the rest of the trunk above that empty until you have painted the clusters of needles.

3. Load a large brush with pale gray ink and make blobs to block out where the large clusters of needles will go.

4. When the washes are dry, load the detail brush with black ink, and paint the wheels in diagonal rows using the technique described in the exercise on painting wheels.

5. When one group is finished, go back and add some extra curving out strokes on the sides and bottom of the cluster to make it appear open and with some needles hanging out.

6. About halfway down, where you left an open space, paint the needles as a cluster in front of the trunk.

7. When all the clusters are painted in, add the branch lines that curve into the large clusters and connect to the trunk. Add wiggly lines to give the branches the same texture as the bark of the trunk.

Planning Your Own Composition

Plan a painting that takes the principles of pine composition into consideration.

1. Plan the trunk and branch composition.

2. Paint the trunk.

3. Plan the positions of the wheels.

4. Use a very pale ink mixture and brush onto the areas where the wheels would be.

5. When the areas are blocked out and the ink is dry, cover the areas with the wheels of needles.

6. Paint the branches and twigs to be visible between the needle clusters.

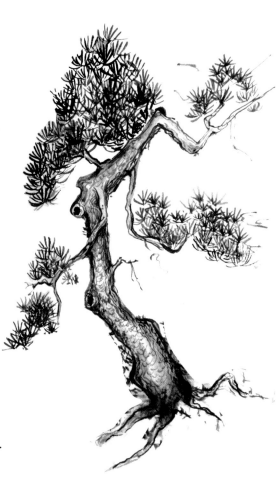

Principles of Pine Composition

- Plan the pine tree in an asymmetric composition that leaves a triangular space somewhere.
- Paint a full tree growing out of the ground, or focus on a detailed branch hanging down from the top or side of the page.
- Make the trunk curve or bend to show its reaction to weathering.
- Make the trunk of a venerable pine gnarled and scarred with roots showing.
- Paint oval scales on a trunk to add bark texture.
- Paint the branches with angles to show structure and attitude.
- Paint a branch or twig crossing over another to create three-dimensional space.
- Follow the principle of asymmetry by using 3, 5, or 7 branches and clusters of needles on twigs.
- The most traditional pine needles are painted in wheels.
- In a detailed painting of a tree, leave a space and then add two or three pine cones hanging vertically from the branch to add interest.

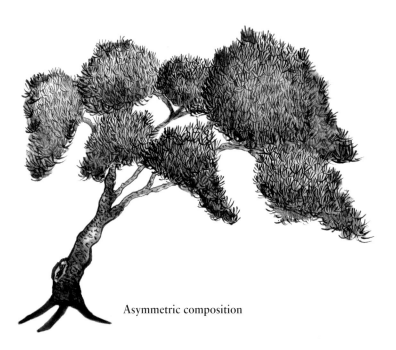

Asymmetric composition

Chapter 8

Painting Orchids

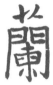 Orchid is one of the Four Gentlemen, along with bamboo, plum blossom, and chrysanthemum. The orchid in Oriental painting is a small, wild grass, not the same orchid we think of in the West. It is like a modest lady, its blossoms hidden in the leaves reaching up toward the sun, each in a different stage of development. The fragrance is delicate and suggests a lady of noble purity and virtue. The long leaves are elegant and aesthetically pleasing, making it a popular subject for painters. The plant grows wild in the rocks and along the banks of streams, and the leaves hang over the water. The graceful dancing and the lyrical expression of an inner spirit in the plant caught the attention of the Japanese monks, who brought samples of old masters' paintings of orchid back to Japan.

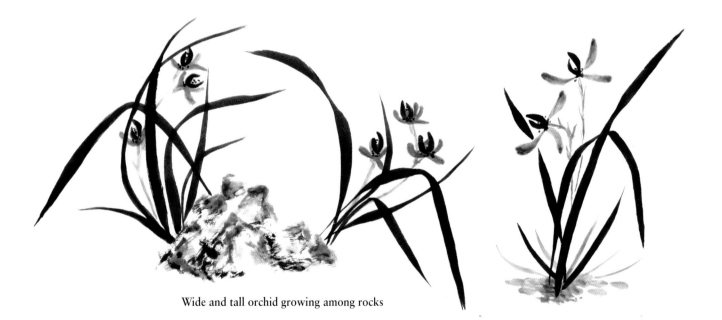

Wide and tall orchid growing among rocks

Types of Orchids

The artist never paints the visually true version of any plant in Chinese painting but always the essence, the composite of the generic plant. However, two kinds of generic wild orchids are popular among painters. The Lan or Ran orchid has one blossom per stem while the Hui has multiple blossoms on a stem.

The various strokes used for the boneless orchid are the same strokes used for bamboo and other plants. You can also paint orchid in the boned style.

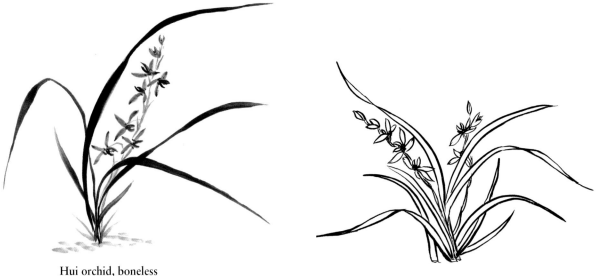

Hui orchid, boneless

Hui orchid, boned

The orchid blossom is usually nestled among the leaves of the wild grass. All of the leaves and stems come up from the root area spreading leaves to the right and to the left. Between these leaves the blossoms are placed. The flower has five petals. Two are small dark commas, and three are longer and paler. All of the petals meet at the center or heart of the blossom. The placing of the comma pairs up or down determines where the petals will be placed. The orchid blossoms should fill the space between the leaves in a pleasing manner, without looking too crowded. Sometimes blossoms are oriented vertically in relation to the leaves, while in other cases the blossoms follow the horizontal orientation of the leaves. Sense the leaves reaching outward while protecting the flowers in the center of the plant.

Principles for Arranging Boneless Leaves

- Use an odd number of leaves, such as five or seven, and plan where flowers could fit between them. Allow for an odd number of flowers between the leaves, such as three flowers or two flowers and a bud. Some teachers say to paint the flowers first and then add leaves. However, for beginners, it is much easier to place the leaves correctly in the design first and then add flowers.

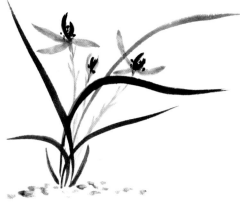

Lan orchid, boneless

- Make each leaf different in size and direction. One of the leaves should be longer and stronger as a main leaf. The first leaf sets the shape of the root in relation to the other leaves nestled around it. Smaller leaves can be made more curved.
- Make some of the leaves bend or twist, but limit the amount of twisting. Avoid having parallel leaves or equal spaces.
- Paint the dominant leaf first with the rich black ink and then paint the rest of the leaves with the same brush full of ink. Then each leaf will have a slightly paler ink tone as the ink runs out.
- Alternate leaves so that some go to the left and others go to the right.
- Make at least one leaf cross over another to create a visible but not too large opening between the leaves, a Buddha's eye.

Practicing Boneless Orchid Leaves

Painting orchid leaves offers the artist a unique opportunity to express qi energy. The leaves can be graceful and beautiful when made with fluid arm and elbow motion and variations of pressure on the brush.

Practicing curves: left curves, and right curves

This exercise helps you to control the long arm sweeps needed to guide the composition and placement of leaves in painting boneless orchid. These strokes need strong qi energy behind them to sustain the continuous flow. Before you start a stroke, take a breath, and then start letting out the breath towards the end of the stroke. As a shortcut, we use the notation "TAB" for "Take A Breath" and "LOB" for "Let Out the Breath" to remind you about the breath.

1. Lay out a piece of newsprint horizontally and load a medium-sized brush.

2. TAB, make an arc across the paper by swinging your arm and elbow from the lower left to the upper right with steady pressure. Gradually lift the brush and LOB as you taper the line to a point at the end. Keep the tip of the brush in the center of the stroke as you drag the brush upward opposite the tip of the brush. When done correctly, the arm and body movement upward with the brush provides a pleasing kinesthetic sensation.

3. TAB, make another arc next to the first one keeping the lines an equal distance apart from each other, and LOB as you finish the stroke.

4. TAB, make a bending arc by gradually lifting the brush at the top of the curve and then swing the arm downward and LOB as you taper the line to a point.

5. Continue to make arcs bending more and more until you run out of space.

6. Next, try stroking from the right lower corner to the left top of the paper. Hold the elbow and arm firmly but relaxed.

7. Make more arcs from the lower right corner, keeping the lines some distance apart.

8. To make a twisting leaf, you use a press-and-lift, press-and-lift technique that makes the leaves thick and thin, as if twisting. TAB, press to make an arc and gradually lift to narrow the line, then press again to make a thicker line, and then lift and LOB to end the line in a point. Sometimes the line is broken with a space at the twisting point, especially if it crosses under another leaf. Nevertheless, the leaf should be done in one action with a single breath.

Twisting leaves

Buddha's eye

Practicing Boneless Blossoms

1. Make a puddle of gray ink in a dilution dish.

2. To make a bud, load the medium brush with gray and tap the side of the brush against a paper towel to remove excess moisture.

3. Hold the brush vertically and touch only the tip to the ink in the ink stone. Touch the tip to the towel to remove excess ink.

4. Holding the brush in a vertical position, with the arm up in good position, touch the dark tip of the brush to the paper, then quickly lay down the side of the brush to make the left gray part of the bud.

5. Similarly, lay down the side of the brush to the right of the first stroke to make the right gray part of the bud.

6. Practice this technique of double-loading the brush, touching the tip, and laying down the side of the brush.

7. Make a slightly opening bud by making the two gray strokes apart at the top.

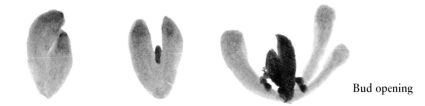

Bud opening

8. Load the tip of the detail brush with black ink and add the tiny black central petal between the two bud parts.

In painting the whole blossom, you start with the two dark center petals, which are small and curve in on each other like commas, and then add the outer petals.

1. Load the medium brush with rich black ink.

2. Hold the brush in a vertical position and then press it down and curve it for each central petal, as if making two commas facing each other with a slight separation.

3. Wash the brush. Load it with a gray mixture, touch the tip in rich black ink, and tap off the excess.

4. Plan in which directions the petals will face, referring to the variations shown. Notice that at certain angles, one petal coming forward or going back is fore-shortened.

5. Stroke one petal from the outer edge of the petal, pressing the brush down and then lifting it up to make a thin line that connects the petal to the bottom of the dark center petals.

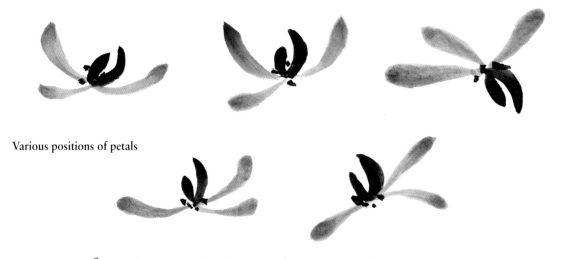

Various positions of petals

6. Stroke a second petal coming from a second direction.

The Heart

7. Stroke a third petal coming from a third direction.

8. Practice the heart used to represent the stamens, so-called because it is based on the character for "heart." Add the heart so that the dots show around the dark center of your blossom.

9. Load the detail brush with gray ink. For some of your practice blossoms, paint the stems coming down from the base of the heart as long curves alternating right and left down to the root. Paint a stroke beneath a petal to represent the sheath that has come off the bud.

Painting Boneless Orchid

This horizontal composition has three blossoms, a Buddha eye, twisted leaves, bent leaves, and long curves. All of the leaves come from one root area at the bottom off center. After practicing the curves for the leaves using the press and lift to make the leaf thin and thick, plan where each stroke will be placed similar to the picture.

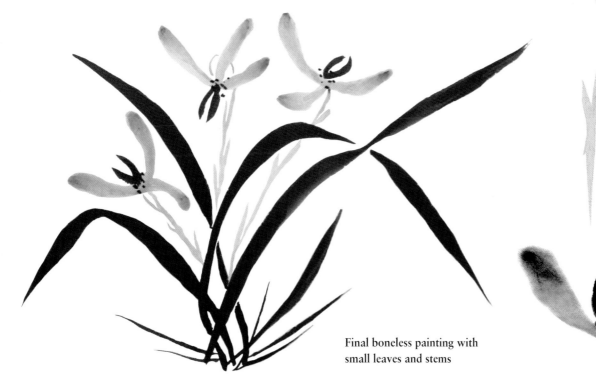

Stem

Final boneless painting with small leaves and stems

Sheath and stem

Planning the Leaves

1. The dominant leaf goes from the root thick and thin, then up high to the right.

2. The next leaf goes up right and crosses under the dominant leaf before it descends.

3. The third leaf is thin and then thick to the left upwards.

4. The fourth leaf rises up and left from the root, then curves downward to the left.

5. The fifth leaf is a short one that curves upward on the right.

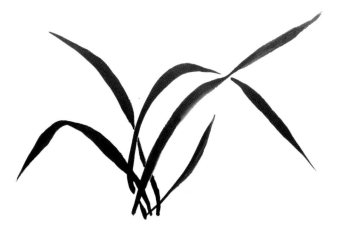

Painting the Leaves

1. Use the large brush vertically loaded with dark ink. TAB, swing the arm and body to make a press and lift stroke to the right and upward. LOB

2. Reload the brush, TAB, start at the bottom, swing arm up and press and lift, cross under the previous leaf and go to the lower right corner, press and lift. LOB

3. Reload the brush, TAB, go behind the other two leaves slightly, press and lift to a point toward the upper left corner. LOB

4. Reload the brush, TAB, from the root swing a short stroke up on the right and press and lift. LOB

5. Reload the brush, start at the bottom, TAB, to the left gradually press and lift quickly, make a thin line, turn arm and brush downward to left corner, press and lift to a point. LOB

6. To help stabilize the root area, you can add several small strokes coming out to the right and to the left.

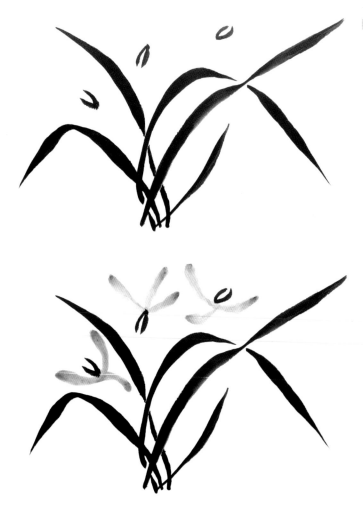

Painting the Blossoms

1. Use a medium brush loaded with dark mix and hold it vertically. Make the three pairs of dark petals in the positions shown where the blossoms will be painted.

2. Load the brush with gray ink and dip the tip only into dark mix. Press the brush down where the outer tip of a petal will be and drag it lightly lifting to make a thin line meeting the heart.

3. Reload the brush with gray and dip the tip in the dark mix again. Paint the second petal of the same blossom.

4. Reload the brush as before to paint the third petal of the blossom. Note that the third petal should not be the same. One petal is longer, and each petal should come to the heart from a different direction.

5. Reload the brush repeatedly to paint each petal of the second and third blossoms.

6. Add the heart dots around the base of the commas and inside.

7. Add several small leaves to help balance the cluster.

8. Load the detail brush with gray ink. Paint the stems coming down from the base of the heart as long curves alternating right and left down to the root.

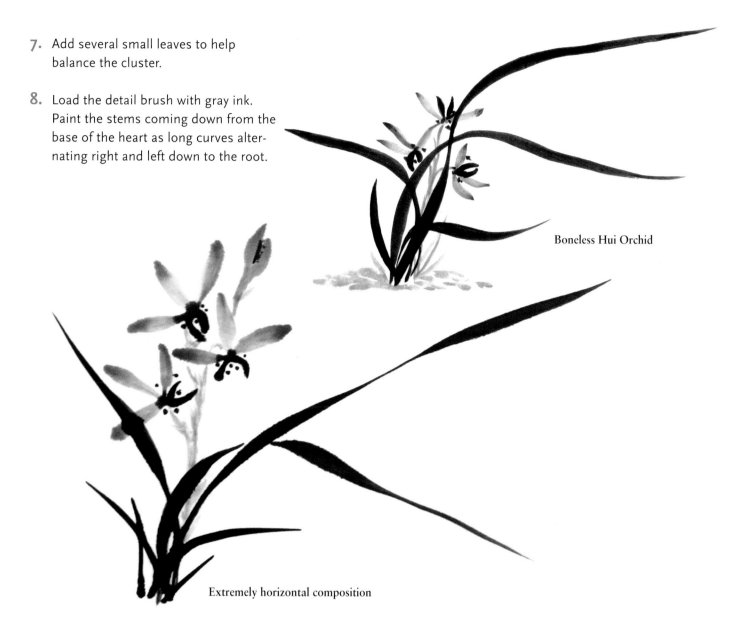

Boneless Hui Orchid

Extremely horizontal composition

Practicing Boned Orchid Leaves

Boned leaves require making long strokes with the detail brush and outlining the twists and turns of the leaves realistically.

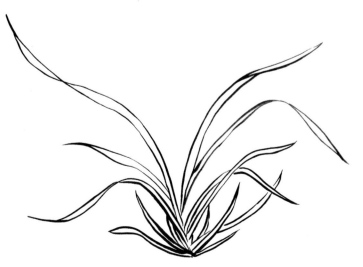

1. Use a detail brush with black ink held vertically. Start with a simple leaf. TAB, swing your arm, and paint a single line at the left side of the leaf curving up and to the right. LOB

2. TAB, start at the bottom of the first line leaving small space between and make a parallel line going up to the right and let the space become narrower as the two lines meet at the tip. LOB

3. To make a bending leaf, make one line up and to the right and then bending down. Make the second line parallel and then narrowing at the bend point and then broadening out and narrowing again at the tip.

4. To make a twisting leaf, paint one of the two lines crossing over the other at the twist.

5. Another type of twisting leaf has a third line that represents the edge of the leaf bent toward you. Paint the longer leaf line and the parallel line up until the twist point. Then add the third line crossing between the two lines and meeting the longer line at the tip.

6. Leaves in the boned style can also be broader with veins and sometimes gray coloring. Try making a broad, twisting leaf. Then add veins. When the dark ink is dry, add a gray wash inside the outlines.

Principles for Painting Orchid Blossoms

- Paint five petals on an orchid blossom. Make two of the petals vertical and darker than the others.
- Make the three outer petals extend out from the base of the two upper dark ones. The outer petals have a character of their own. Some artists paint them with less variation than others, but the most beautiful and graceful ones are painted with a dark tip.
- In the center of the flower, paint stylized stamens with the dots that make the calligraphic character for the word "heart."
- On the stem below an opening blossom, paint the sheath that once covered the bud.

Practicing Boned Orchid Blossoms

Boned orchid blossoms have pointed tips that give them a slightly different shape from boneless blossoms. The opened petals have gray lines to suggest their fibrous nature. The petals of the blossom are painted differently depending on the stage of development and the angle of the blossom in a painting.

1. The bud is like a pod made with two lines. Use the detail brush with medium dark ink. Start from the top and make a curved line on each side to make a vertical oval. Add vertical line down the center and lines on alternating sides to make a short stem.

2. For the opening bud, paint the two black comma strokes to make the dark petals in the center. For the two top petals, which are nearly vertical in this case, paint two curved lines from the tops towards the center. Add a smaller, foreshortened petal at the lower right. Add the heart strokes. Use the detail brush with medium gray ink to paint the stem lines and the veins on the petals.

3. In the more fully opened blossom tilted slightly to the right, the right and front leaves are foreshortened.

4. A blossom can have the black petals facing downwards, and the back petal is foreshortened.

5. A blossom can be tilting forward so that the black petals are tilted and the back petal is vertical.

6. A fully opened blossom with horizontal petals towards the front has a foreshortened back petal.

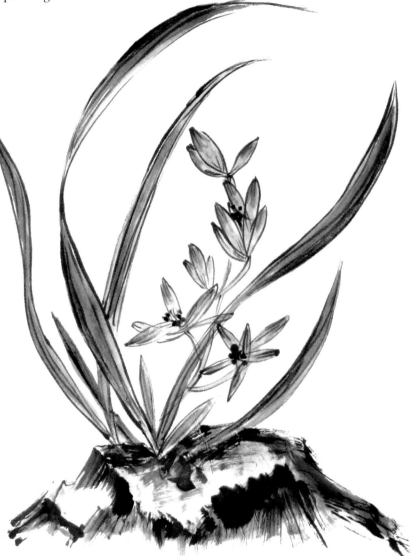

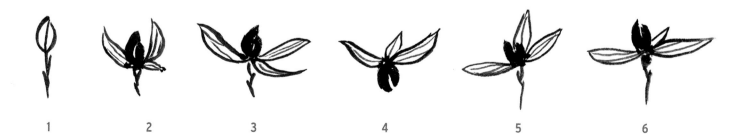

1 2 3 4 5 6

Painting Boned Orchid

The Hui orchid has blossoms along the stalk. This is different from the Lan orchid, which has a stem for each blossom. The composition of this orchid is triangular and has seven leaves, five blossoms, a small Buddha's eye twisted, and straight leaves.

Painting the Leaves

1. Use a small brush vertically loaded with dark ink to outline the large center leaf. TAB, swing arm, and make a stroke up to where the leaf twists. Stop, reload, and continue the curve to a point. LOB

2. Reload TAB and stroke the right side of the leaf. Stop at the twist and reload. Continue the curve to a point. LOB

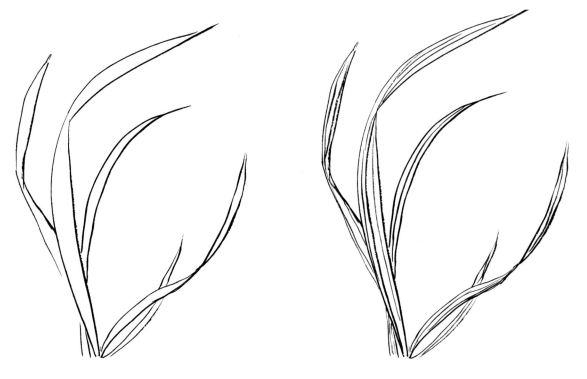

3. Start at the bottom. Make two parallel strokes from the bottom behind the large leaf. Reload the brush and start on the edge of the large leaf and make a curved line under the large leaf. Go back and add the right side brush stroke so they come to a point.

4. To the left of these two leaves, start a stroke from behind the large leaf up and to the right a short distance, curve upward and slightly to the right. Go back to the side of the large leaf and stroke a line narrowing to the left line and then curving up wider to the right making a point.

5. Plan a leaf position for the far right corner in such a position that there will be space for the stem of blossoms. This leaf starts at the bottom, curves to the right, and at an angle upward to the right. Go back to the bottom and make the right side of the leaf, widening it slightly, and then narrow where there will be a twist. On the other side of the twist, widen the leaf and taper it to a point.

6. Plan how a small curved leaf can cross behind the far right leaf and outline each side. On the far left coming off the center cluster make a small curved up and to the left leaf outlined.

7. When the leaves are completed, go back and with a detail brush stroke in some fine lines to represent the veins in the leaves.

8. The leaves can be left outlined only, or they can have a light wash to the center of the leaf.

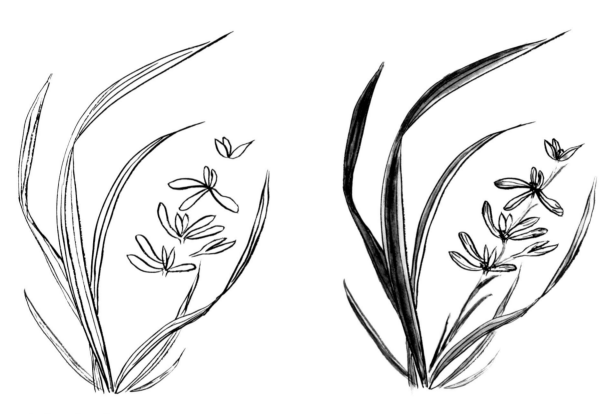

Painting the Blossoms

Hui blossoms grow on one stem. There is usually a bud at the top and the blossoms attach along the stem downward.

1. With the detail brush and dark ink mix, start with two very small strokes to represent the small petals in the center of the opening bud. Then place two lines coming from the center bottom up to make a point. Make another pair of lines to make the right petal. Behind these and to the side of the small center petal make another petal. These three small petals make an opening bud.

2. The next lower blossom on the stem has two larger outlined comma-like strokes that meet at the center heart area. From this center, using a detail brush vertically outline a large petal on the left. Make one down and slightly to the left and then one to the right downward. Work from the left to the right petal so your hand will not smudge the strokes.

3. Change the direction of the petals on the next blossom down and make each a different size.

4. Imagine a stem that will hold these blossoms and that there is another bud coming off the main stem. This will have two petals barely separated without the center comma.

5. The next blossom on the stem moves more to the left suggesting the stem will come up from the root area slightly angled to the right. Paint in the two comma strokes first and then add the petals on the left and a smaller one on the right.

6. With the detail brush, make a thin line of middle gray ink from the bottom of the bud downward and add a line for the sheath that surrounds the petal before it opens. Make this double lined as it runs into the next blossom below.

7. The doubled-line stem has a sheath also before it runs into the next lower blossom. Add the stem under it and a stem to the bud on the right. Continue the stem outlines from the bottom of the blossom to the bottom making some leaf strokes to show the stem emerges from the leaves at the root area.

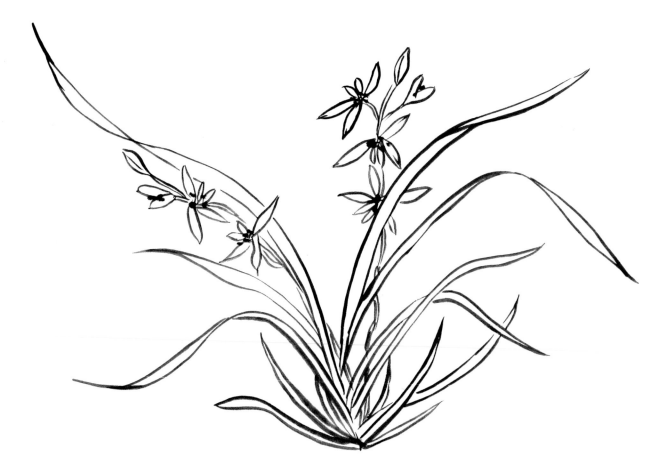

8. The petals have veins and these can be painted in carefully with a detail brush and middle dark mix.

9. The petals can be left outlined or a light wash can be added. If the wash is added, darken the center commas.

Guidelines for Painting in the Boned Style

- You can add veins in the leaves and eliminate the veins in the flowers or have veins in both leaves and flowers.
- You can paint the details in a light color and then fill in the areas with values of gray ink.
- Since you cannot draw with pencil on rice paper, you learn to draw with the brush, using variations made by the changes in pressure on the brush to give different thicknesses of line. Even thickness of line is boring, so you want to use very thin lines and then broaden some, usually on the curves, or add a twist, to give more interest.
- You can use the boned style for both Lan and Hui types of orchid.

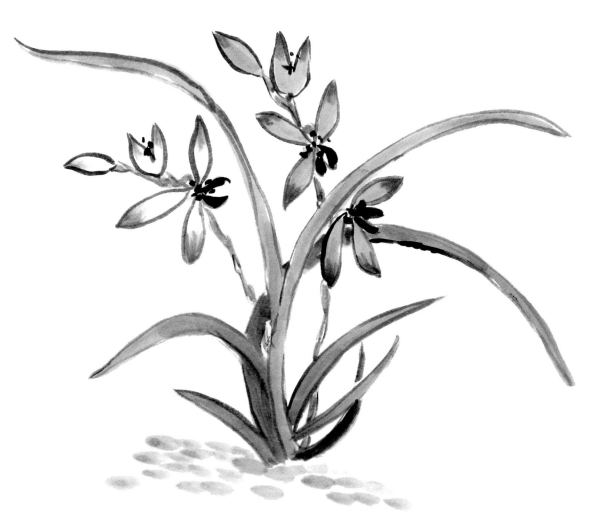

Chapter 9

Painting Plum Blossoms

Plum is considered the national flower of China. The blossom has five petals, which could represent the five Chinas: 1) Chinese, 2) Manchu, 3) Tibetans, 4) Mohammedans, and 5) Mongolians.

Since the buds of plum trees bloom in winter, plum blossom is considered one of the Three Friends of the New Year, along with bamboo and pine. The trunk of the tree is gnarled and cracked and looks almost dead. When the blossoms appear, you see the tree is alive even though no leaves appear until the blossoms are almost gone. This continuity and reemergence of life suggests longevity. The plum tree is like a person surviving the severe elements of winter, one who stands tall and firm, rugged and unbreakable. The purity of the white blossoms also makes the plum tree like a man of character.

The very delicate blossoms range from white, to pale pink (the most popular variation), to dark pink, to red, depending on the particular species. The fragrance is delicate but delightful, especially during the winter days when the scent fills the air. The tree has a tiny fruit, and its seed is used for medicinal purposes. The top part of the character for plum blossom character is the radical for "tree" and the lower part distinguishes the tree as a plum tree.

Composition and Structure

In painting plum, the blossoms and arranging the composition are most important. For this reason, the artist rarely paints a whole tree. Compared in size to a whole tree, the blossoms would be very small, and you would lose the unique proportions of the fragrant flowers overshadowed by the huge tree. The scale of the branches and the flowers should be relative to each other.

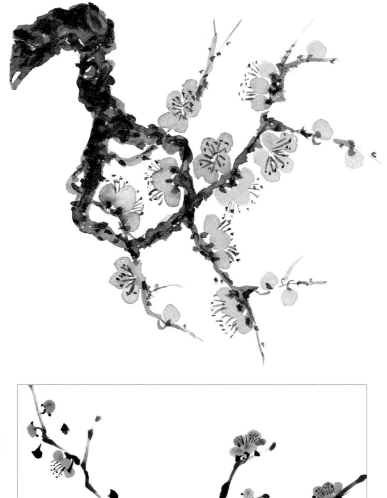

The winter-blooming plum has delicate blossoms that range from white to red

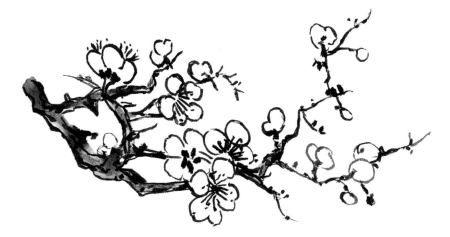

Scale of branches and blossoms

The artist usually paints only two or three small branches with their twigs and blossoms. To suggest the three dimensions of the tree growth, a main branch goes in one direction with a smaller one in the opposite or back direction. The positioning suggests that the tree grows normally with branches and twigs going out in all four compass directions.

The roots vary depending on the location of the tree. Some trees near water have roots reaching out to the water. On a cliff, the roots wrap around rocks and other roots to hold the plant to the cliff. These roots may be very rugged and strong, while a tree in a lush garden might have more delicate roots spreading out around the perimeter of the tree.

The trunk or trunks grow up from the roots and are the oldest part of the tree. Weather-worn and gnarled branches with cracks and moss dots suggest an old tree. Usually one or two trunks come from the roots, and from these trunks branches reach out in different directions. Because this tree grows through severe weather, it often has broken or bent branches by the time it gets old.

The branches usually have some crossing over of twigs that cut back on the branch and make an interesting arrangement of these parts. The younger branches and twigs have straighter and smoother surfaces than the weather-worn older branches. The tree grows out in all four directions to give the tree balance, but when branches are broken or dwarfed, the tree loses its symmetry. This asymmetry lends itself to more variety in painting twigs and blossoms. Where the branches and twigs grow out from the older portions of the tree, knots of various sizes add interest to a long, uninteresting branch. It is desirable to have at least one crossover of a branch to create an angular "eye."

To understand the plum tree, look at the tree in nature and compare the gnarled and cracked trunks to the smoother, smaller twigs. The contrast is painted into the plant even though it may have only one small branch or twig. The contrast is necessary in identifying the tree. Usually, the buds do not grow on the trunks or large branches but on the twigs of the small branches. Only rarely does a bud appear out near the tip of a twig. Most of the blossoms appear near the middle section of a twig. These blossoms are attached to the twig by a stem with a calyx at the bottom of the blossom. Sometimes groups of two and three blossoms are attached to the twig in the same area, giving the effect of a large cluster of blossoms. Actually, however, each blossom is independent of the others.

Cross-over branches and angular eyes

Rough old branches with smooth young branches

The blossoms have five petals unless one is broken or deformed. The petals form a circle in the center of which is a cluster of stamens with small dots of pollen. The blossoms face in all directions, so you can paint a head-on view, a profile, the back of a blossom, a downward facing blossom, or an upward facing one. Painting the blossoms in every way gives great variety to the shapes.

In a head-on view, you see the circles of stamens and an irregular row of dots. In one profile position, you may not see any stamens. In another profile, the stamens show over the edge of the petal. For this reason, you learn to paint each position with the proper orientation of the stamens. The stamens and the pollen dots are painted with dark ink. The pollen dots are not painted in a row even though you may see them close to that in viewing the blossom. Tradition dictates that they alternate one up and one down to give a fluttering area of dots rather than a more solid row. Here again, composition is important in painting plum. You learn composition by observing those of the old masters as well as the formulas for placing objects in a format. It is most acceptable to copy the old masters.

In painting plum and in pine, painters commonly hang a branch or twigs from the top of the page suggesting an extension of the tree hanging down. This approach leaves a negative space in the bottom corner of the composition. The gentlemen painters, the literati in southern China, used devices

like this in their free-formed, boneless style of painting, suggesting only a portion of a large subject. In Oriental painting, the artist does not paint real life but only the spirit of the subject. This is a form of abstraction, and the portions not defined leave questions for the imagination to dwell on. The artist suggests and does not show it all.

It is important to do the suggested exercises not only to learn the order of the strokes but the angle of the brush, the pressure on the brush, and the ups and downs to vary the width of the twigs. Remember that you cannot erase or correct strokes on rice paper so it is important to practice on newsprint several times to be able to make the correct strokes before going to rice paper for your final composition.

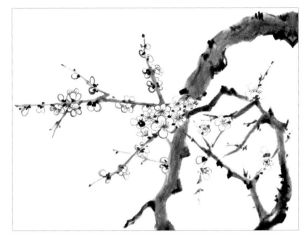

Abstract composition

Practicing Boned Branches

Use a dark ink mix to give the appearance of boned or outlined style.

1. Use the detail brush vertically with dark ink. Start at the bottom of the page or the side where the main branch enters the page.

2. Press and lift the tip of brush to make a variable line that is thick and thin. Make a single line up one side of the branch. Plan where the branch will turn and become a smaller branch and another smaller twig.

3. Reload the brush and make the other side of the branch, curving it to make split-off smaller branches. Add more lines for single twigs.

4. Add a branch coming off the main branch at the bottom. Let it cross behind to the right and up.

5. Make a smaller branch and let it cross behind to the left.

6. Add some small lines in the middle to make the main branch look more gnarled.

7. Make a scar like an oval with a dark center at the curve of the main branch at the bottom.

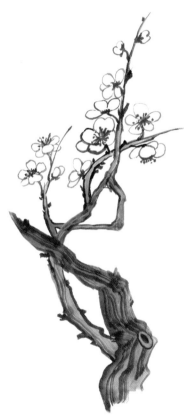

Practicing Boned Blossoms

Each blossom is made up of five petals seen in different positions or a single petal representing the bud.

1. With the detail brush held vertically and dark ink, swing the arm and body to make a small circle. Do not use the fingers. Start at the side and swing the arm up and around to meet the beginning stroke. Practice this many times. This single circle represents a bud.

2. Try making three circles touching. This is a profile.

Various positions of petals

Various positions of petals

3. Using the detail brush vertically with dark ink, make a head-on view of a blossom by putting five circles next to each other, leaving a circle of space in the center. The head-on view of the five-petal blossom does not show the calyx unless it is viewed from behind and then all five will show.

4. Make five circles arranged so that three are in the front and two smaller ones are behind. Try another profile position with three behind and two in the front.

5. The bud connects to the twig with a calyx, which is made with a dragged dot. The profile petals can have the dragged dot at the bottom, which connects them to the twig.

6. The center of the cluster has 24 stamens radiating out from it, but painting eight to twelve looks less cluttered. These are made with dark ink as thin lines. On the end of the stamens the pollen is shown as a single dot. The pollen dots are not in rows but alternate up and down.

7. Because the blossoms in nature are usually white or pale pink, you can leave the blossoms colorless or you can add a pale gray to the petals.

Painting Boned Plum Blossom

Notice in this composition that the branches and twigs makes triangles and leave large, open, triangular spaces. Some branches cross over. You can leave the whole composition in outline form or add lines, moss dots, and a wash to the branch. Do not cover the lines completely. Allow the texture to show.

Painting the Branch

1. Start with the detail brush held vertically and loaded with dark ink. Press and lift at the widest part of the main branch where it comes off the bottom of the page. Make a single line defining one side of the branch.

2. Reload and make another line for the other side of the branch. Allow a line or two to curve out to become smaller branches and twigs.

3. Make the curved branch up from the main branch to the left. Add the other side to that branch.

4. Make a small branch crossing behind the curved branch.

5. Add lines in the middle of the trunk of the main branch to make it look old and gnarled. Make a circle to represent a scar with a dark center.

Painting the Blossoms

Look at the branch arrangements and plan where the blossoms might fit. Where the main branch comes off the tree it is usually old and gnarled and does not have blossoms. The middle branch has most of the blossoms, and the twigs towards the end have a few single buds. The buds do not grow on the end of the twigs.

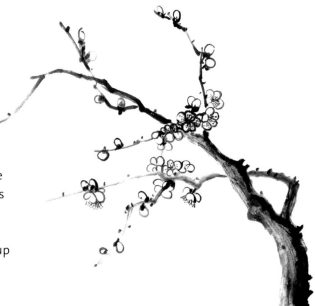

1. Use the detail brush vertically. Load with dark ink and paint five circles touching each other near the center of each branch. This makes a full blossom. Make several of these.

2. Out along the twig add three circles in profile and another group on the other side along the twig.

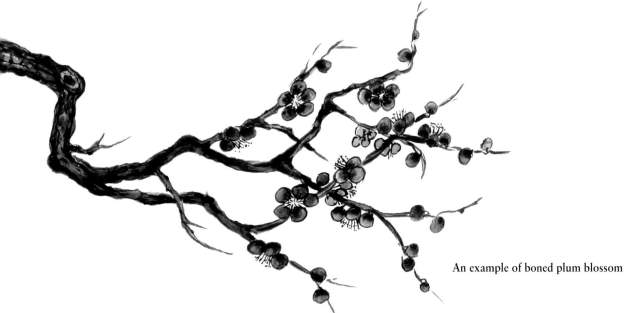

An example of boned plum blossom

3. On other small branches make five circles. Make two in front and three behind. Then try a place where you can put three in front and two behind. This shows the blossom tilted forward.

4. Near the end of the twigs place a single circle for a bud. Do not put it on the end.

5. Use the detail brush vertically with dark ink and carefully make small lines for the stamens radiating out from the circle of five petals. Near the ends add the pollen dots alternating up and down so they are not in a row.

6. Look at the diagrams and see where the stamens come off the profile centers and add only a few pollen dots.

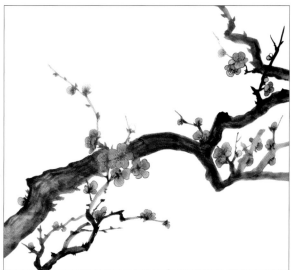

The bud is connected to the twig with a calyx made by using a dragged dot. The bottom of the profile clusters will have a calyx on each petal. The full blown blossom has the calyx at the back. Some types of plum blossoms have colors. You can tint the blossoms in a painting with a light gray wash to represent color.

Practicing Boneless Branches

1. Use the large brush with medium light ink. Squeeze out the tip and dip it into dark ink. Rotate the hand to the right and lay the whole brush down on the page at the top left.

2. Press and lift and zig and zag slightly as you move the brush to the right and turn down to the left lifting the brush slightly to make it thinner. Curve right and up using the tip of the brush.

3. Go back to the main branch at the right and zig-zag down to the left crossing the first branch and lift to make a thinner twig.

4. With a medium brush with medium ink add extensions and small twigs as you press and lift the brush.

5. Add dots on the edge of the bark to suggest gnarling.

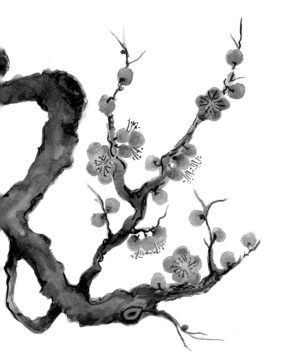

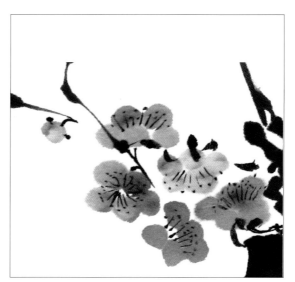

Examples of boneless blossoms

Practicing Boneless Blossoms

Look at the examples on this page to see how petals are arranged for a head-on view, a profile, and bud shapes.

1. Use the medium brush vertically with pale ink. Swing your arm from left to right to make a circular dot. This is a bud.

2. Make five circles touching to make a head-on blossom.

3. Try shifting the circles to make a head-on blossom at a slight angle.

4. Make a profile view with two petals in front and three behind.

5. Make a profile view with three petals in front and two behind. With the detail brush held vertically with dark ink add a calyx by making a dragged dot.

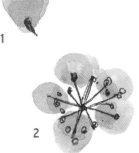

6. To make an opening bud, make a center petal and then add two half side petals.

7. To make a more fully opened bud, make a center petal with two fully opened side petals.

8. The stamens radiate out from the head-on position leaving an open circle in the center. The pollen dots alternate above the stamens. Paint in the stamens and then add the pollen dots above them.

9. Usually three stamens show between the petals in the profile positions. Add stamens and pollen dots for the profile views.

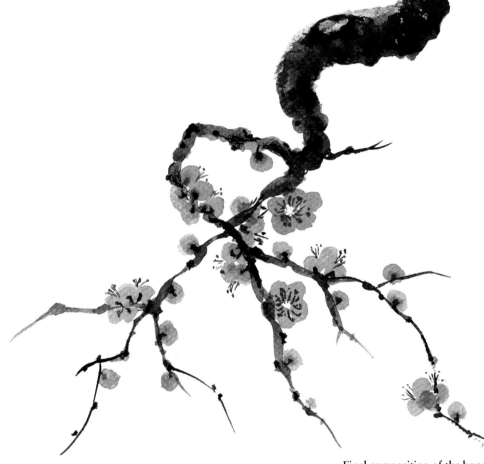

Final composition of the boneless plum blossom

Painting Boneless Plum Blossom

Painting the Branch

Paint the branch in the composition above using the same technique as in the branch practice. Outline a scar at the bend and add a dark center.

Painting the Blossoms

1. Use a medium brush vertically, and loaded with pale ink. Start near the crossover area and add a few clusters of petals in groups of three or five depending on the space.

2. Below add five-petal full blossoms clustered close together.

3. Further out on the twig add profile clusters of three petals.

4. Where the twig gets smaller attach some buds. Do not add the single petal bud to the end of a twig.

5. With a detail brush and dark ink make the dragged dot calyx on the sides of the buds where they attach to the twig. Also add thin stamen strokes according to the profile position. Usually add three stamens with the pollen dots placed above.

6. Look at the overall composition and add small twigs. Add moss dots on branches.

Painting Boneless Plum Blossom on Tea Paper

The brownish, tea-tinted paper makes an effective background on which to paint boneless plum blossoms with Chinese white watercolor paint.

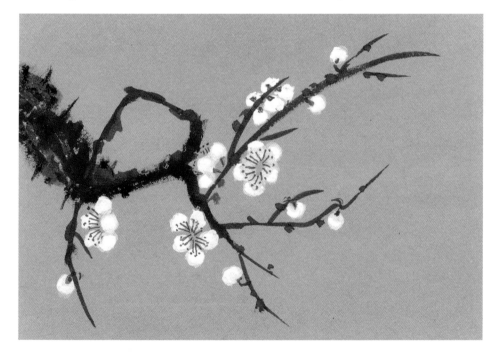

1. Use black ink and a medium brush to make a gnarled and irregular trunk area. Add small branches coming off the main trunk. Cross one branch behind at an angle.

2. Make a thick mix of Chinese white watercolor from a tube. Use a medium brush well-loaded with white, hold it vertically, and twirl the brush to make a single rounded petal near the ends of some twigs.

3. Near the center of the trunk, plan to group full five-petal blossoms and some three-petal blossoms facing back and then paint the blossoms.

4. When the paint is dry, use the detail brush loaded with black ink to paint the stamens radiating out from the centers of the flowers. Put pollen dots near the ends, alternating in and out so they are not in a row.

5. Use the detail brush vertically to make a small dragged dot for the black calyx that connects the single buds and three-petal blossoms to the twig.

Principles for Painting Plum Blossom

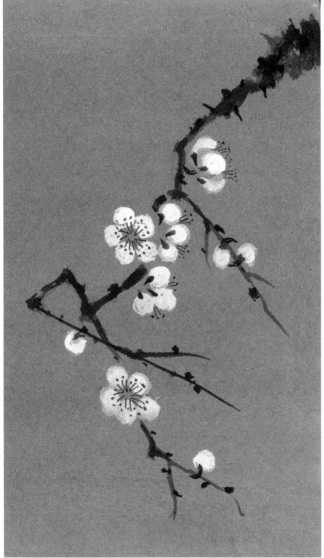

- Make a composition with a triangular arrangement.
- Make sure the composition has open space, odd numbers, and asymmetry.
- Paint a branch entering from the top, side, or bottom of the page where it might be connected to the main part of the tree.
- Make at least one branch cross over another at an angle to identify the plum tree uniquely.
- Place small branches and twigs in asymmetrical balance.
- Add many small twigs with crossovers as they are the new growth that has the blossoms.
- Contrast the gnarled old trunk with the new, smooth growth of twigs.
- Paint rings with a dark center to represent scars where branches have broken off.
- Suggest the old age of the tree by adding moss dots on the edge, and for a boned trunk, by adding vertical lines on the bark of the branch representing an old trunk crack.
- Do not put blossoms on the main trunk of the tree or large branch as it enters the picture.
- Do not attach buds to the end of a twig.
- Make variations in the shape and positioning of the blossoms.
- Connect a bud to the stem by a calyx made by a dragged dot.
- Make the stamens in the center of the blossom with small straight lines and pollen dots at the top of them, where the dots go up and down rather than in a row.

Chapter 10

Painting Popular Zodiac Animals

The Chinese people have been looking for guidance from nature since ancient times when fortunes were read by priests from scratches on oracle bones. The Chinese zodiac is another example of relating natural patterns to people to determine their characters and fortunes.

The twelve animals of the zodiac are associated with the year, the month, and a two-hour timeframe of a person's birth. The inner animal associated with the month and the secret animal associated with the hour could each be different from the animal associated with the year. Given the yin-yang and Five Elements (earth, wood, metal, fire, and water) also associated with a zodiac animal, each year has a unique combination that only recurs every 60 years. These combinations explain why not everyone born in the same year has the same traits. Although it is common for Chinese people to give their age by stating the animal associated with the year of their birth, you need to know the month and hour of their birth to get a reading of their specific set of traits.

The year of a new animal, such as the Year of the Rat, or the Year of the Ox, starts at Chinese New Year. The Chinese use a lunisolar calendar to determine the Chinese New Year. According to the Gregorian calendar, Chinese New Year falls on different dates each year, on a date between January 21 and February 20. The latest twelve-year cycle starting with the Rat occurred in 2008.

Because everyone is related to an animal, people sometimes choose their animal to be the carved figure on the top of their seal stone with their name on the seal at the bottom. Other people may prefer a Guan Yin figure or some other pleasing design. The character for the animal is also used as a symbol of the new year on New Year's cards and banners.

This chapter shows you how to paint five of the zodiac animals that are popular among artists. You can paint them as paintings for display. When the year for one of the animals comes along, you can also paint the animal on cards and banners to celebrate Chinese New Year.

The 12 animals of the zodiac

2009	Ox
2010	Tiger
2011	Rabbit
2012	Dragon
2013	Snake
2014	Horse
2015	Ram
2016	Monkey
2017	Rooster
2018	Dog
2019	Pig
2020	Rat

Different views of a seal with a dragon sculpture

Painting a Rat

Painting a rat is an exercise in contrast of dark and light, controlling the brush with the moisture on the paper. A rat can be stylized or made into a caricature.

1. Dip the brush in light gray ink, tip it with a darker color ink, swing the arm to make a curve for the back, like a large circle. At the bottom, extend a portion to make a leg.

2. The ears are in darker gray and are almost circles touching in the center. With a smaller brush and black ink, paint a broad tail, lifting the brush to make a thin ending.

3. With black ink in front of the two ears, paint two round circles for eyes, and leave a clear area around the edge.

4. Between the eyes, paint a black, pointed nose. Lay the brush down at the tip and draw it into the space in front of the eyes.

5. Add whiskers on either side with a detail brush.

A rat can be made in other views using these ideas, but you can also paint one as a large oval for the back of the rat and add a tail. Put these together with a stalk of wheat, and you have a humorous scene.

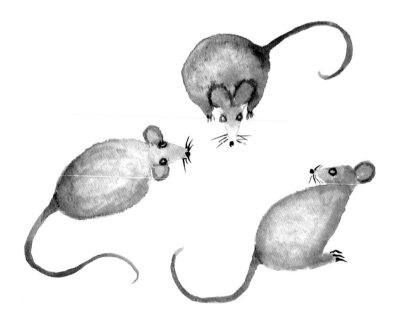

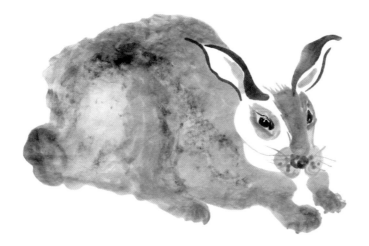

Painting a Rabbit

The rabbit is an animal not only associated with the Chinese Zodiac but with the moon. The myth is that in moon viewing, you can focus on the dark part of the moon and it suggests a rabbit with two ears going up to the right. The moon is considered to be female, so rabbits are associated with fertility. Rabbits can be drawn with ink as boned or boneless. A front view shows eyes, nose, and ears, and a rounded body behind it. A rear view shows the cotton-like tail and the head and ears above it. Rabbits are usually drawn in profile so the head shows and the neck is turned to the right.

Rabbits come in many colors, but mostly they are painted in light ink with dark feet, ears, nose, and eyes. If done in gray color, leave a lighter area for the belly and tail. Rabbits can sit on their haunches upright or on all fours. They can be drawn head on or in profile. If upright, they usually have something in their paws. Otherwise, it is awkward to have paws under the nose. The ears of the rabbit are usually drawn fairly symmetrically, but in some cases, one ear may droop lower on one side to add interest. The difference between a rabbit and a hare is that a hare has longer ears that stand up all the time.

Painting a Sitting Rabbit

1. On scratch paper, make a sketch of the rounded body and head of the rabbit sitting down. This will help you to see the relationship between the body and the size of the head and where the legs come off the body.

2. With dark gray ink mix on the large brush on newsprint practice these strokes first to place the parts properly. Turn the hand to the left so the side of the brush hairs can make a curved stroke from the left to right to represent the curved back down to the tail area. Reload the brush with darker ink to make the curved back leg. Reload with lighter ink to make the front legs, which are smaller.

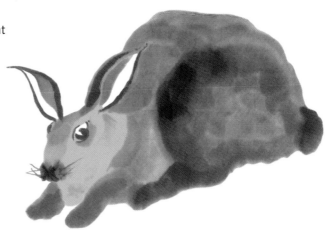

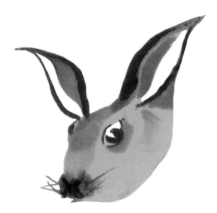

3. To make the head, use the small brush and light ink and look at the sketch to see how large to make the oval for the head, which comes above the front leg. Swing the arm to make a slanted oval.

4. To suggest the nose, make a medium ink stroke down the ridge of the oval to the end of the nose. Then add two darker areas at the end of it. With the small brush and dark ink, make small strokes for the nose, mouth, and whiskers.

5. For the eye, make a tilted oval with the small brush and dark ink. Alongside this line, add a dark, three-quarter circle to represent the eyeball with a white highlight in the pupil.

6. For an ear, on the far side of the outlined head, with dark ink on the brush, make a long sloping curve. On the other side, make the strokes for the other ear. To make the ears look more rounded, add a medium gray stroke inside each ear.

7. To make the cheeks more rounded, add curved strokes of medium gray ink.

Painting a Standing Rabbit

1. Make a quick sketch of the rounded up back of the body with a head on the top, which will be in profile.

2. To make the left side of the rabbit bulging out toward the bottom for the rear leg, load the large brush with medium gray and rotate the hand to the right so the tip of the brush is on the left. Start at the top and make a stroke with the hairs down on the paper.

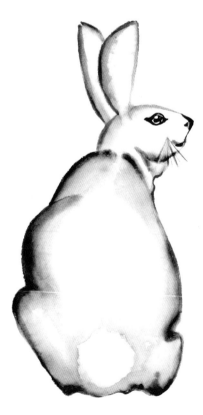

3. Reload the brush and make a stroke for the other side of the body bulging for the right leg. At the bottom where the two strokes come together, leave a stroke for the cotton tail bottom curve.

4. To represent the head, use a small brush and dark gray ink and swing an oval. At the far right, make a spot for the nostril and whiskers and a small line under it for the mouth.

5. Like the other rabbit, curve the ears to make a long oval narrow at the bottom where it attaches to the head and pointed at the tip.

6. Make the eye similar to the oval with a dark spot for the pupil.

7. With a small brush and dark ink, accent the shoulder and leg areas.

Painting a Rabbit Composition

Using the poses you have practiced, make a scene with the standing rabbit and a sitting rabbit. Perhaps you can arrange them so there is a carrot in front of the rabbit sitting down.

Painting a Carrot

1. Load the medium brush with a medium ink mix and then tip the brush in dark ink.

2. Rotate the hand so the hairs are at the left, and starting at the top part of the carrot, touch the brush to the paper and drag and lift. Repeat this several times in a row, getting smaller as you move to the left and the tip of the carrot gets smaller.

3. Load the medium brush with dark ink and draw some lines like for the stems of the carrot top.

4. Load the medium brush with medium ink and add strokes for the leaves of the carrot top along the stem lines.

Painting a Rooster

The rooster is an important bird as it is one of the animals in the Chinese Zodiac. Like other birds, roosters are also cared for as special pets. Some are kept on high perches so the tail feathers will grow long and curved. These can be seen painted in landscapes in trees with the long plumage.

Sometimes a rooster is painted on the ground, by itself or with hens. For a family scene, there may even be chicks. Roosters come in many colors, but for our purposes, they will be variations of black, white, and gray. The tails are usually dark and the wing feathers are dark. The rooster has a character determined by the strokes of its tail. Do not use too many strokes because you want to see spaces between the feathers. The feathers all have the same curve except that some are more vertical. A rooster can be humorous in the way he tilts his head and in the angle of his coxcomb. The body is usually painted with one leg ahead of the other as if the bird is strutting. A rooster is a nervous, mobile creature, not a static creature, because of the tilt of his tail and the angle of his head.

Painting a Standing Rooster

1. To make the beak, use a small brush loaded with black ink in vertical position. Make an outline for the beak pointed slightly downward.

2. Make a large teardrop shape around the eye touching the beak using a medium brush and fill in the eyeball.

3. With a medium brush with light gray, make a number of curving out strokes around the tear drop shape leaving an area at the top for the rooster's comb, a jagged shape.

4. Under the beak, make a light gray shape touching the teardrop but not the beak. Leave a white space around the teardrop and the beak for the collar.

5. To make the feathers coming out of the white collar area, use a large brush with gray ink to make thin strokes curving outward.

6. Under the collar, using darker ink on a large brush, stroke downward to make the chest down to the front leg. On the right side, add a few strokes for the right leg folded back.

7. With a large brush loaded with black ink, make thick strokes to add side feathers around the gray collar out to the wings.

8. The tail feathers come out from behind the collar and are stroked upward, then sideways, and then bent down. Keep the hairs of the brush separate so air shows between the strokes. As the feathers come down, stroke the brush more horizontally and then downward.

9. With a small brush and black ink in vertical position, make a few dark strokes downward from the gray body to the left leg. This will be the leg meeting the foot. Outline the leg and the claw with a small, pointed dark brush, suggesting a joint at the back and an ankle where the claws hook on.

10. Make a few dark strokes for the right leg and then outline a small foot turned back.

Painting a Rooster in a Tree

1. To make a composition with the rooster and the long tail, make a sketch on newsprint with pencil to get the best proportions. Use an oval sloping downward for the body and a smaller oval at the top for the head.

2. Load the medium-size brush with a light ink mix and outline the shape for the body.

3. With the same brush, make several curved strokes below the center to represent the wing area on the body.

4. Judge where the head would be slightly tilted forward of the body and a smaller oval than the body oval and outline the upper part of the oval.

5. Use a detail brush and darker ink mix and stroke several triangular strokes for the comb at the top left of the head.

6. Below the comb, use dark ink to outline the triangular shape for the beak.

7. Back from the beak, use dark ink outline an oval eye with a dot in the center.

8. Fill in the beak with pale ink.

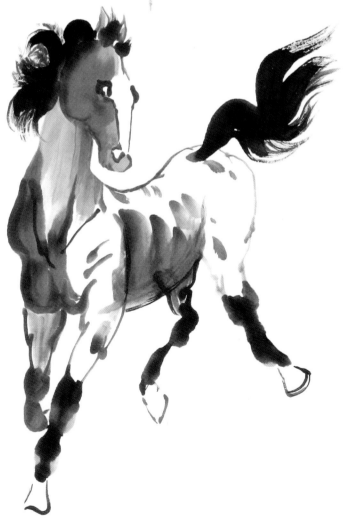

9. Under the beak and out in front of the body, use medium dark ink to outline two blobs, one large and one smaller to represent the wattles. Add a small one under the eye also.

10. Judge where at the bottom of the body the legs would bend forward and the feet would show. Outline a portion of the leg with the feet curving downward.

11. Use the large brush filled with dark ink and use the arm and swing curved lines from the back of the body to the right up and curving downward for the tail. Make several of these but let some white paper show between some of the strokes. This lets the individual feathers show and the energy of the curves become dynamic.

12. With the medium brush and medium ink, make a stroke for the branch to come out from under the tail to the left under the curved foot, across, under the other foot, and out to and down to the left to make a branch of the pine tree. Make a second branch to show it is a strong tree and can support the rooster. Add pine needle clusters along the branches and a light wash behind to make the clusters more visible.

Painting a Horse

The horse is famous in Chinese history. The early Han dynasty horse is still being reproduced as sculpture thousands of years later. It shows a prancing horse with tail and mane flying. The horse is also important because it is one of the animals in the Chinese Zodiac.

The horse is usually drawn in profile with the tail and mane flying. It is said that the artist paints the best flying tails and manes by using horse hair brushes, which are stiff and long so the hairs separate slightly to give the effect of long, separated hair flying upward.

One of the features that distinguishes the Chinese style of painting horses is the way the joints and hoofs are painted. The bottom of the legs are painted in bone-less style so the joints and hooves are large. The mane and tail and the leg joints are usually very dark. It takes practice with the brush to get the press and lift black spots to match where the joints would be on the leg. Horses are not usually painted all white or all black. If mainly white, there are usually blotches of gray under the belly, along the neck, and down the nose. When you paint a horse in head-on view, he becomes very long and thin. You can use flying mane on one side and a flying-out tail on the other side.

Practicing a Horse Head and Mane

On a piece of scratch paper, make a quick sketch of the line of the forehead to the nose. Then add another around the chin, up the side of the nose, to a rounded jaw. Notice the mouth curves under the nostril and the curved back chin. Under the jaw, the neck begins. Try to get the head shape by using three lines.

1. To paint the lines for the nose, load the small brush with black ink, hold the brush in vertical position, and very lightly touch the tip to the newsprint. Start at the top and make the long straight lines that shape the lower head.

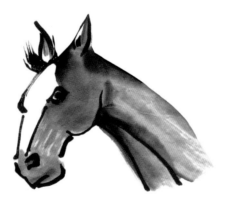

2. Stroke in a circle for the nostril and make the lines that form the nose, mouth, and chin.

3. Make the two lines for the right side of the nose up to the jaw and add a neck line from the jaw down to the chest.

4. Make an oval for the eye and add a black spot covering three-quarters of the oval. The white part is the highlight in the eye that makes the dark eye look shiny and wet.

5. To make the ears, use the detail brush with dark ink and outline each ear with two strokes.

6. Fill in the side of the head and the neck with medium light ink, leaving the front of the head white for contrast.

7. To make a mane, load a medium-size brush with black ink and squeeze out the tip on a paper towel so it is very dry. Tap it against the dish to separate the hairs.

8. Rotate the arm to the right so the tip is at the left and swing the arm quickly, barely touching the back of the neck area and flipping the hairs up to the right. Then with a dry brush, swing the arm to make a flying mane. Sometimes the ears are hidden in the mane. You can make a forelock with the dry brush, too.

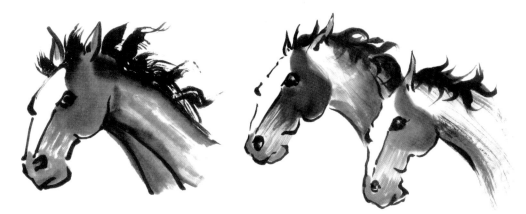

Practicing a Horse Body

Make a quick sketch of the body of the horse in pencil on scratch paper. Start with a curved back for the body and add a sloping line up to the neck. On other end of the curve, add a rounded-up hip area.

1. On newsprint, with light gray on a medium brush, try out the three curved strokes that outline the back.

2. Make a line for the front of the neck down to the chest.

3. Practice these curves on newsprint until you have graceful curves and then try to paint them on rice paper.

4. Load the medium brush with medium dark ink and make curved lines below the back line to represent the rounded form of the belly.

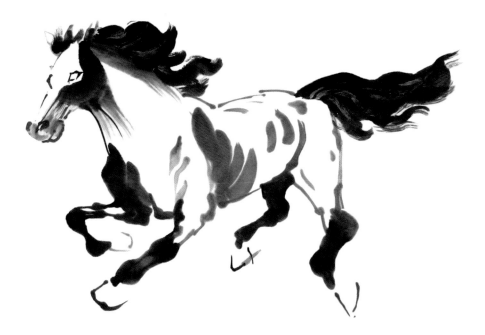

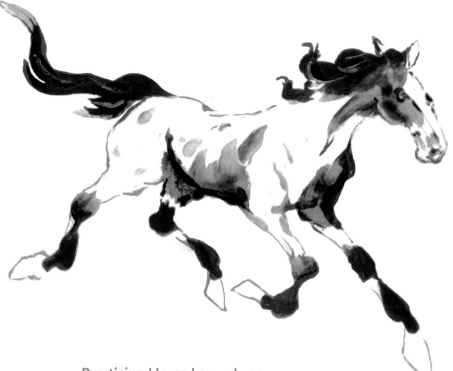

Practicing Horse Lower Legs

The dark parts of the lower legs are very important. They have the Chinese character, so practice the brush strokes many times.

1. Load the large brush with dark ink, hold it in the vertical position, and practice the two press-and-lift strokes over and over again to get the press areas uniform. Try these in different positions left and right to suggest a horse in action.

2. Look at the samples and copy the leg variations.

Practicing Horse Upper Legs

1. Load the detail brush with dark ink and outline the upper leg to connect the lower leg to the body for each leg. Practice these outlines many times to make them energetic and graceful.

2. Outline the hoof for each leg using small, black, thin lines in varying positions to represent the position of the leg and ankle.

Practicing the Horse Tail

The horse mane and tail are both painted using curvy strokes with a dry brush.

1. To make a tail, load a medium-size brush with black ink and squeeze out the tip on a paper towel so it is very dry. Tap it against the dish to separate the hairs.

2. Rotate the hand to the right so the tip is at the end of the horse, press, lift, go down slightly, then go up and lift off. Swing the arm quickly and let the brush hairs separate as you lift to get flying white.

Painting a Horse Composition

Now that you have practiced painting all the parts of the horse, you can put them all together into a horse composition. Paint the parts of the horse in sequence from the head down.

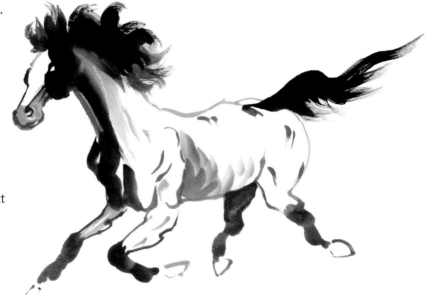

1. Paint the head.

2. Paint the neck and back

3. Paint the belly.

4. Paint the lower legs in boneless style.

5. Paint the upper legs in boned style and connect the whole leg to the body.

6. Paint the hoofs in boned style.

7. Paint the mane and tail.

The shadows for the head, neck, belly, and legs are painted when you paint those parts of the body. When you paint the full horse, wait until you have the neck and back defined before you paint the mane. Adding the mane and tail at the same time at the end of the painting adds the final energy and life to the animal.

Painting a Dragon

In Western Medieval culture, the dragon was a mean, ferocious creature causing much fear and dread. Eastern culture has had a quite different attitude, giving this mythical creature a light-hearted and more benevolent character. The dragon conveys a sense of great power yet is playful and good. He has the gift of being visible or invisible when he wants to be. The dragon hidden in the clouds represents the yang principle, heaven, light, and the emperor as the head of state.

The dragon is closely associated with nature, the seasons, and the weather. In spring, he ascends to the sky and plays in the clouds. In autumn, he buries himself in watery depths or marshy mud or hibernates in a dark cave. He dances in storm clouds and washes his mane in whirlpools. His claws can be jagged like lightning bolts. His voice is heard in hurricanes.

The dragon has been considered a predecessor of the alligator. Rare alligators living in the Yangzi River appear to be one of many species of reptiles. In the mythology, the dragon is a flying creature as well as a swimming water creature. The dragon is usually depicted with four legs and a long body with a tail. It is a composite creature that has been variously described as having parts of other animals: the head of a camel, the horns of a deer, the eyes of a rabbit, the ears of a cow, the neck of a snake, the belly of a frog, the scales of a carp, the claws of a hawk, the palm of a tiger, and the tail of a horse. Some dragons have horns, and some have wings, scales, and clouds of smoke or fire coming from the mouth that can change into fire or water.

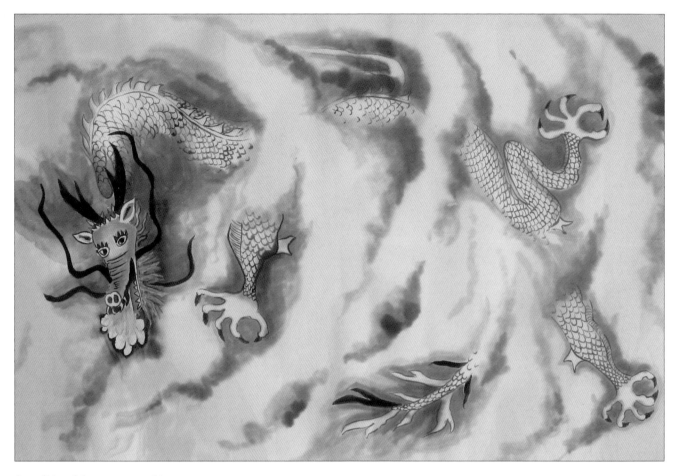

A traditional dragon composition

The Chinese have accepted three species of dragon. The Lung dragon is the most powerful and usually found in the sky. The Li dragon is found in the ocean and swims. The Chiao dragon is a more scaly creature that is found in marshes and mountain dens. He has whiskers and a beard in which he holds "the pearl of great value," a national treasure, which is a charm against fire. He has no horns, a red breast with green stripes on his back, and some yellow scales. He can shrink into a very small size or enlarge himself to fill the sky.

The dragon appears in ancient history as far back as 4000 BCE as seen on bronze vessels. The Buddhist and Taoist philosophers both tell of dragon adventures. One of the dragon's virtues is that it has a restraining influence against the sin of greed. People born in the Year of the Dragon are supposed to have wonderful character traits, such as being passionate, honest, brave, soft-hearted, energetic, intelligent, and gifted.

The Imperial Palace at the North Lake in Beijing has a screen with nine dragons depicted in glazed tiles with bright colors. Each of the nine coiling, writhing dragons is alert and ready to fight and protect the Emperor. These represent the nine main variants of dragons within the three species.

The Chinese Imperial Coat of Arms, which originated in the Han Dynasty, includes a pair of dragons fighting over "the pearl of great value." The Emperor wears a robe of yellow silk with a dragon on the back that has five claws. Only the Emperor and his son are allowed to wear five-clawed dragons.

The dragon represents a unique personality and a benevolent creature warning one against greed and supplying the needs for agriculture. To help the planet,

he causes rain to fall when there is a drought. He is rarely seen as a whole creature as he is hidden in the mist. Parts of him have been seen. One rarely paints the eye pupils in until all of the dragon is painted because when the dragon has eyes to see with, he will quickly fly away. He breathes out mist as he flies. In painting, one starts with the shape of the head and adds the other features working from top to the bottom of the head from left to right.

Because the dragon will be horizontal on the paper, use a long end of the roll on the left and leave the roll on the right to be unrolled as the parts of the body emerge from the clouds onto the paper.

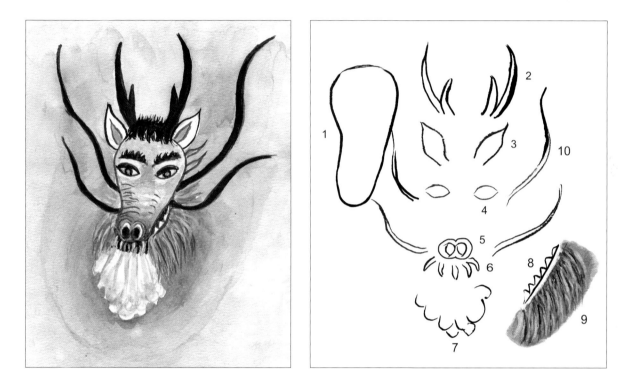

Practicing the Dragon Head

Like many mythical creatures, the dragon is a composite of different animals. Different artists put these elements together in different ways; no one version of a dragon has been established as a standard.

When you paint a dragon, you always start with the head. You can assemble the parts of the head piece by piece by following the numbers in the illustration above.

1. Load the detail brush with a very pale ink mix. Try using newsprint to practice the shape of the head. In general, the head is long and lizard-like or may look like an elongated peanut shell. Start at the top and make a curve for the top of the head. This is larger than the chin area curve. Connect these two curves with curved lines. When you feel you have the right shape, paint it onto the rice paper with a very pale ink mix.

2. The double deer horns are dark. Load a medium brush with medium dark ink and draw a single-stroke wide curve on the left curving up and outward. Next to that make a smaller stroke curving outward.

3. The ears are shaped like a cow's. Load the detail brush with pale ink and out-line the ear shape on the left and then on the right side of the head.

4. The eyes are not quite halfway down the head. They are the eyes of a cow, large and rounded. Paint them with pale ink on each side of the head. Do not put in the eyeballs until the end, or he will fly away.

5. The nose of the dragon is pig-like with two rounded openings next to each other. Make them large with pale outlines. Inside the circles make a smaller circle of darker ink to represent the opening.

6. The front teeth are below the nose coming out from under the lip. They curve out on each side of the mouth. Outline the teeth with very pale ink as they are to appear white.

7. Under the teeth there is a lower lip where the mist shoots out. Load the detail brush with very pale ink and make a few curved lines to suggest the cloud blast of mist. Add a few pale lines coming out of the mouth to the cloud of mist.

8. On the right side of the head is an opening of the mouth with some teeth showing. Load the detail brush with pale ink and draw some teeth lines un-der the upper lip. Add dark ink above there to represent the inner part of the mouth.

9. Under the jaw with teeth make some whiskers. Load the detail brush with pale ink and make lines curving out from under the jaw. Reload the brush with dark ink and make lines between the pale ones. This should look like a pale gray batch of whiskers.

10. The dragon has long dark whiskers higher up on the head. One pair is longer and higher on the head. The lower pair is shorter. Both of the pairs of whiskers are one stroke wide with dark ink.

11. There are short hair strokes across the forehead painted with shaggy dark strokes. Below and above the eyes are some shaggy eyebrows. These are painted with dark ink.

12. To make the nose look long, load a detail brush with pale ink and make some strokes across the nose above the nostrils. Make fewer as you move toward the eye area.

13. Load a detail brush with dark ink and paint a circle inside the eye shape. The pupil will be dark with a white highlight. When the dragon can see with this pupil, he will be transformed and may disappear. Add the pupil when you fin-ish the whole dragon.

Practicing the Dragon Spine

The dragon hides in a cloud, but his curvy spine, scaly neck, and jagged tail peek out to define some of his size and form.

1. Load the detail brush with dark ink and paint the curvy line that defines the center of the dragon's back.

2. Add another line above the first line to make the seam down the back. The spine horns attach to this second line.

3. Working from left to right, paint the curvy strokes to make the flame-shaped spine horns.

Flame-shaped spine horns

4. Add another curved line behind the right spine horns to represent the other side of the dragon's back where it is twisted.

5. To make scales, practice making U-shaped strokes that overlap each other, alternating and covering the scale above. Add the scales on the sides of the spine.

Practicing Dragon Legs, Fingers and Claws

The dragon has five sharp nails on his five fingers. Because the dragon is long and hiding in the clouds, he is only seen and painted in parts. One may only see a few clawed digits clutching on a cloud or a tail whipping the storm up. Look at the claws and the clouds and see how they hook into the clouds with a scaly leg slightly showing.

1. To the right of the dragon head is a short front leg with claws coming out of the clouds. Load the detail brush with dark ink. Start at the left top of the leg coming out of the cloud and draw a line curving down into the wrist.

2. Curve the line out to the left and outline a finger. Continue outlining fingers until you have five. The far right one curves in like an opposing finger, and the line curves to make the leg going up.

Front claws

3. The bottom palm is attached to a long hind leg coming out of the clouds. Outline the left side of the leg and curve into the first finger.

Bottom claws

4. Continue outlining fingers until you have five, and then outline the right side of the leg.

5. Another hind leg coming out of the clouds is bent in an S curve. In this case, start by outlining the five fingers.

6. From the back of the palm, outline the leg section getting wider and making the large S curve to fold the leg up to the body.

Top claws

7. Add the flag-shaped wing on each leg.

8. Add the second line within each leg that defines the inner part of the leg. Fill in the inner part with little straight lines to suggest a softer texture.

9. Add rounded scales to each leg up to the palm, which has no scales.

10. With the detail brush and dark ink, carefully make curved claws on the end of each finger. Make them curve like they are clutching the clouds.

Practicing the Dragon Tail

The curved tail has several forked pieces in either black or white.

1. Load the detail brush with dark ink and outline the curved lines that make the long curve of the tail.

2. Outline the different forked pieces that come off the tail.

3. Fill in some of the forked pieces with dark ink and leave the others white.

4. Add scales to the center part of the tail.

Practicing Clouds

Clouds vary in dark/light patterns and should be soft and fuzzy.

1. Practice on newsprint. Use the large brush loaded with water to make a long curved line of water.

2. With the medium brush and medium ink, do a few press-and-lift strokes in the center of the lines of water.

3. With the large brush and water, quickly add another line of water down the center to make the dark ink run out and make a fuzzy edge.

4. Practice this many times with variations so the edge of the cloud will be fuzzy.

5. When you can control the ink distribution, plan where to put the fuzzy-edged cloud to make it look like the part of the dragon is coming out of the wet cloud. Each of the claws, the neck, and the tail should have a cloud.

Painting the Dragon Composition

Now that you have practiced painting all the parts of the dragon and clouds, you can put them all together to create the dragon composition shown on page 142.

Paint the parts in the following sequence. Remember to leave room for the different segments of the dragon that will be hidden behind the clouds.

1. Paint the head and its details.

2. Outline the spine and add the spine horns and scales.

3. Outline the legs and fingers and add the scales, wings, and claws.

4. Outline the tail, paint the forked pieces, and add the scales.

5. Paint the clouds around the dragon to finish the surroundings.

6. Add the pupils to the dragon's eyes so that he can see. Then he may be transformed and disappear.

Chapter 11

Painting Landscapes

山水 In Chinese painting, the symbol for landscape uses two characters, one for water and one for mountain. A proper landscape contains mountains, trees, rocks, small plants, and always water. The water can be a waterfall, river, and/or lake and in the form of mists, clouds, or fog to cause atmospheric effects in contrast to clear areas.

A painting may also contain birds, boats, buildings, pavilions, bridges, and people to suggest scale and lofty sky.

Perspective in Chinese Landscape

In planning a landscape composition, the Chinese idea is to have the focal point near but not in the central area of the page, leaving the outer corners more sparse. This creates a spotlight view like looking up a mountain scene with binoculars to see the details. The details in the painting are well defined and usually do not use the idea of Western perspective where the details in the distance are blurred.

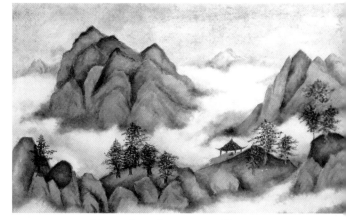

Mountains, mist, trees, pavilion

Mountains, lake, boats, trees, houses, people

Details visible near and far away

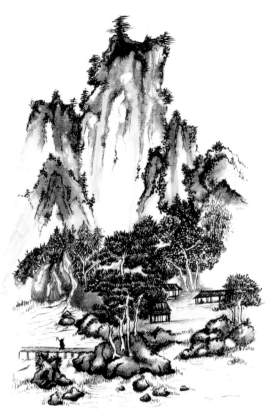

Three points of view

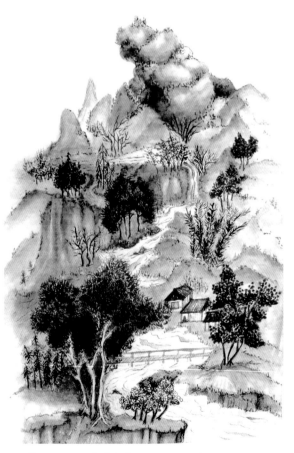

Stream meandering down a mountain

In Western perspective, objects close to the viewer are larger and those far away are smaller. The Chinese use a type of reverse perspective. The objects in the foreground are smaller because they are viewed from above as if you are on a mountain looking down on them. According to the ancient canons of Chinese painting, a landscape should have three levels of perspective. The level in the foreground appears as if you are looking down from above. Further up the page, you see things at eye level. As you move up the page, it is as if you are looking up with the perspective greatly exaggerated. This looking up makes the mountains seem of great height. When people or houses are in the front, they are small so that the mountains appear monumental and awesome. This approach could express the Taoist philosophy that humans are a small part of the greater nature around them and should try to stay in harmony with it. It could also express the Confucian sense of different levels within society working harmoniously together in relationship to each other. A good composition in a landscape contains a balance of the three points of view, interesting details, and linear movement that directs the eye around the painting, such as up the mountain and back down again.

Every landscape should have a visual path through the objects leading you through the three levels of the painting. The path can be simply sight lines or an actual trail through the scenery. You can imagine yourself taking a walk along a trail. You can start at the bottom and travel upward enjoying the view at each level and looking up to the peak with a sense of awe. As you go up, the view changes and you appreciate more of what you see.

On a walk up a trail, you can admire the trees and the river. You may see a boat on the river or even a pavilion along the trail. When you get above the pavilion, you may look back and see the perspective from a different view. Along the path, you can see different kinds of trees depending on the level and the altitude. Some trees may be young and some may be old, gnarled, and damaged with broken branches.

The best landscape paintings contain interesting details that invite you to observe and admire the shapes and textures of mountains, rocks, and trees. The objects are not treated realistically but are abstracted and stylized to capture their linear and sculptural qualities.

Planning a Landscape Painting

Since a landscape painting contains three perspectives and many components, it is helpful to plan what you are going to do in advance.

- Generally, start with the mountain, then work on the foreground, and then fill in the middle ground.
- Leave space for a waterfall, mist, lake, or a river when you plan your mountain.
- Use a path or river to lead the eye from the foreground up the mountain.
- Add a variety of trees, plants, and rock shapes with details in the foreground, and sketchier trees and plants on and near the distant mountain.
- Include human elements, such as people, boats, bridges, houses, and pavilions.

Painting Rocks

Learning to paint rocks teaches you approaches and brush techniques that you can also use on mountains, which are just larger rocks in most cases. The type of a mountain can be based on the rock structure, the height, and whether it is a horizontal mountain range or a vertical monolith as in the Ming style.

Different Rock Forms

Rocks and mountains are shaped by wind and water erosion. Water flowing down ridges creates visually interesting cracks that artists like to paint.

Eroded ridges

With certain types of rocks, erosion can cause chunks to break off at cracks. These rocks have straight edges as if sliced with a knife. Artists like to paint the sharp angles using the "axe-cut" stroke, with its quick, flying- white effect and abstract appeal. These types of rocks can express a lot of qi energy to add drama to a painting.

Angular rock

Axe-cut rock

Perforated Taihu rock

Along river banks and in lakes, you can see rocks eroded by the water. Some of these may be rounded and even have holes where the water has washed away the softer portion of the stone core. The most famous rocks of this type are the Taihu rocks brought out of Lake Tai, which is just west of Suzhou in Jiangsu province. These rocks are white limestone with perforations caused by constant erosion from wind, sand, and waves within the lake. When classical Chinese gardens were developed in Suzhou starting in the Song dynasty, Taihu rocks became major elements in every garden plan. The rocks are appreciated for their fascinating shapes, which may suggest animals or people or may simply be appealing abstract forms.

Some rocks are built up with layers of deposited minerals that solidify and may form a flat top. You can see the layers and striation where the mineral colors have been built up. Flat rocks offer an interesting variation in a painting. You can paint a flat rock as being viewed from different angles. When painting a flat top rock, do not use a baseline. Let it disappear as the mist rises from the valley.

Different views of a flat rock

Yang

Yin

Grouping of yin and yang rocks

A rock has an inner spirit and a yin or yang identity. A yang rock or mountain is more vertical, ascending towards heaven. A yin rock is more horizontal, crouching over the earth. Yin and yang rocks should be grouped so as balance these two forces.

In doing a painting, you may find that using different kinds of rocks in different areas adds more interest because they are made with different brush strokes. Group the same kinds of rocks together, or the composition will be confusing. Establish a host-guest relationship among a group of the same kind of rocks.

The dark dots used for shading in this rock grouping are called Mi Fei dots because they were introduced by the Song dynasty landscape painter Mi Fei, known in modern times as Mi Fu. The dots are made with a detail brush held in the East position. The flat brush makes marks the size and shape of rice kernels.

Chinese painters have named strokes used to make rocks. Can you visualize the strokes described by these names? A fun game for a group would be to try to paint each stroke and then use the stroke to paint a rock. This exercise can help you to develop a repertoire of interesting rock textures and shapes to add to a painting. Another exercise is to look at classical landscape paintings and search for interesting rocks to copy. Put together a scrapbook of rock examples that you can draw upon for inspiration when painting a landscape.

A host rock with guest rocks

Painting a Cluster of Rocks

This exercise introduces a few of the techniques used to represent rocks and mountains.

1. Load a detail brush with a pale ink mix.

2. Start at the left rock and make the curved line to outline the mound.

3. Next to the first mound and behind it outline the second mound.

4. Behind the second mound outline the larger third mound.

5. Load a medium brush with a darker mix.

6. To make the rocks look three-dimensional, lay the brush down along the curving line of the second mound, as if its shadow is cast on the larger mound behind it.

7. Add similar lines along the left inner edges of the second mound and the first mound.

8. When the lines are dry, load the medium brush with a pale mix and paint a wash on all three rocks to soften the edges of the shadowed areas.

9. When the washes are dry, load the detail brush with a dark mix.

10. Add some Mi Fei dots along the shadow behind the second mound. Turn your hand to the right to East position and tap a few dots gently along the line of the mound.

Painting Mountains

Mountains are larger collections of rocks, more massive in scale, placed in a larger setting with other elements.

Different Techniques for Painting Mountains

During the Sui dynasty, 581–618 CE, mountains, rocks, trees, and water in landscapes were made with dots and lines. Mountains were outlined and ridges were defined with linear grooves down each side. The ridges might be further defined with Mi Fei dots that fill in gullies and give a three-dimensional look to a mountain. Some paintings may have more than one ridge with distant mountains or even a waterfall running between two ridges. Sometimes there will be two different kinds of rocks and textures where the river has washed away the hill and left an eroded rock bare.

Names of Strokes Used to Make Rocks

alum lump	dragon scales	rolling wave
bean pod	finger flicking	sesame seed
bedraggled	fish scales	skull-like
big axe	ghost skin	split hemp
broken ribbon	horse tooth	tangled hemp
bullet hole	lotus leaf	torn net
chopper cut	ox hair	unraveled rope
cracked jade	raindrop	water weed
curling cloud	rice dot	woodpile

Overlapping rocks

Ridges with lines and Mi Fei dots

During the Tang dynasty, 618–906 CE, painters used rougher surfaces and added textures made with continuous lines.

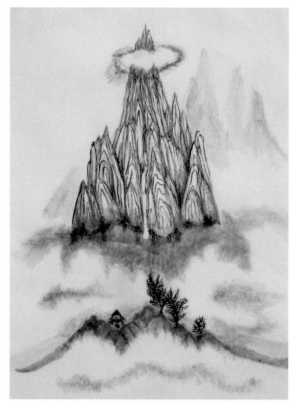

Textures made with lines

Even later, when exposed to European art, artists introduced soft, graded washes in addition to the dots and lines. This made a great difference and broke from the linear painting done with the tip of the brush to use the side of the brush in some cases.

Lumpy peak with graded washes

Soft, graded washes

The literati, the retired court officials who were the calligraphers, experimented with the techniques of the painter. They painted rocks with both the linear strokes and the soft shading done with the side of the brush.

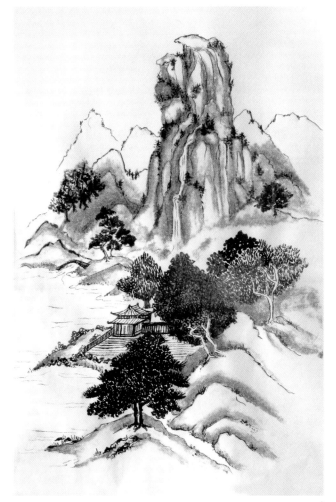

Lines and soft, graded washes

This exercise shows one method of painting mountains, which is similar to painting rocks. You can also try to paint other types of mountains shown in the landscape examples.

1. Plan where the overlapping ridges will go and how to vary the sizes.

2. Load a medium brush with pale ink.

3. Start at the bottom of the left mountain and make a line up one side and down the other.

4. Above this form make another slightly different mound.

5. Make another mound above the second with a taller peak at the top.

6. Add two more mounds to the right.

7. Use a pale ink mix to add a wash on all the mounds.

8. When the ink is dry, load the detail brush with a dark ink mix.

9. Rotate the hand to the right to East position and use the side of the tip of the brush to lay down Mi Fei dots along the ridges where the vegetation grows. The dots shade the mountainsides and the areas in between the mounds.

10. When the ink is dry, load the detail brush with medium ink and add lighter-colored Mi Fei dots next to the dark ones to make a graded shadow between the ridges.

Painting a River Scene

One of the challenges of painting a river or a path in a landscape painting is making it look like it is going into deep space rather than vertically up the page. One solution is to include overlapping rocks or mountains along the way to create a sense of depth.

1. Load a medium brush with pale ink.

2. Starting in the front, outline the mountains on the left and then the mountains on the right.

3. Load the medium brush with a medium ink mix.

4. Lay the brush down along the lower ridges of the mountain in back of each mountain to create a shadow.

5. Load the medium brush with pale ink.

6. Brush a wash on all the mountains to soften each shadowed area and blend it into the overall mountain color.

7. Load the medium brush with dark ink.

8. Add vertical lines along the bottoms of the front mounds to suggest that water runs down the slopes into the river.

9. Add some small horizontal lines in the river valley space to suggest moving water.

Overlapping mountains along a river

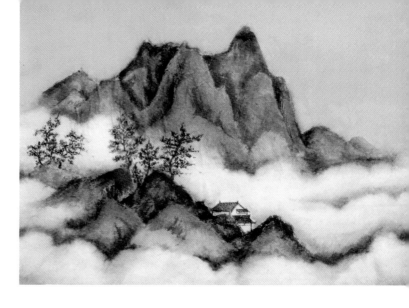

Painting Mountains with Mist

Painting mist in a mountain valley adds a sense of mystery and meditative serenity to a landscape. First you paint the mountain range, leaving room for mist, and then you add the rolling mist or valley fog.

Practicing Graded Lines

The secret to blending the mist into the bottom of the mountains is to use a graded wash that is dark on top and fades downwards.

1. Load a large brush with medium ink and then dip the tip of the brush into dark ink.

2. Rotate your hand to the right to East position and paint broad horizontal strokes to make dark-to-light graded lines.

3. Do the same again except make curved lines.

4. Reload the brush with medium ink and dark ink at the tip.

5. Move your arm up and down as you make connected curved lines that suggest the rolling mist.

6. Clean the brush.

7. Load the brush with clear water and stroke water beneath the connected curved lines to make the ink ooze downward more in a larger gradation. You should have what starts to resemble mist.

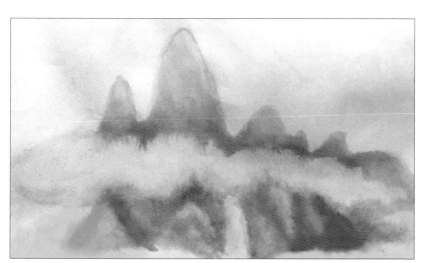

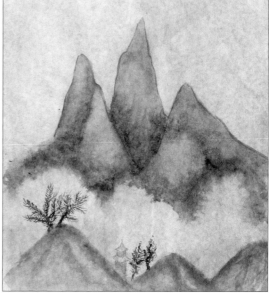

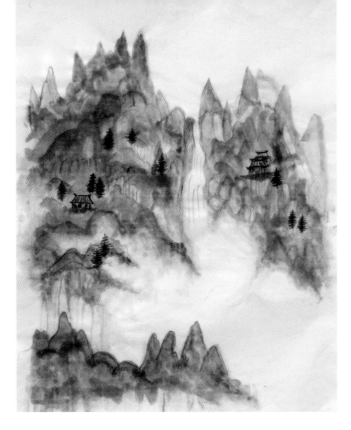

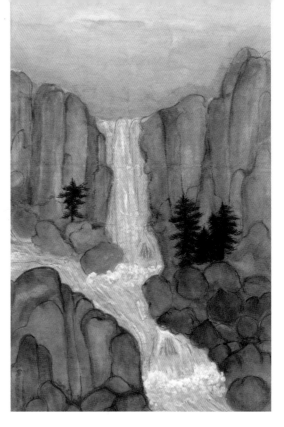

Painting Mountains with a Waterfall

A waterfall placed between mountain ridges can add a dynamic focal point to a painting. Waterfalls differ according to the shapes of the rocks between which they flow, the breadth of the channel, and the amount of water that flows through it. Some waterfalls are narrow, some start narrow and broaden out as they flow around boulders, and others start out broad as they flow from lakes in a cascade of white water. Some have multiple levels where they fall and puddle in a lake and then fall again.

A waterfall can change direction when there is an interrupt in the flow. Some waterfalls have descriptive names, such as horse tail, silver streak, white ribbon, and white thread cascades. Whatever the shape, the waterfall should look like it is a runoff from the mountain that falls into a river or lake.

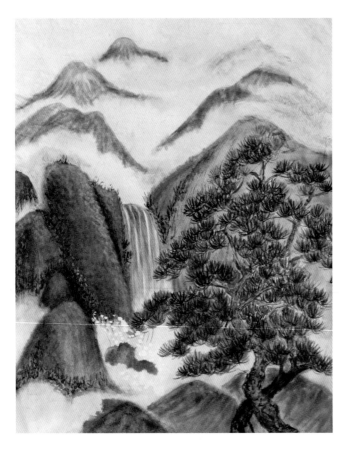

The strokes used to suggest the flowing water can vary. Typically, you use a detail brush or even a toothpick to draw thin, vertical, straight or wavy lines. You can use sparse dark lines on white water, thicker medium dark lines on white water, or white paint on tinted paper.

Creating a Waterfall with Thrown Ink

The thrown ink technique is used for painting the environment in which trees and waterfalls are situated. Liquid Chinese ink in a bottle is dribbled onto papers to create abstract effects that can be shaped into landscape features.

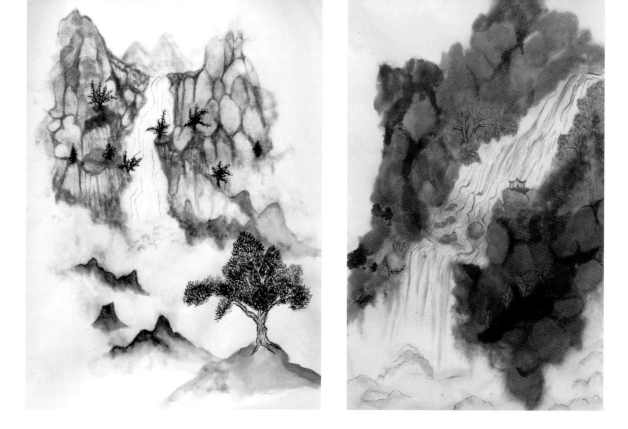

1. Cut four tall sheets of practice paper all the same size.

2. Lay one sheet down on newspaper and use a spray bottle to spray the sheet lightly with water so that it is moistened but not soggy.

3. Add the second sheet and spray it.

4. Add the third sheet and spray it.

5. Add the fourth and final sheet and spray it well to cover all areas thoroughly.

6. Dribble the liquid ink onto the wettest part of the paper and watch it as it oozes out into patterns. Try to make some areas darker than others for variety and interest. If the dribbles do not run together, spray on more water.

7. Allow the ink to soak in through the layers for five minutes.

8. Peel up the sheets and spread them out to look at them. Determine where you could put a waterfall and where the interesting areas would be around it.

9. Some of the patterns will be darker than others. If the pattern on one sheet is not mottled enough, paint on some pale blobs to fill in the white spaces to suggest rocks or cliffs.

10. When a sheet is dry, paint in the waterfall with white Chinese watercolor paint.

11. Use black ink to paint in the details of trees, cliffs, and rocks around the waterfall. Be sure to make different kinds of trees, such as tall, thin trees, rounded lollipop trees, and silhouettes of dead trees.

12. Add a pavilion on a rock that sticks out from a cliff or some other kind of human element.

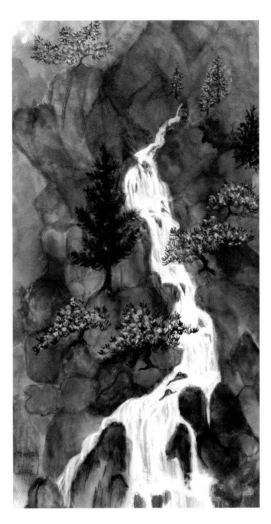
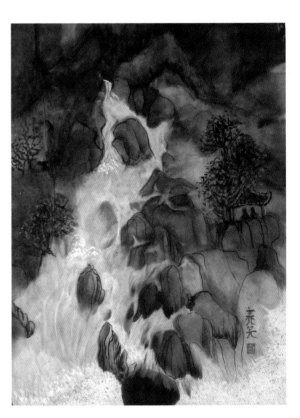

Painting Trees

Trees are important elements in a landscape painting. They help to establish the scale and distance of rocks and mountains and provide stimulating visual interest. Artists try to include a variety of trees with different shapes and textures.

Planning Trees

Adding trees to a landscape painting requires planning and decision making.

- **Where will you place trees to balance the composition?** Trees in the foreground are larger and painted in detail, while trees in the distance are smaller and sketchier. Trees in the middle ground have only a few details.
- **Where will you have individual trees and where will you have groups of trees?** Consider the relative sizes of trees and plan to have a host tree in a group with guest trees around it.

- **What types of trees will you include?** The type and age of a tree determines its overall shape and the type of trunk, bark, leaves, and roots.
- **How will you make each tree stand out from its background?** Distant trees on a medium dark hillside can be painted in boneless style with dark ink. To make a detailed tree in the foreground stand out, leave white space for it in advance and use boned or boneless style to create interesting bark, branches, and roots.

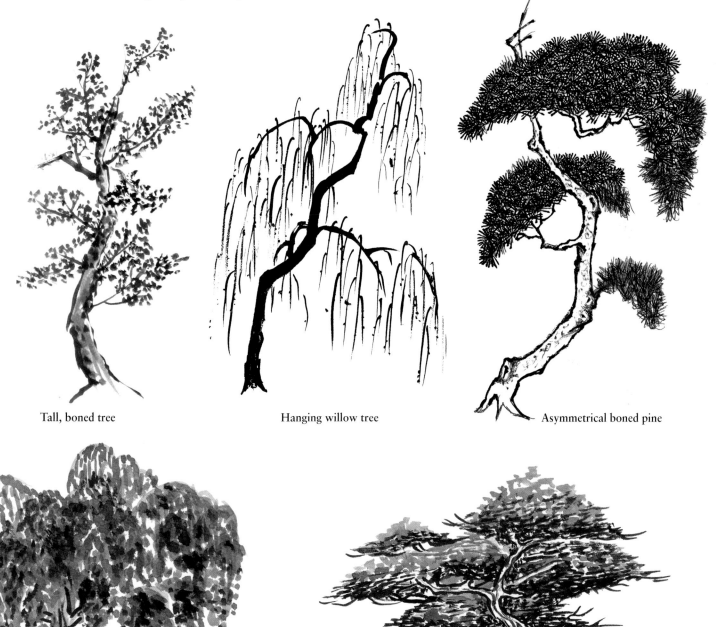

Tall, boned tree Hanging willow tree Asymmetrical boned pine

Broad-crowned tree Cypress tree

Trees can be identified by the way the roots, the trunks, and the branches grow, how the branches spread out, and the shape of their foliage. Fruit trees can easily be identified based on these qualities. Some trees, like evergreens, are conical unless damaged by storms and pruned to be asymmetrical. Usually trees grow out in four directions like the cardinal points of the compass. This suggests the Confucian idea of uprightness and a sense of fitness and wisdom.

Because of the way willow branches bend down with rows of leaves along the stems, willow trees become very wide unless trimmed. Willows can have dense foliage, but they can be pruned to be sparse, showing graceful branches shaped like a waterfall or like a lady dancing with her arms spread out.

Painting Young and Old Trunks and Roots

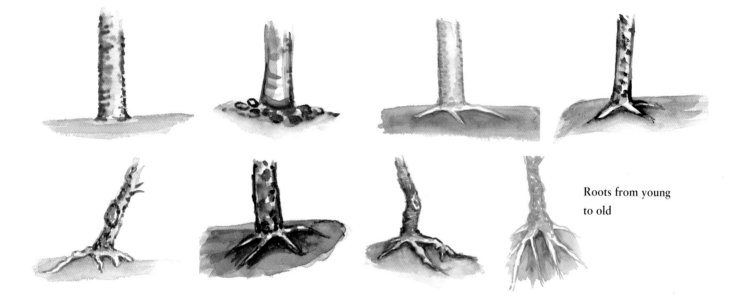

Roots from young to old

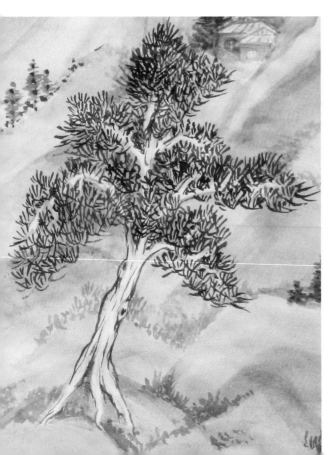

Old tree with long roots

Old trees are larger and their bark is more grooved, gnarled, and scarred. Their roots show above ground and radiate in all directions. Short roots can look like claws grabbing the ground, and long roots can look like branches spreading around the base of the trunk. Young trees have smoother bark and their roots do not appear above ground. Young trees among older ones should appear modest and retiring. If a few young trees are used, define the scene with a variety of trunks.

In many cases, the tree trunks can be painted in linear strokes leaving the paper white. When the trunk is light, it will show up better with dark foliage around it to make the trunk appear whiter. This single tree in the foreground of a landscape shows how the linear strokes and white trunk show up well against the gray wash of the mountainside. The dark leaves make the trunk look lighter. The trunk has grooves and scars and long roots above ground, indicating that it is an old tree, a venerable survivor.

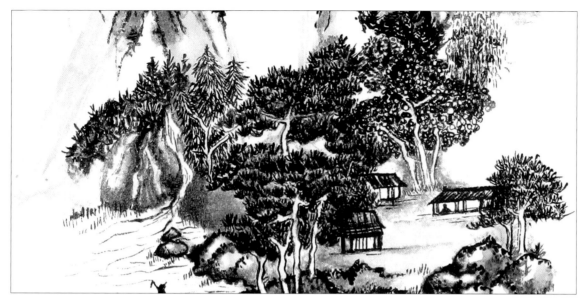

Varieties of trees with boned trunks

Painting Leaves

The leaf formations on trees are particular to each species. The way they are arranged on the branches creates a profile of the tree, and in some cases trees can be identified by their profiles. The forms of leaves are typical for each species.

Leaves can be painted in boned or boneless style. For boned leaves, you need to reserve white space in the background and in the trunk and branches where the leaves overlap. Use the detail brush with dark ink to outline the leaf shape.

For boneless leaves, you need a light background to make the leaf strokes visible. Boneless leaves use different types of brush strokes depending on the type of leaf. Use a medium brush and dark or medium ink for the strokes. Use dark ink for leaves near the front and medium ink for leaves further back on the branch to create a three-dimensional effect.

As with painting a pine tree, start with the leaves at the top of the tree, work down toward the left and across the middle, and then to the right side. Paint leaves fuller near the trunk and move outward to paint the sparser leaves near the ends of the branches.

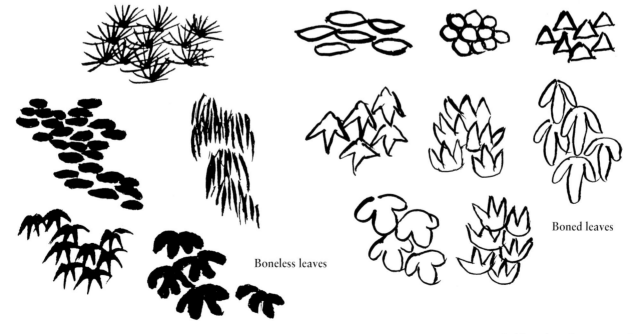

Boneless leaves

Boned leaves

Painting Trees in the Distance

Sketchy trees in the distance can be painted in boned or boneless style. The trunks are generally like sticks, and the trees are defined mainly by the types of leaves on the sticks. At the smaller scale, the leaves can only be suggested.

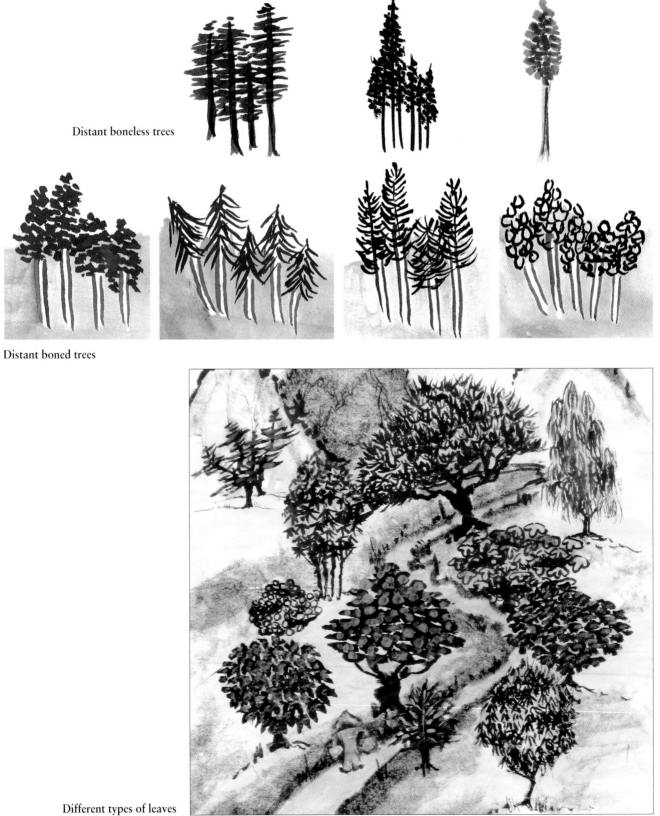

Distant boneless trees

Distant boned trees

Different types of leaves

Painting Small Plants and Grasses

In the details in the foreground of a landscape painting, you can add small plants and grasses for interest. Use a detail brush and dark ink on a light area so that the plants show up as decorative elements.

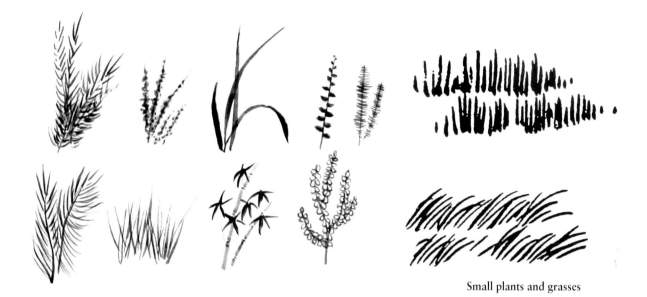

Small plants and grasses

Grouping Trees

Grouping trees is a very important part of the composition. Trees are usually painted small in groups in a landscape, which contrasts them with the expanding scene and tall mountains. Ideally, use groups of three or five trees. Try grouping three detailed trees in a composition with a focal point behind.

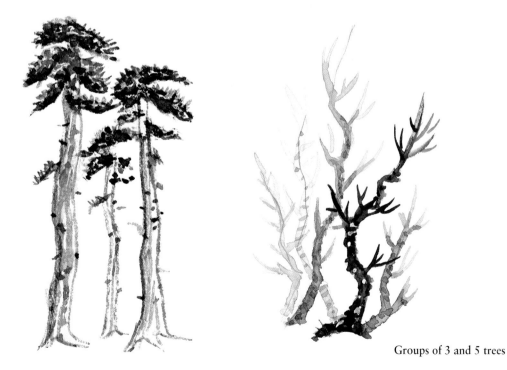

Groups of 3 and 5 trees

When you group trees together, they do not have to be the same species. If they are, try to vary the positioning back and forward. To suggest this depth, make the back ones paler in color and make their roots higher on the page.

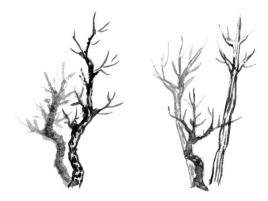

Paint three trees together as if they are a group of friends having a conversation. The tallest and sturdiest one represents the Confucian idea of goodness, uprightness, and a sense of fitness and vigor. That is the host tree, while the others are his guests and are usually smaller. In addition to being taller, the host tree can be darker, more varied in trunk, more interesting in branch formation, and/or of contrasting value. For a boned host tree, add texture, values of ink color, knot holes, and scars to make it distinctive.

The guest trees are less noticeable but still a part of the group. Some branches of a guest tree should overlap or curve toward the host and relate the guest to the other guests. Similarly, the host tree should have a branch reaching out in the direction of the guests. This tends to hold the group together. This is important as there may be other clusters of trees and other guests in the groupings. The guests should appear to be more retiring so that the main host will appear as the dominant one.

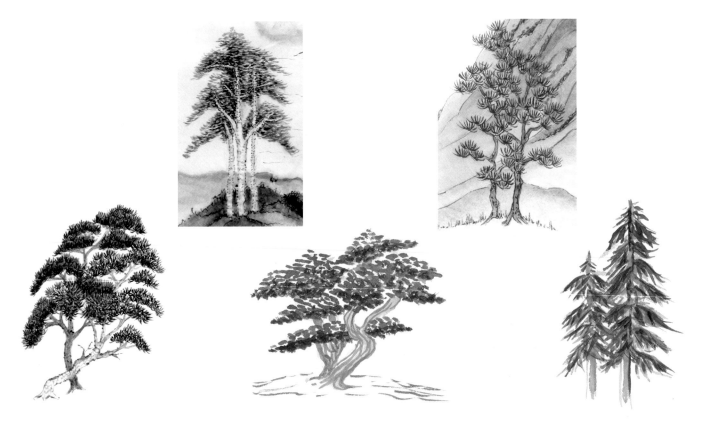

Painting Human Elements

In addition to mountains, rocks, waterfalls, rivers, and trees, landscapes typically have tiny people, buildings, boats, bridges, gates, or other man-made elements that are dwarfed by the grandeur of nature.

Practice your elements on scratch paper and test the scale against the painting before adding them to the landscape. Having too large a scale can ruin the effect of distance.

Figures in a landscape · Boats and barges

Houses and a pagoda

Bridges

Painting a Complete Landscape

Now that you have practiced many of the elements of a landscape, you can put them all together into a complete composition. This example contains many of the elements that you have learned about:

- Distant mountains made with lines and Mi Fei dots
- A waterfall between two ridges
- Mist at the foot of the mountains
- Detailed trees and grasses in the foreground
- Sketchy trees and shrubs on the distant mountains
- Overlapping planes along a path to create a sense of distance
- Tiny houses in the middle ground

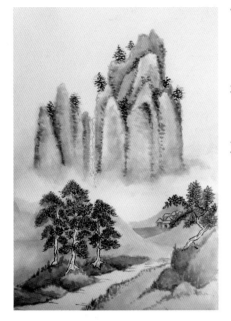

Painting the Mountains in the Distance

1. Load the medium brush with pale ink, hold the brush vertically, and start drawing a wiggly line up the left side of the leftmost mountain and down the other side.

2. Add three more wiggly lines to represent the receding mountains behind the front one.

3. To the right of this cluster of mountains, leave a space for a waterfall and to the right of that outline the mountain ridges in the front. Fill in more mountain lines behind and a large one behind the middle area. Note that you always need to paint the front mountains first so that lines for the back mountains do not cross over the front mountain space.

4. Load the medium brush with pale ink and make shadows behind the front mountains to make them look three-dimensional.

5. Load the detail brush with dark ink and add Mi Fei dots along the mountain ridges to represent shrubs and small trees.

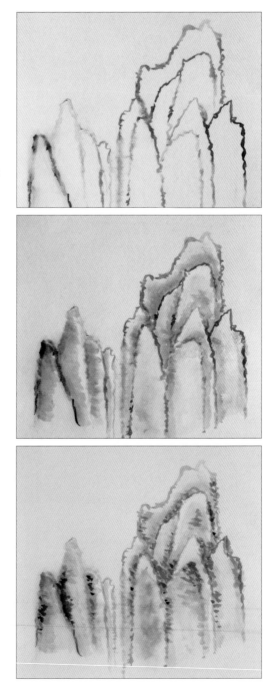

Painting the Foreground

1. Look at the foreground of the composition where the path leads the eye into the village. Load the detail brush with pale ink and outline the path from left to right and getting narrower as it moves into the middle ground.

2. Along the left side of the path, outline several overlapping mounds. On the right side of the path add taller mounds.

3. Load the medium brush with darker ink and add shading around the mounds to make them more three-dimensional. Vary the use of dark and light values so that each mound is slightly different.

4. Load the detail brush with dark ink and outline the trunks and branches of the three trees on the left side of the path. On the mound on the right side of the path, outline a different kind of tree.

5. Reload the detail brush with dark ink and paint pine needles on the tall trees on the left, working from the top down.

6. Since the tree on the right is a different type, it should have a different kind of leaf. Paint boned, triangular leaves to add variety.

Painting the Middle Ground

1. Look at the cluster of houses in the village and copy them using the detail brush and dark ink.

2. Load the medium brush with pale ink and make the overlapping slope areas around the village.

3. At the bottom of the mountains brush in some clean water. Above this area, use the medium brush to add some pale ink to ooze into the water to suggest a fuzzy mist line.

Adding the Finishing Touches

1. Load the detail brush with dark ink and add some distant trees on the mountain slopes.

2. With the detail brush and dark ink, add tiny horizontal strokes along the path to make it look flat.

3. Load the medium brush with medium ink and add some shading and grass strokes along the path and mounds.

4. Dip a toothpick into dark ink and very carefully make some vertical lines to represent the flow of water in the waterfall between the mountain ridges.

The finished composition

Creating Your Own Landscape Composition

Master painters today have learned by copying those who have come before them. They adhere to the traditions of the past by copying, and their students, who in turn copy their teachers, are learning the old ways, also. However, a painting that is a person's own work must have an original composition and the ideas and qi energy of that person.

You can train yourself by copying examples in this book and in books that contain master works of Chinese landscape painters. Recreating different compositions and components can teach you patterns and habits that you can use in creating your own compositions. The process of landscape painting is a combination of general planning and execution, adhering to artistic and philosophical principles and goals, and modifying your strategy if you fail to execute some element as planned.

Planning a Composition

In planning a landscape, you need to make many choices. Start by deciding on the larger scale issues and then work your way down to the details. Try out small sketches with pencil to work out the general layout before picking up the brush to paint.

1. **Choose a format, vertical or horizontal.** Cut your paper to an appropriate length for the proportions you want.

2. **Plan the mountains in the distance.** You could have high, pointed peaks, broad, massive mountains, or rolling hills and large rocks. When painting mountains, remember to reserve white space for a waterfall between ridges, a river running down or a path going up a mountain, mist between or at the foot of mountains, or trees or rocks in the foreground or middle ground that might overlap the mountains.

3. **Plan the areas of interest in the foreground.** Remember to take the bird's-eye view looking down on the foreground. Plan interesting rocks and trees in front and maybe a path, river, or lake that leads into the middle ground towards the mountains. Determine whether you want a lone tree with pleasing roots and branches as a focal point or groups of trees of various types. Plan balanced groupings of host and guest trees. Decide on the size, age, trunks, branches, roots, and leaves of the trees you want to paint.

4. **Plan the middle ground and the water elements.** The middle ground is important to connect the foreground to the mountains behind. A path, river, or lake can lead from the foreground through the middle ground to the mountains. Plan the positioning of the objects as if a person is taking a walk from the bottom to the top of the scene (or from left to right on a horizontal painting) and viewing all the objects along the way. Plan the story that you want to tell with the water, in the form of mist, rain, snow, a waterfall, a river, or a lake.

5. **Plan the human elements to make the scene inhabited.** Consider the placement and scale of figures, buildings, bridges, or boats to show human activity within nature. Remember to keep the human elements small in relation to the grandeur of nature.

6. **Let the final details take care of themselves.** Wait until you have painted the major components to decide on the finishing touches to complete the painting.

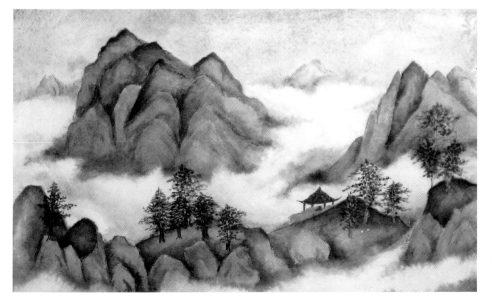

Horizontal scroll

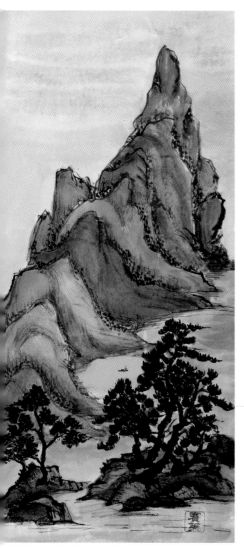

Vertical scroll

Following the Principles

In the Yuan period in the 13th century, a manuscript by Jao Tzu-jan quotes Shih Erh Chi's description of twelve things to avoid in landscape painting. The principles expressed still apply to painters trying to capture the essence of nature and create the effects of "divine" landscape paintings. You can use these principles as a checklist to critique your own paintings and as guidelines for making better paintings.

The Twelve Things to Avoid in Painting, by Shih Erh Chi

1. To avoid is a crowded, ill-arranged composition (composition)

2. Far and near not clearly distinguished (composition)

3. Mountains without Qi, the pulse of life.
 Referring not only to the need for pictorial vitality created by composition with a quality of spirit, particularly since mountains were symbols of life, of the Yang (of Heaven and the Spirit).

4. Water with no indication of its source. (The element regarded as a source of life and associated with the Yin.)

5. Scenes lacking any places made inaccessible by nature (natural and logical).
 Where man has ventured, paths are a sign of his presence and should naturally lead somewhere.

6. Paths with no indication of beginning and end

7. Stones and rocks with one face.
 The rock has three faces, referring to the third dimension and technical skill in rendering it.

8. Trees with fewer than four main branches.
 The tree has four main branches and is represented as having solidity, roundness, and unity.

9. Figures unnaturally distorted.
 Emphasize fitness based on naturalness, contributing to the harmony of the parts and the whole of a painting. Figures not only should be undistorted but should be shown in action, their position and mood in tune with the rest of the painting and thus with the order of nature.

10. Buildings and pavilions inappropriately placed.
 Houses, pavilions, bridges, waterwheels, or boats, never overshadow other elements in the picture but contribute to its main theme, usually some aspect of nature rather than of human activity.

11. Atmospheric effects of mist and clearness neglected

12. Color [values] applied without method.

 Mountains and water are not only the main structural elements in a landscape painting but serve as symbols of the Yin and Yang. They are structural ideas, hence the significance of the term Shan-Shui (mountain water) for landscape pictures.
 – "Shih Erh Chi," quoted from a XIII-century work by Jao Tzu-jan.

Guidelines for Landscape Elements

Mountains—The painted mountains should look spontaneous, created by quick brush strokes that taper off at the edges. Among several mountains, one must be dominant as a host with guests around it.

Water—A landscape painting must have water in it in some form. Mists ring the mountain tops and fog fills the valley. Clouds can be suggested. Rain may be shown with a few slash marks. A waterfall pours into a lake or a river, which may have ripples or a visible current. The source of a river must be evident. Snow may be shown as light beside a darker river or lake.

Trees—A landscape painting must have a variety of trees if there are more than seven trees. The trees should be related as host and guests reaching out to each other. Put at least four main branches going in different directions on a tree.

Rocks—Mountains, stones, and rocks should have more than one face so that they look three-dimensional. Arrange them in clusters as male and female.

Paths—A path should have an indication of a beginning or end. However, there should always be places made inaccessible by nature.

People—Figures should look natural and in the process of doing something, like rowing or sailing a boat, hiking up the mountain, or meditating in a pavilion. People are usually solitary and contemplative, enjoying the scene around them, and conveying a mood of reverence or ritual appreciation of nature.

Buildings—Buildings and pavilions should be placed where they have views looking out over a canyon, up at a mountain, or on a peak isolated from everything else. They should be small to make the environment look large.

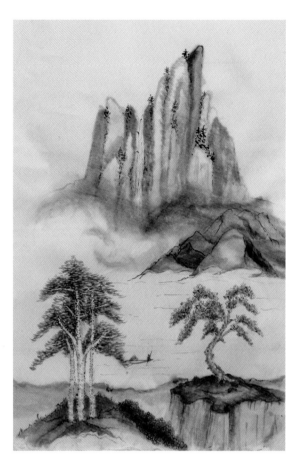

Visual Principles of Landscape Painting

Composition—The items toward the middle sections of the landscape are more important and taper off towards the four corners. A landscape painting should have a triangular composition off center with an empty corner. It should not be crowded, and the edges should be sparse.

Values—Contrast dark values and against light values, light trees against dark backgrounds, dark trees against light backgrounds, light water, mist, or fog against dark mountains. Waterfalls should be light so they show up against dark rocks.

Size—Large objects in front and small in rear suggest the rear one is farther back. If people are painted small, the mountain looks huge. The far and near must be clearly distinguished.

Space—Objects low on the page appear closer and those higher seem further back.

Overlapping—Objects in front overlap those behind and create the illusion of space between them. Use small fingers of shore overlapping on both sides of a river to create the sense of the river going back in space.

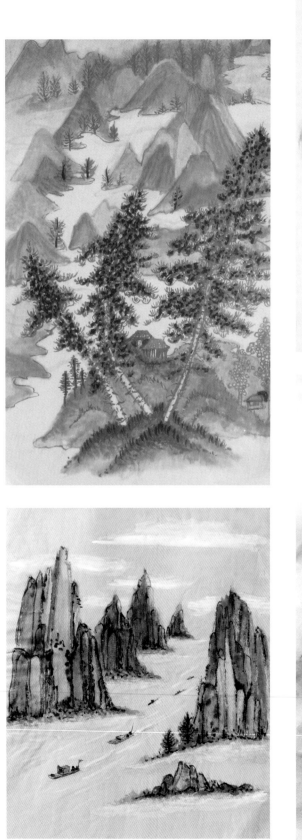

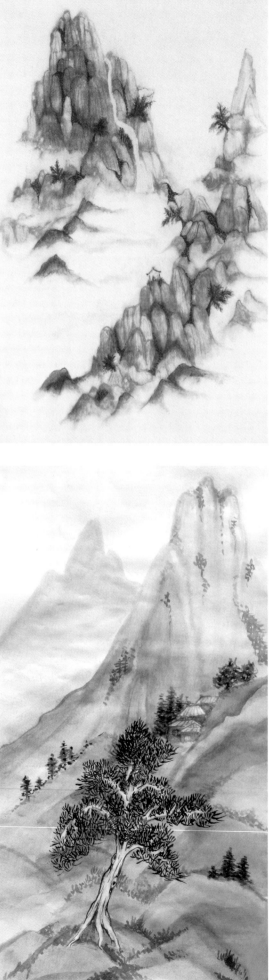

Acknowledgments

We thank Sherry Kendrick for her advice, for use of her paintings in the first chapter,
and especially for her help in doing calligraphy.
Thanks to the Barbara Bauer Literary Agency for all their help.

Published by Tuttle Publishing, an imprint of
Periplus Editions (HK) Ltd.

www.tuttlepublishing.com

Library of Congress Control Number: 2021938285

ISBN: 978-0-8048-5452-8
(Previously published as *The Art of Chinese Brush Painting*,
ISBN 978-0-8048-3989-1)

Distributed by
North America, Latin America & Europe
Tuttle Publishing
364 Innovation Drive
North Clarendon, VT 05759-9436 U.S.A.
Tel: 1 (802) 773-8930; Fax: 1 (802) 773-6993
info@tuttlepublishing.com
www.tuttlepublishing.com

Japan
Tuttle Publishing
Yaekari Building 3rd Floor
5-4-12 Osaki
Shinagawa-ku
Tokyo 141-0032
Tel: (81) 3 5437-0171; Fax: (81) 3 5437-0755
sales@tuttle.co.jp
www.tuttle.co.jp

Asia Pacific
Berkeley Books Pte. Ltd.
3 Kallang Sector #04-01
Singapore 349278
Tel: (65) 6741 2178; Fax: (65) 6741 2179
inquiries@periplus.com.sg
www.tuttlepublishing.com

"Books to Span the East and West"

Tuttle Publishing was founded in 1832 in the small
New England town of Rutland, Vermont [USA].
Our core values remain as strong today as they were
then—to publish best-in-class books which bring
people together one page at a time. In 1948, we
established a publishing office in Japan—and Tuttle
is now a leader in publishing English-language books
about the arts, languages and cultures of Asia. The
world has become a much smaller place today and
Asia's economic and cultural influence has grown. Yet
the need for meaningful dialogue and information
about this diverse region has never been greater. Over
the past seven decades, Tuttle has published thousands
of books on subjects ranging from martial arts and
paper crafts to language learning and literature—
and our talented authors, illustrators, designers and
photographers have won many prestigious awards.
We welcome you to explore the wealth of information
available on Asia at **www.tuttlepublishing.com**.

24 23 22 21
10 9 8 7 6 5 4 3 2 1

Printed in Singapore 2107TP

TUTTLE PUBLISHING® is a registered trademark of
Tuttle Publishing, a division of Periplus Editions (HK) Ltd.

Sources for Oriental Art Supplies

Asian Brush Painter
1301, 13/F, Chung Nam Building
No. 1 Lockhart Road, Wanchai
Hong Kong
www.asianbrushpainter.com
info@asianbrushpainter.com
facebook.com/asianbrushpainter/
Browse the biggest selection of Oriental brush painting & calligraphy supplies

Awesome Art Supply
(retail store of Paragon International Arts)
Tel: (425) 497 9915
awesomeartsupply.com
info@AwesomeArtSupply.com
Oriental brushes, ink, paper, seals and accessories

Dick Blick Art Materials
PO Box 1769
Galesburg, IL 61402-1267
Tel: (800) 828-4548
www.dickblick.com
facebook.com/BlickArtMaterials/
info@dickblick.com
Oriental and Sumi brushes, ink and paper

Kyukyodo
520 Shimohonnojimaecho,
Nakagyo Ward, Kyoto, 604-8091, Japan
Tel: 81 75-231-0510
www.kyukyodo.co.jp (in Japanese only)
Large selection of high quality papers, brushes, ink sticks, ink stones and accessories. A source of "the artist's treasures." This venerable stationery store in the Teramachi shopping district of Kyoto has been serving customers since 1663! A must-see destination for the artist visiting Japan.

Oriental Art Supply (OAS)
21522 Surveyor Circle
Huntington Beach, CA 92646
Tel: (714) 969-4470
www.orientalartsupply.com
facebook.com/OrientalArtSupply/
Oriental brushes, ink, paper, accessories and painting classes

Paper Connection International, LLC
166 Doyle Ave.,
Providence, RI 02906-1645
Tel: (401) 454-1436
www.paperconnection.com
www.facebook.com/PaperConnectionInternational
Fine art papers and decorative papes from Asia

Rochester Art Supply
150 West Main St, Rochester, NY, 14614
Tel: (585) 546-6509; (800) 836-8940.
www.fineartstore.com
facebook.com/FineArtStore
customerservice@fineartstore.com
Premier store for all your fine art supply needs

Sumi E Store
Redmill, Virginia Beach, Va, 23456
Tel: (757) 986-0022
www.sumiestore.com
Oriental and Sumi brushes, ink and paper